PERSIA

THIRTY CENTURIES
OF ART & CULTURE

HERMITAGE ❧ AMSTERDAM

PERSIA

THIRTY CENTURIES
OF ART & CULTURE

Lund Humphries

In association with the

Hermitage Amsterdam

The exhibition was made possible by:

FOUNDER: BankGiroLoterij

MAIN SPONSOR: **FORTIS**

SPONSORS: *KPMG* Fugro Heineken International

INSURANCE: AON

SUBSIDISING BODIES:
State of the Netherlands
Province of North Holland
City of Amsterdam

WITH THANKS TO THE:
W.E. Jansen Fund

PARTNERS:
Internet / IBM Nederland
Media partner / Avro Kunst
Travel partner / Voyage & Culture, Amsterdam
Courses / Vrije Academie voor
Kunsthistorisch Onderwijs, Amsterdam

I am**sterdam.**

CONTENTS

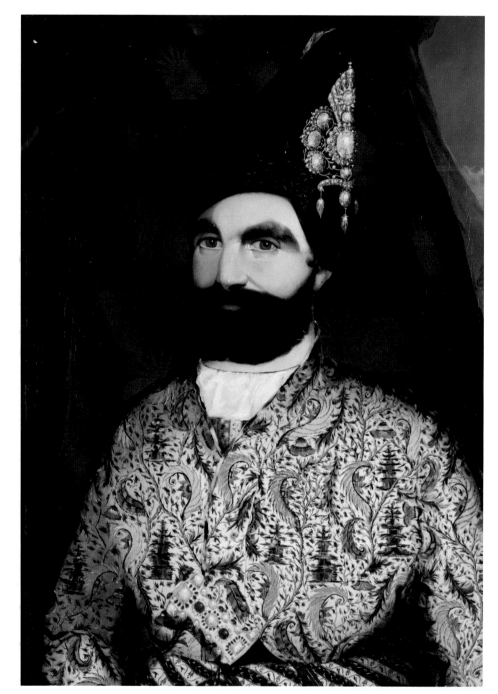

Portrait of
Muhammad Mirza (?)
Oil on canvas
1830s

CAT. NO 181

PERSIAN RIDDLE

Today Iran-Persia occupies ours minds no less than it did in the days of the Graeco-Persian wars, when the confrontation between Iran and Western civilisation was the very essence of history. The antiquity of Iranian civilisation endows it with particular rights, demands that was pay close attention for its unique features and its traditions. However strange it may seem, exhibitions devoted to Persian history are always a revelation, for even today we know little of events of the past and of what is taking place today beyond the bounds Western culture and history.

Today there are still many riddles in the life and behaviour of Iran; its actions are at times incomprehensible. Some answers and resolutions to those riddles are provided by Iran's art and culture, which have long inspired great admiration among Europeans. Those answers are not direct. They are, rather, allegorical and allusive, filled with discreet hints, in many ways like the sophisticated art of Iran itself.

Achaemenid art, monumental and durable; Sasanian silver, strong yet elegant; magnificent bronzes, sparkling miniatures, charming lacquer wares... The Hermitage is extremely lucky to be the keeper of these rarities, magnificent proof of the repeated flowering of art in the lands where Zarathustra / Zoroaster once preached. This is a great culture that was reborn time and time again after periods of decline, but never, perhaps, of dormancy.

Persian art reflects the mutual enrichment of cultures that formed the backdrop to the great confrontations: between Darius and Alexander the Great, Shapur and Roman Emperor Valerian, Yezdegerd and the Arab conquerors, Nadir Shah and the Great Mongol Empire, and so on. That interweaving of traditions and influences kept Persian art alive and vivid. Yet its readiness to adopt the best offered by its neighbours did not prevent it preserving its own unique face and that charm which in turn stimulated imitation by those same neighbours. The Persian language is one of the key languages in world culture. Persian visual language is one of the key languages in world art.

Iran is Russia's neighbour and thus ties between our countries have always been important and varied. Iranian merchants and Iranian embassies frequently visited Moscow and St Petersburg; our armies repeatedly came into conflict; Russian scholars have studied the culture of Iran with great passion, resolving many of its riddles for the world. One result of those ties is the Hermitage's collection of Iranian art, a collection that deservedly the object of great pride today. It is part of that collection, and the results of research by several generations of Russian scholars, that we present here to visitors to the Hermitage Amsterdam. We hope that this exhibition will bring you aesthetic pleasure and the joy that comes from discovering something new.

Prof. dr. Mikhail B. Piotrovsky

DIRECTOR, STATE HERMITAGE MUSEUM, ST PETERSBURG
PRESIDENT, STICHTING HERMITAGE AAN DE AMSTEL

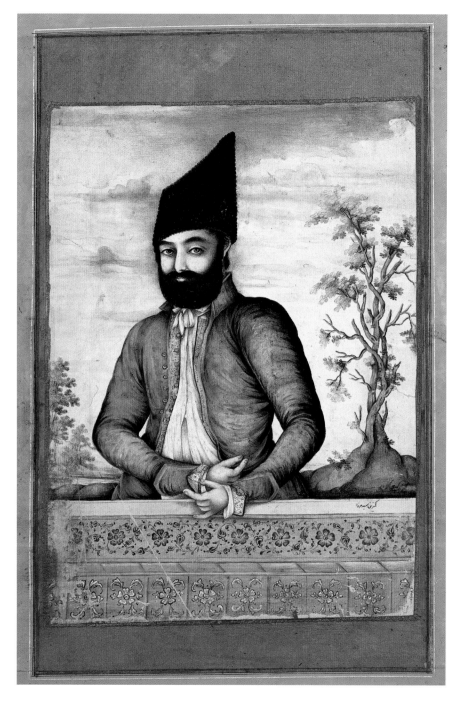

Portrait of a man
(probably Prince Muhammad Mirza)
Gouache on paper
Sayyid Mirza, ± 1830

CAT. NO 180

Persia. Thirty centuries of art and culture: a tale from a Thousand-and-One-Nights

The history of Persia reaches far back into the mists of time. Officially called Iran since 1935, this country is regarded as one of the cradles of Western civilisation. For thirty centuries it was ruled by a number of dynasties; some indigenous, others Greek, Arabic, Mongolian and Turkish in origin. Their vestiges and influences are evident in the rich cultural heritage of this unique region.

The seventh exhibition organised by the Hermitage Amsterdam, 'Persia. Thirty centuries of art and culture', presents an overview of some three thousand years of Persian art and culture. It has yielded a wide range of objects. From antiquity comes Scythian gold jewellery, from Tsar Peter the Great's Siberian Collection, and fine examples of the Sassanids' celebrated silverware. The objects in the antiquity section have been supplemented with some ten loan items from the Allard Pierson Museum, the University of Amsterdam's archaeological museum. The Islamic period – which forms the crux of the exhibition – is illustrated by magnificent ceramics, skillfully made bronze objects and unique examples of what is regarded as the highest and noblest of all the Islamic arts, calligraphy and refined miniature paintings. Finally the nineteenth-century Qajar period is represented by such pieces as striking examples of Persia's renowned portrait painting.

Thanks to the Hermitage's rich collections in St Petersburg it has been possible to compile a fine overview of the history of Persian civilisation, in which connections between the various objects are expressed in the forms, decorations and traditions.

As in a tale from a Thousand-and-One-Nights the doors of the Hermitage Museum in St Petersburg have once again opened to reveal their treasures to visitors to the Hermitage in Amsterdam.

I would sincerely like to thank Adèl Adamova, curator of Islamic Art in the Hermitage's oriental department in St Petersburg, and her colleagues, for their knowledge and enthusiasm. And once again my thanks also go to the Hermitage in St Petersburg and the regular sponsors of the Hermitage Amsterdam.

Ernst W. Veen

DIRECTOR HERMITAGE AMSTERDAM

HERMITAGE ❧ AMSTERDAM

No race is so ready to adopt foreign ways as the Persian;
for instance, they wear the Median costume because they
think it handsomer than their own [...] Pleasures, too,
of all sorts they are quick to indulge in when they get to
know about them — a notable instance is pederasty, which
they learned from the Greeks. Every man has a number
of wives, and a much greater number of concubines.

HERODOTUS, THE HISTORIES, BOOK I, 135
(translated by Aubrey de Sélincourt, 1954, revised edition by John Marincola 1996)

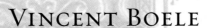

VINCENT BOELE

PERSIA AND ITS MAGNIFICENT BEAUTY

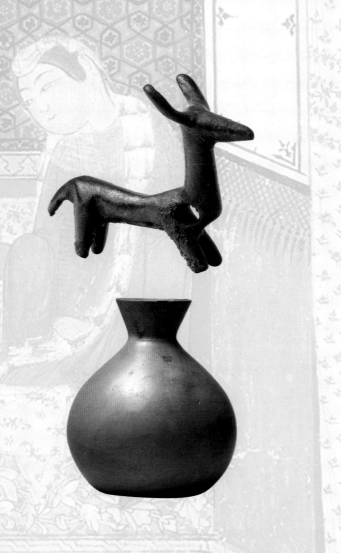

T

Think of Persia, and you think of the Shah, Farah Diba, Scheherazade, King Xerxes and Darius the Great. Names from times long past. Names which conjure up a magical world, an ancient world of grand exploits, the fabled world of a Thousand-and-One-Nights. But what do we actually *know* about Persia? What is the truth about this country and its colourful past?

Persia is a land with a long and rich history. A land whose culture is individual and unique. Its characteristic designs and iconography have survived down the centuries, despite the many changes and developments to affect the country. From ancient times until the nineteenth century Persian artists depicted the world around them in reliefs and ceramics, on paper, parchment and canvas. The figurative element was never banished from Persian art, although the Koran discouraged human pretentions to emulate divine creation by bringing man and beast to life in artistic representations. Yet artists aspired to heavenly perfection in their art, as a way of honouring Allah and working in His spirit. Thus Islamic tradition accorded almost divine importance to aesthetics.

The history of Persia – or rather of Iran (it was the second last Shah, Persian for 'king', who in 1935 requested the international community to henceforth call his country by its own name, Iran, 'Land of the Aryans') – is a long one. The earliest known – Assyrian – mention of the land by this title dates from 844 BC, although the first ancestors of the Iranians probably settled in the region as early as circa 1500 BC. The previous inhabitants were the Elamites, whose oldest archaeological traces date back to the

(previous page)
(above) CAT. NO 205
SMALL FIGURE OF A GOAT
Bronze
Luristan, *early 1st millennium BC*

(below) CAT. NO 206
FLASK
Grey earthenware
Amlash, *1350-1000 BC*

(above) CAT. NO 171
SCENT BOTTLE
Glass
18th – 19th century

fourth millennium BCE. Much later in the region's history the Achaemenids, the first royal dynasty of Persia, were heavily influenced by the Elamites' legacy and adopted their cuneiform script.

All these early peoples laid the foundations for the art and culture of Iran, in which tradition succeeded tradition, even in the later Islamic period. Persian artists liked to show that their work was rooted in tradition by quoting forms and images created by older masters, although they also added new elements. Of course, there was nothing new or unique about this practice. In ancient Egypt the iconography and style of the Old Kingdom (2575-2150 BC) was regularly reprised, for it was regarded as a 'golden age'; pharaohs such Hatshepsut (1479-1458 BC) and rulers from the Late Period (664-323 BC), including the Persian overlords of the land along the Nile (525-c 400 BC), were keen to add weight to their authority by establishing a link with this earlier time.

In the modern period the shahs of the Qajar dynasty sought to legitimise their rule over Persia in similar fashion, consciously reviving the age of the Achaemenids through the construction of palaces in Achaemenid style or of similar grandeur. The ancient ruined city of Persepolis became a new symbol for the dynasty (cat. no 200).

EXHIBITION STRUCTURE

A leitmotif in Iranian art is the recurrence of old forms and traditions. The exhibition *Persia: Thirty centuries of art and culture* uses the objects selected for display to create an overview and impression of three thousand years of art and culture, with the accent lying on Islamic art. The exhibition has been subdivided into six groups.

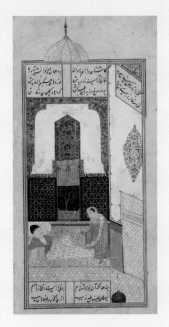

PAGE FROM THE *KHAMSEH* BY NIZAMI:
BAHRAM GUR IN THE WHITE PALACE (F. 310B)
Gouache, ink and gold on paper
Text copied by the calligrapher Mahmud in Herat, *835 AH / 1431*
Nasta'liq script, 38 miniatures

CAT. NO 99

The objects from antiquity – all modest in format – constitute a single group of pre-Islamic art. The leitmotif of recurring forms and long traditions is firmly established in this section through the inclusion of ten pieces from the collection of the Allard Pierson Museum, the University of Amsterdam's archaeological museum. A 'beaked jug' from the Amlash period (1350-1050 BC), with its characteristic, sharp, bird-beaked spout, marks the beginning of a tradition which continued into the Islamic period (cat. nos 156 and 201). A plain earthenware *phiale* (offering dish, cat. no 208), with a small animal figure in its centre, from circa 750 BCE, is echoed by the silver Sassanid dish from the fourth century BC (cat. no 23). Fragile yet impressive Amlash flasks of eggshell thin pottery (cat. nos 171, 206) are the precursors to elegant pieces of Islamic glassware from

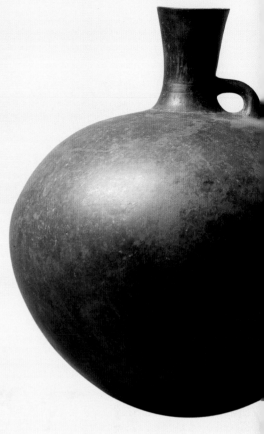

the seventeenth and eighteenth century. And finally, the Amlash *rhyton* or serving jug in the form of a ram (cat. no 203) is reprised by the animal-shaped jugs and incense burners produced by potters in the Middle Ages and the nineteenth century, under the Qajars (cat. nos 38, 39, 192, 195).

The second group comprises a collection of bronze and ceramics from the Middle Ages. Iran has a rich tradition of bronze and ceramic production. Medieval ceramics were heavily influenced by the blue Chinese porcelain exported to Europe and the Near East from the fifteenth century onward. Iranian pottery in its turn influenced ceramic production in Italy and the Netherlands. Iranian bronzeware, with its ingenious copper and silver inlay and Arabic and Persian inscriptions, was first produced in the Middle Ages, becoming an enduring element in the repertoire of applied art in Iran.

below, left to right
CAT. NO 156
DECANTING CUP
Copper

CAT. NO 201
BEAKED JUG
Black earthenware
Amlash, 1350-1000 BCMid 17th century

CAT. NO 208
PHIALE WITH CENTRAL
FIGURE OF A GOAT
Earthenware, red painting
Iran, 750-550 BC

CAT. NO 23
EARLY SASSANIAN
SILVER DISH DECORATED
WITH A SMALL GOAT AND
A PARTHIAN INSCRIPTION
Silver, sheet gold, parcel gilt
*2nd century BC – 2nd century AD;
later reworking AD 240-260*

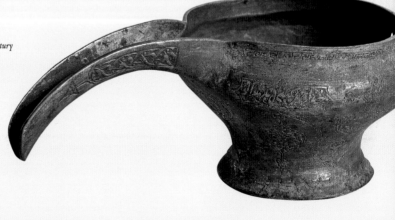

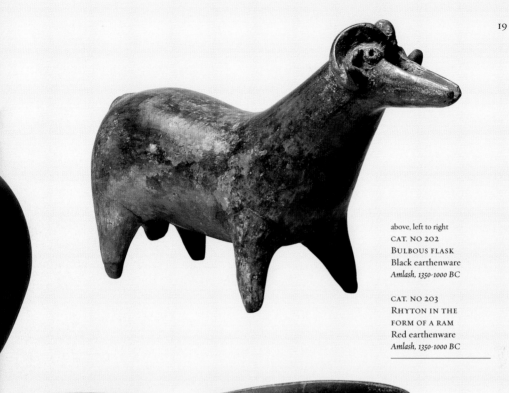

above, left to right
CAT. NO 202
BULBOUS FLASK
Black earthenware
Amlash, 1350-1000 BC

CAT. NO 203
RHYTON IN THE
FORM OF A RAM
Red earthenware
Amlash, 1350-1000 BC

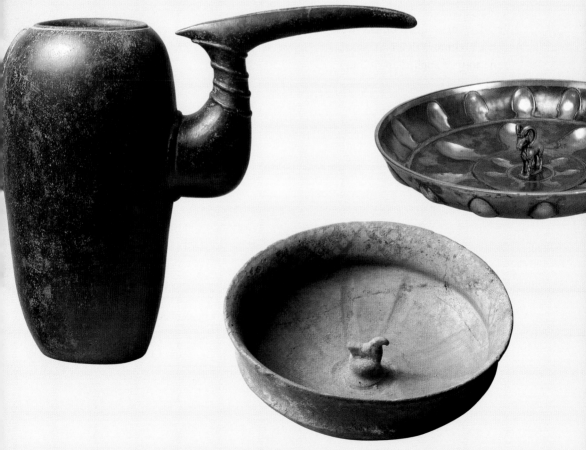

The third group presents two other art disciplines for which Iran is rightly famous, calligraphy and miniature painting. Within Islamic tradition calligraphy, or fine writing, is regarded as the highest form of art. The aim of calligraphy is to present the word of Allah, the Koran, as beautifully as possible. Many schools of calligraphy were founded in the Middle Ages, including the Persian school, one of the most famous. It is possible to distinguish different styles of calligraphy, such as Kufic, Italic and *maghríbi* (from the Magreb, in northwest Africa). Calligraphy was considered an art, rather than a craft, and the spiritual aspect was heavily emphasised during training. In this respect, therefore, the art of Islamic calligraphy displays parallels with Christian Orthodox icon painting.

Some manuscripts were illustrated with colourful miniatures. Exhibitions held in Munich and Paris in the early twentieth century made these depictions of scenes from Persian literature famous in the west where this literature already enjoyed considerable renown. Persian miniature painting soon acquired the status of an independent art form. These small book illustrations bring to life the enchanted storybook world with which Persia was, and still is, so associated in the west. Colourful images depict a range of scenes from Persian love poetry – including the celebrated homoerotic poems of the fifteenth century – and stories from everyday life, offering a glimpse into the lives of all Iranians.

The fourth group presents more bronze and ceramic objects, all from a later period in which craftsmen worked according to traditions established in the Middle Ages with little notable change.

The fifth group focuses attention on glass and textiles. Fragile, elegant flasks in blue and green glass display the craft of Iranian glassblowers whose skills matched those of their Venetian counterparts. Iranian glass found a ready market throughout Europe, including Russia. Textiles, generally woven in silk, were not exclusively abstract in motif, as in many other Islamic countries: mantles, scarfs and other garments were adorned with representations of people and animals, although such items were only worn indoors or within palace walls. These costly fabrics were another popular export item.

The sixth and final group comprises objects from the time of the Qajar dynasty, whose members regarded themselves as the direct descendants of the Elamites and the Achaemenids. Antiquity inspired the Qajars to wear loose clothing and let their beards grow. The finest example of this link is the carpet which shows Persepolis (cat. no 200). Although the ruined city had been known for centuries and often visited, the first excavations were not conducted there until 1878.

Animal figures from the Qajar period were no longer made of copper or bronze, but of steel, and were crafted with the same exquisite skill employed in the Middle Ages.

The Qajars also drew inspiration from the west. Many Persian motifs acquired a western veneer; painting began to incorporate western techniques and portrait painting made its appearance.

1. SUCH AS THE WORKS OF THE PERSIAN POET NUR AD-DIN ABD AR-RAHMAN JAMI (1414-1492).
2. THE DUTCHMAN CORNELIS DE BRUIJN (1652-1727) VISITED PERSEPOLIS IN 1704/1705 AND PUBLISHED HIS OBSERVATIONS IN 1711 IN HIS BOOK *REIZEN OVER MOSKOVIË, DOOR PERSIË EN INDIË*. THE AMERICAN ARCHAEOLOGISTS ERNST HERZFELD AND ERICH F. SCHMIDT, OF THE ORIENTAL INSTITUTE IN CHICAGO, HEADED EXCAVATIONS IN THE CITY FROM 1931 TO 1939.

Alexander Nikitin

Ancient Iran

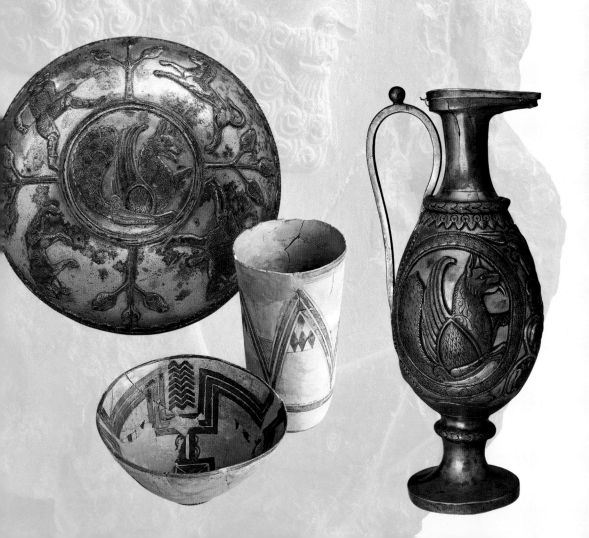

T The ancestors of modern Iranians, who called themselves Aryans, appeared on the territory of Iran in the second half of the 2nd millennium BC, probably as part of the same migrational processes that brought the ancestors of today's Europeans – speaking Romance, Germanic and Slavic languages – to the lands of Europe. It was also at around this time that Indo-European (Aryan) tribes related to the Iranians made their way onto the Hindustan Peninsula. The very name of the country – Iran (Ayran) – derives from that early name, Aryan. Scattered information about Iranian tribes can be found in cuneiform and akkadian documents, above all in Assyrian chronicles. At the start of the 1st century BC the Assyrians set out to conquer western Iran and succeeded in subordinating several Iranian tribes, who were thus forced to pay them tribute. Stele of a number of Assyrian kings have been found in the western regions of Iran that bear texts providing evidence for these campaigns and for punitive expeditions against the unbowed rulers of Media.

Having settled on the territory of Iran, the Aryan tribes came into contact with several ancient civilisations, above all that of Mesopotamia. In southern Iran there was another ancient state, Elam, that had existed since the 4th millennium BC. Even today, no agreement has been reached by scholars regarding the Elamites' origins and ethnicity, but we cannot exclude the possibility that they were distant relatives of the modern population of Southern India, who speak languages of the Dravidian group. Elam was to have a major influence on the culture of the Iranian peoples. Indeed, Elam cuneiform script was the official writing of the Achaemenid Empire in the 5th and 4th centuries BC.

(previous page, from left to right)
CAT. NO 28
SASSANIAN DISH DECORATED
WITH HUNTING SCENES AND
A *SENMURV*
Silver, parcel gilt
Late 6th – 7th century

CAT. NOS 1 & 2
ELAMITE CUP AND BOWL
Ceramic
4th – 3rd millennium BC

CAT. NO 25
EWER DECORATED
WITH A *SENMURV*
Silver
6th – early 7th century

Consolidation of these Iranian tribes' position in the region was speeded up by association with neighbouring ancient cultures of the Near East and by political pressure from Assyria. The first independent Iranian state was Media, which in the 8th century BC united the peoples of western Iran. Allied with Babylon and the Scythians who came from the north, Media was able to bring down the Assyrian Empire. So significant an event was the fall of Nineveh, capital of Assyria, which had oppressed the neighbouring peoples for many centuries, that it was reflected in the writings that make up the Christian Bible. The rulers of Media con-

ducted an expansionist policy and their influence was to be felt across southern Iran, northern Mesopotamia, the Transcaucasus and the eastern part of Asia Minor. Media was to be the forerunner of the great Iranian Empire that united all the lands of the Ancient Orient, yet little is known even today about its culture. We can be certain only that it was, by the standards of the age, a civilised land capable of borrowing and applying all the achievements of ancient eastern civilisations.

The Achaemenid Dynasty

Great political upheaval in the middle of the 6th century BC brought to power the Achaemenid dynasty, which had previ-

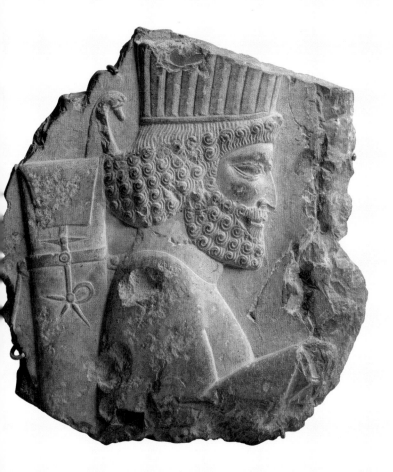

Fragment of a relief depicting a Persian guard in the service of King Darius or King Xerxes
Stone
Persepolis, *5th century BC*

CAT. NO 3

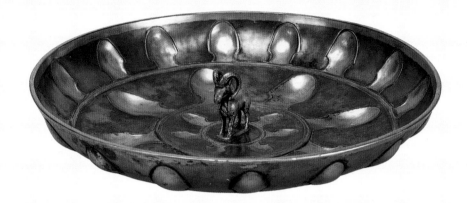

EARLY SASSANIAN SILVER DISH
DECORATED WITH A SMALL
GOAT AND A PARTHIAN
INSCRIPTION
Silver, sheet gold, parcel gilt
*2nd century BC – 2nd century AD;
later reworking AD 240-260*

CAT. NO 23

ously ruled in Anshan (Anšān) in the south of Iran. Cyrus, King of Persia, who seized the throne of Media, was clearly a relative (according to legend the grandson) of the last Median king, Astyages, and thus the Medes did not perceive this change of affairs as foreign intervention. Henceforth, the Persians and the Medes were to be a single people, occupying a dominant position in the multicultural empire established by Cyrus. Over the course of several decades, Cyrus brought a huge territory under his control, including Asia Minor, Mesopotamia, the eastern Mediterranean, Bactria and part of Central Asia. Under his immediate successors the empire came to include Egypt, northern India and many islands in the Mediterranean. The success of Achaemenid expansionist policy can probably be explained not only by superior military organisation. In subjugating any new land, the Persians always sought the support of at least part of the local nobility and their internal policies seem to have been on the whole rational and humane, allowing for freedom of religion and seeking not to destroy established local structures but rather to make use of them. In some regions a form of local self-government was even permitted. For many peoples, Achaemenid rule was undoubtedly a blessing, the most outstanding example being Cyrus' liberation of the Jews from Babylonian captivity. They were permitted at last to return home to Judea, which under the Achaemenids gained the status of an autonomous theocratic republic, and to rebuild the Temple in Jerusalem. It was thus thanks to Cyrus that our civilisation gained the Bible, which would not otherwise have been written.

With almost unlimited resources at their command, the Achaemenids were able to build roads and canals, to erect magnificent palaces and temples which they adorned with sculptures and reliefs. Documentary records (cuneiform tablets) from Persepolis and Susa provide evidence that craftsmen of different nationalities – including Egyptians and Greeks from Asia Minor – were involved in all these works. Monumental architecture and art of the Achaemenid epoch served a very specific purpose: to glorify the dynasty and assert the new world order. It is therefore not surprising that a scene of single combat between a royal hero and three different monsters – the gryphon, the horned lion and the bull – is repeated several times in the reliefs of the palace at Persepolis. Each of those monsters was a symbol of the Babylonian monarchy and their defeat at the hands of an Iranian hero signified the overthrow of the old world order and the establishment of the new. The same propaganda purposes were served by reliefs with endless rows of royal bodyguards and people bringing tributes and gifts, of representatives of all those peoples who were subject to the Achaemenids.

We can judge the nature of unofficial art of Achaemenid Iran mainly from a few surviving examples of metalwork, jewellery and parade armour. Clearly Iran was already producing magnificent carpets and textiles, athough they have not survived. Almost nothing has survived of the painting that once adorned the palaces of Iran.

Amongst the many subjects still open to much debate is the nature of the religion of Achaemenid Iran and whether indeed Iran had an official religion. The Achaemenids saw Ahura Mazdah, supreme deity of the Iranian pantheon, as their patron, and yet they recognised the existence of other divinities, such as Mithra and Anahita. Some part of the Iranian priesthood may have already believed in a monotheistic concept, seeing Ahura Mazdah as the sole god and creator of all things, in keeping with the teachings of the great Iranian prophet Zoroaster (Zarathustra). Zoroaster probably lived in the 9th to 8th centuries BC, although some scholars set his life somewhat earlier. We should note, however, that Zoroaster's name does not appear in any surviving Achaemenid texts, nor do they contain any excerpts or quotations from the Avesta, the holy book of the Iranian peoples. A little information about the religion of Achaemenid Iran is provided by Herodotus, who was much impressed by the fact that the Persians did not link worship of the deity with adoration of his image. He saw this as a positive aspect when compared with the 'primitive' beliefs of the Hellenes, who bowed down before sculptures of the gods. There is no doubt that the religious and philosophical ideas of the Iranian peoples exerted considerable influence on the development of Greek philosophical thought. It was on the Ionian Islands and in Asia Minor, which formed part of the Iranian state, that the most progressive philosophical schools were to take shape.

By the second half of the 4th century BC the Achaemenid state had been considerably weaked by inner conflicts and it was conquered by Alexander the Great. Alexander had great respect for the Persians and their cultural achievements. Himself an idealist, he sought by artificial means to create a new dominant nation, encouraging intermarriage between the Persians and the Macedonian Greeks. Persian ceremonial was introduced at

the Macedonian court and the empire that Alexander had conquered preserved overall the Achaemenid system of rule, with noble Persians occupying high state posts and (in some regions) regional dynasties left in power.

AFTER THE DEATH OF ALEXANDER

Alexander's empire fell apart almost immediately after his death in 323 BC. Iran became part of the state of the Seleucids, descendants of one of Alexander's commanders, and Alexander's successors rejected his policy of uniting peoples. Under the Seleucids, only Macedonian Greeks – who formed an exclusive military caste – and a very small layer of the local hellenised nobility were permitted to occupy administrative posts. The power of the Seleucids rested on the towns, mainly populated by Macedonian Greeks and organised as city-states. Local populations were kept under control through the military preeminence of the hellenic armies. Such a policy was bound to do little for cultural integration and the population of Iran continued to see the Seleucids as foreigners and conquerors. In southern Iran, however, in Pars – homeland of the Achaemenids – the power of the Seleucid rulers was purely nominal. From the early 3rd century BC the area was in effect ruled by a local priestly dynasty that claimed to be related to the Achaemenids. Seleucid control of Northern Iran ceased in the midddle of the 3rd century BC and here, on the territory of what is today southern Turkmenistan, an Iranian dynasty came to power, founded by Arsaces, leader of the Parni (Parthian) tribe. Gradually, the Arsacids attached each of the historic Iranian lands taken by the Seleucids, creating a new Iranian empire. By 136 BC it included Mesopotamia and had extended to India in the East.

Arsacid internal policy was liberal: they did not interfere in local government, left local dynasties in control and were extremely tolerant of different religious faiths. The polis system remained in place in those Iranian and Mesopotamian towns inhabited by Greeks. Soon the Parthian nobility had mastered the elements of Greek culture and a knowledge of Greek language and literature became the norm. Greek, Aramaic and Parthian were state languages on a par with Parthian under the Arsacids. Thus the conditions were right for true cultural integration. This was reflected in Parthian art, which frequently made us of hellenic subjects and images, and in everyday life where vessels of traditional hellenic form came into use. Cultural integration in turn influenced religious life and it is during this period that we find images of syncretic Graeco-Iranian gods such as Heracles-Verethragna and Helios-Mithra.

By the middle of the 1st century BC the Parthian state had come up against a new opponent to the West, Rome. More than two centuries of conflict between the two empires were to ensue, in which the Parthians were only rarely the aggressors. More often it was Roman commanders and emperors who initiated conflict, seeking to resolve internal problems through 'a small victorious war'. Some Roman campaigns, such as that led by Crassus in 53 BC, ended in utter defeat for the Romans, while others were considerably more successful: Trajan managed to reach the shores of the Persian Gulf and Septimus Severus enjoyed several victories over the Parthians. Although the Romans could not take full advantage of the fruits of their victo-

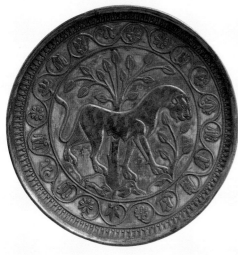

(above) CAT. NO 27
SASSANIAN 'BEAKER'
(CUP WITH FOOT BROKEN OFF)
Silver, parcel gilt
6th–7th century

(below) CAT. NO 26
SASSANIAN DISH DECORATED
WITH A LIONESS
Silver, parcel gilt
6th century

ries, being unable to keep hold of the conquered territories, their attacks seriously weakened the prestige of the Arsacid dynasty, despite its four centuries on the Iranian throne. As a result, separatist movements gained power and influence until they brought about the collapse of the Parthian state.

THE SASANIAN DYNASTY

The Arsacids were replaced in the first quarter of the 3rd century AD by a new dynasty, the Sasanians, who once again united Iran and turned it into a centralised state.

The Sasanians were from Pars and saw themselves as direct heirs of the ancient Achaemenids. Under them the number of independent rulers calling themselves kings – of which there had been some 300 towards the end of the Parthian epoch – was considerably reduced. Ardashir I and Shapur I, the first Sasanian rulers, defeated the Romans and added considerable territories to the east (including modern Afghanistan) to their empire.

Religious tolerance was rejected by the Sasanians, who made Zoroastrianism Iran's official religion. Representatives of other religions were periodically subjected to persecution, particularly during the first two centuries of Sasanian rule. The Zoroastrianism priesthood became part of the bureaucratic structure, with priests or magi serving as judges and notaries.

Sasanian art too was subordinated to the new ideology, being called on to glorify royal power. One of the favourite subjects was the royal hunt and today there are numerous surviving silver dishes showing kings out hunting (cat. no 24). Sasanian rock reliefs show scenes of investiture – the divinity investing a new monarch with the mark of royalty – and triumph over Iran's enemies, as well as riders engaged in single-combat. Sasanian applied art exerted a great influence on the art of neighbouring countries: Sasanian metalwork, arms and textiles were highly prized in Byzantium, India, China and Central Asia, serving as models for local craftsmen.

Iran's cultural influence during the Sasanian period, its diplomatic and military successes, were all facilitated by a stable economy. Situated at the crossing of trading routes linking China, India and Europe, Iran made great profits from international trade. Sasanian silver coins (the main monetary unit being a drachma, weighing about 4 grammes) were accepted not only in Iran but in the neighbouring lands. They were notable for the high quality of the silver used, without any admixture of non-precious metals. Sasanian coins always bore a portrait of the ruler on the front, wearing his own individual and recognisable crown, and a legend around the edge in Middle Persian including his name and title. On the reverse was an altar with a burning flame, symbol of Zoroastrianism, the official state religion. From the 4th century onwards, the reverse also included a monogram of two or three letters representing the abbreviated titles of the mint where the coin had been made. To judge by these different monograms there must have been between 30 and 50 Iranian mints active at one time. Then, in the 5th century, dates appeared, indicating the years of the monarch's reign.

With time, relations became tense between the Sasanians and their new western neighbour, the Byzantine empire. Initially the Sasanians enjoyed considerable success in their battles against the Byzantine armies but during the seventh century they suffered several crushing defeats. Thus weakened, the Sasanian Empire was unable to withstand the Arabs who were now moving from strength to strength, inspired by their new religion, Islam. Islamic belief shares many common features with Zoroastrianism and the Iranians soon adopted the new faith, the few remaining Zoroastrians moving east. The last official Sasanian king, Yazdagird III, died in 651.

THE STUDY OF IRANIAN ANTIQUITIES IN RUSSIA

Few people were interested in the arts and culture of ancient Iran in 18th-century Russia. Their perceptions of ancient Iran were limited to the little information provided by Classical authors such as Herodotus and Xenophon. Iranian works of art – dishes and items of jewellery – found in the region around the River Kama, in Siberia and the Northern Black Sea area began to make their way into imperial and private collections from the start of the 18th century but they were to be subjected to systematic study only in the second half of the 19th. During the reign of Catherine II (1762-96) oriental languages were taught only in professional schools for the training of translators and there was almost no specialised literature on oriental studies. The teaching of oriental languages at universities, including Persian, began only in the 19th century – according to the first Regulations of Moscow University in 1804, the faculty of history and philology was to include the teaching of oriental languages. But it was Kazan University, under the trusteeship of M.N. Musin-Pushkin, that became the centre of university teaching of oriental studies. It as also during this period that the first scholarly descriptions of Iranian antiquities made their appearance in Russian periodicals, among them a notice by Friedrich von Adelung on Kushan gold coins bearing depictions of Iranian (Zoroastrian) divinities.

Between 1817 and 1820, on the initiative of Alexey Olenin, President of the Academy of Arts, the British painter Robert Ker Porter undertook an expedition to Persia sponsored by the Russian government, producing detailed descriptions of ruined towns in the Transcaucasus and north-western Persia, including precise sketches of the reliefs at Persepolis and of the Achaemenid and Sasanian rock reliefs in southern Iran, as well as some monuments from ancient Elam. One album with Ker Porter's drawings is today in the Hermitage. Ker Porter's description of his travels was published in English in his native land.

In 1840-41 Baron C.A. von Bode, secretary to the Russian mission to Teheran, visited some regions of Iran. He published his *Travels in Luristan and Arabistan* in English in two volumes, while a number of essays by him in Russian appeared in the notes of the Russian Geographical Society and in the journal *Biblioteka dlya chteniya* [Library for Reading]. Baron von Bode was interested above all in Achaemenid monuments and assembled his own small archaeological collection.

In numerous works, academician Bernhard Dorn touched on questions relating to Sasanian and Parthian numismatics and epigraphy. In 1860-61 Dorn undertook a trip to the regions of Persia around the Caspian

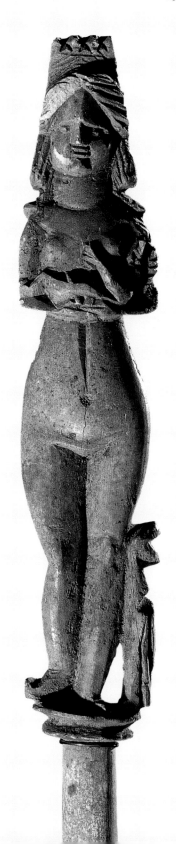

COSMETICS SPATULA WITH
HANDLE IN THE FORM OF
A FEMALE NUDE
Ivory
Parthia, *1st–2nd century*

CAT. NO 21

Sea. They also put together an album containing engraved images of Sasanian coins from the collection of General de Bartholemy (1872).

Sasanian coins attracted the attention of Russian scholars largely because of the large number found in hoards of arabic dirhems of the 7th to 10th centuries found on Russian territory, on sites along the legendary route 'from the Vikings to the Greeks' (the great trading route that ran from Scandinavia through to the south and east). In Antiquity, Sasanian coins circulated across the Transcaucasus, which became part of the Russian Empire in the 19th century. General de Bartholemy was one of the first Russia collectors to pay particular note to Sasanian coins, commencing his study of the Middle Persian alphabet whilst still a young officer: contemporaries recalled that he was not to be parted with his study notes even whilst on guard duty. Like many other celebrated collections, Bartholemy's several hundred coins eventually found their way to the Hermitage. Parthian and Sasanian coins were collected by A. K. Markov, author of one of the first essays on Parthian numismatics (1877, in French). A notable numismatics collection was put together by General A.V. Komarov, participant in campaigns in southern Turkmenistan. Komarov's well-documented body of material was gathered in the settlements of Old Merv, once the capital of northern Khurasan, with the aid of the rota of soldiers at his command. It was Komarov who had t he first investigative boreholes dug on Erk Kala, ancient citadel of Merv. A hundred years later, his finds provided the necessary basis for determining the origins of a whole group of Sasanian coins in the mint at Merv. Another celebrated collector of Sasanian

coins was the Russian manufacturer P.V. Zubov who in 1894 acquired the collection (some 3,000 items) of the collector Andreas Mordtmann, one of the pioneers in the study of Sasanian numismatics, from the latter's heirs. Zubov's own collection of Sasanian coins numbered more than 6,000 Sasanian by the end of his life in 1922. It was to enter the State Historical Museum in Moscow.

By the end of the 19th century interest in the history of Sasanian Iran had grown considerably thanks to translations into Russian of a whole series of Byzantine and Armenian sources (the works of Moses of Chorene, Elishe and Agathangelos) that contain information relating to Iran. These then formed the basis for several essays on the history and culture of Sasanian Iran by K.A. Inostrantsev. Growing interest in Iranian antiquities was also influenced by the addition to the Russian Empire of the Transcaucasus, once (some 1500 years before) part of the Iranian empire (under the Achaemenids, Arsacids and Sasanians). Iran had also once controlled the southern parts of Central Asia that were appendixed by Russia between the 1860s and 1880s.

Interest in the study of ancient Iranian languages in Russia was most closely tied to growing interest in comparative linguistic studies. In this Russian scholars were following, in part, the example of their German colleagues, who compared the language of the Avesta with Sanskrit and Slavonic, seeking to reconstruct the Aryan pre-language. It was in this context that several chapters of the Avesta were published in Russia at the end of the 19th century. K.G. Zaleman's first grammar of Middle Persian was a major achievement in the sphere of Iranian linguistic studies.

In 1904 an American expedition was led to southern Turkmenistan by Rafael Pampelli. The latter was to gain fame above all for his discovery of the ancient farming culture of Anau, but the expedition also made maps of the ancient settlements of Merv, where they sunk several large investigative shafts. In one of those shafts they found two of the first tablets with cursive Middle Persian texts. Those tablets are today in the Hermitage.

In 1909 Yakov Smirnov published his atlas *Oriental Silver*, including nearly all the items of ancient and early medieval Iranian metalwork then known in Russia He also put together a text describing and analysing the works reproduced in the album, but this was to remain unpublished.

OLEG NEVEROV

PERSIAN GEMS

The first Persian gems – so-called 'Graeco-Persian' scaraboids – arrived in the Hermitage collection during the reign of Catherine II. They were published in the first half of the 19th century in F. Layard's *Introduction à l'étude du culte de Mithra* (Paris, 1847, pls. 43.21, 44.9). A Sasanian portrait gem with the magi Khusraw entered Catherine's possession as part of the gem collection of the Duke of Orléans, which she purchased in 1787 (*Splendeurs des collections de Catherine II de Russie. Le Cabinet de pierres gravées du Duc d'Orléans*, exh. cat., Mairie du Ve arrondissement, Paris,

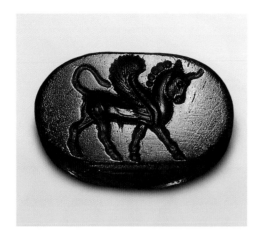

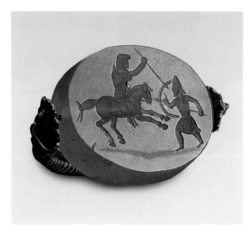

2000, No. 200/16). A second similar gem from the same collection is an engraved gem with a portrait of the satrap Papak (Borisov, Lukonin 1963, No. 6). A third, with a portrait of the grandee Makhan (6th century), entered the museum in 1804, having been a gift to Alexander I from General Nikolay Khitrovo (Borisov, Lukonin 1963, No. 46). From the 1830s, Persian (Achaemenid) and 'Graeco-Persian' gems began to enter the Hermitage from burials in the northern Black Sea area, the Crimea, the Kuban region and the northern Caucasus. At that same period, purchases were made of Iranian gems from private individuals. The Hermitage acquired the collections of Dzh. Lemme, A. Zvenigorodsky, L.A. Perovsky and T.V. Kibalchich, with some individual pieces from the collections of the counts Stroganov, the counts Shuvalov and from Alexander Polovtsov. The latest acquisitions were amongst the collections of Moscow mineralogist G. Lemmlein (1964) and an Achmaenid gem that was the seal of A.A. Peredolskaya, head of the Hermitage's Department of the Antique World (1985).

(above)
SCARABOID SEAL
WITH WINGED BULL
Cornelian
Late 5th–early 4th century BC

(below) CAT. NO 9
SCARABOID SEAL ON
A GOLD HOOP WITH
PERSIAN HORSEMAN
SPEARING A GREEK HOPLITE
Chalcedony, gold
First half 4th century BC

Elena Korolkova

Gold of the Nomads in Peter I's Siberian Collection

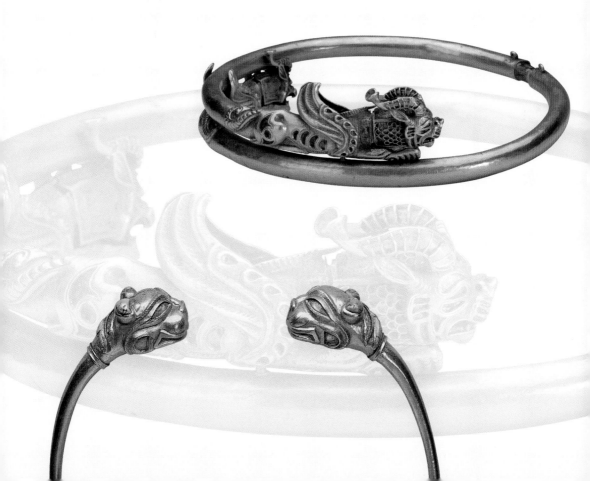

F

From the 1st millennium BC through the first half of the 1st millennium AD the territory of Siberia was home to nomadic tribes — some of whom would seem to have spoken the languages of Iran — who interred their dead in family burial sites. The nomads of the Scythian era (7th-3rd centuries BC) left behind in southern Siberia and the Altai region large barrows, tombs containing the actual burial pit or chamber and a structure of earth over the top which might reach a height of up to 20 metres and a diameter of 70 metres or more. In accordance with their beliefs, the Scythians and other Iranian-speaking peoples despatched their dead into the other world fully equipped with a whole range of necessary objects in keeping with the dead individual's social status during his or her lifetime. Nomads buried their 'kings' and noble warriors with particular pomp, placing

(previous page) CAT. NO 4
ACHAEMENID TORQUE
DECORATED WITH
A WINGED LION
Gold, turquoise and smalt inlay
5th–4th century BC

(previous page & right) CAT. NO 12
TORQUE DECORATED
WITH HEADS OF
PREDATORY ANIMALS
Gold, turquoise
Scythia, *4th–2nd century BC*

in the tomb not only precious items, including gold objects and ceremonial weapons, but also other people (wives or concubines, warriors and servants) and horses killed for ritual purposes. There might even be several hundred horses in a single burial, some of them buried fully caparisoned with rich bridle and saddle, ready to take the long journey into the next world. Every aspect was important in the burial ritual, numerous norms and rules had to be observed, including the orientation of the burial according to the points of the compass, the placement and pose of the dead body, the accompanying sacrifices and selection of items.

Excavations of these barrows have proved to be an extremely valuable source of information regarding both the material and spiritual worlds of the ancient peoples. Indeed, the Siberian barrows have presented us with numerous wonderful artistic objects from the Scythian age.

To all intents and purposes, Peter the Great's Siberian Collection represents the oldest archaeological collection in Russia. It consists of some 240 items, gold pieces made by the ancient nomads of Eurasia. Some of them are undoubtedly of Iranian origin and are closely linked with the culture of ancient Iran; Peter was thus the first Russian to collect Iranian antiquities.

Just how he came to put that collection together is a remarkable story, reflecting the spirit of an age in which, as the poet Alexander Pushkin wrote, Russia 'matured with Peter's genius'. During the first quarter of the 18th century Russia was transformed into an empire, its territories expanded considerably. The petrine era was a time of radical transformation and reforms touching on all aspects of life, from how the state was run

to everyday habits and practices. Change affected not only the economy and the way people lived but their very minds, broadening their horizons and inspiring curiosity and a desire to learn more about the world around them. Part of this whole trend was the study of geography and of the history of different peoples inhabiting various parts of the Russian state, including Siberia and Central Asia. Peter himself was driven by a desire for knowledge, which in turn broadened his outlook and led to his passion for collecting. It was Peter's collections that formed the basis of Russia's first public museum, the Kunstkammer, founded on his initiative in 1718. Not simply a curious collector, the great statesman and reformer also laid the basis for all further scholarly museum collecting in Russia. Despite his desire to promote public education, however, Peter would seem to have had a particular interest in and reverence for the archaeological gold in his possession, for these items were not immediately given to the Kunstkammer, remaining in his own palace even after his death and being transferred to the museum only in 1727 on the demise of his widow, Catherine I.

It was in the 19th century that these objects came to be known as the Siberian Collection of Peter I, although additions had continued to be made after Peter's death in 1725. In 1859 the Collection was moved, by order of Emperor Alexander II, to the Hermitage.

Chance finds of gold items from ancient tombs during Russia's mastery of Siberia in the 17th and 18th centuries gave rise to rumours of untold treasures, attracting numerous treasure-seekers and grave-robbers. Barrows containing the burials of noble tribesmen, containing a wealth of precious

gold objects, became a source of much profit. The governors of Tomsk and Krasnoyarsk equipped whole platoons of diggers, who often brought back quite stunning material. Their expeditions were essentially dual in nature: on the one hand they were part of an official state programme for the mastery of Siberia, entrusted with drawing up maps and seeking out potential sources of gold (which naturally involved inspecting the ancient barrows); on the other, participants in these often dangerous raids were presented with the opportunity to make money on the side through the undisciplined excavation of rich burials. Brigades of diggers, sometimes consisting of two or three hundred people, found seasonal employment digging up the tombs each year between spring and autumn. The items they discovered found a ready market and were on sale in all the major Siberian towns. So great would the extent of these activities seem to have been that knowledge of the rich finds reached Moscow in the 17th century. One of the earliest documentary sources relating to finds of 'tomb gold' in Siberia is a copy, dated 1708 and discovered in the chancellory of the Province of Siberia, of a report written to Tsar Alexey Mikhaylovich (1629-76) in 1670 relating how the year before, near the River Iseti in Tobolsk Region, 'Russian men dug out from Tatar burials or graveyards gold and silver items and vessels'. This information inspired the government with interest in the potential sources of those precious metals used by Siberia's ancient inhabitants. Early documents relating to precious finds make it clear that objects were being discovered over a wide territory encompassing Siberia, the Urals and part of Central Asia.

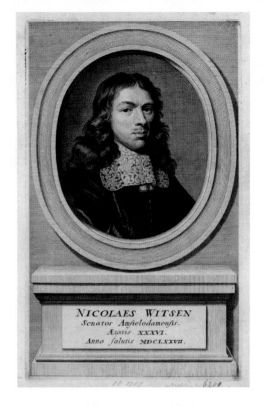

Portrait of
Nicolaas Witsen, Senator
Amstelodemensis (1641-1717)
at the age of 36.
Engraving
Collection City Archives,
Amsterdam

Peter published a series of decrees intended to regulate the harvesting of archaeological treasures. In carrying out Peter's orders, Matvey Gagarin, governor of Siberia, sent men out to seek gold, silver and copper and 'other items in the depths of the mounds for the sovereign's treasury...' On 13 February 1718 he ordered the gathering of everything 'that is very old and unusual'. Although we do not have Peter's own decrees relating to the antiquities found in burials, their existence and content is recorded in the period 1717-18 in a number of other sources, including letters from statesmen and officials.

NICOLAAS WITSEN:
A DUTCHMAN IN RUSSIA

By the start of the 18th century Siberian treasures were attracting attention not only for their material value, as pure gold and silver, but also for their historical value. The first person to display scholarly interest in Siberian antiquities, to appreciate their artistic and historical value and to set out to deliberately collect them, was the Dutch scientist Nicolaas Corneliszoon Witsen (1641-1717). He undertook research in the northern and eastern regions of Russia, notably in western Siberia. His particular spheres of interest were probably determined by long-standing trading relations between the Witsen trading company and the state of Muscovy. Indeed, soon after completing his university studies Witsen had expressed the desire to take part in a Netherlandish embassy being sent to Moscow in 1664 and

he was thus included in the suite of the envoy, Jacob Boreel. He was to spend a whole year in Russia, keeping a diary and making sketches of architectural monuments in the towns he visited, gathering geographical, linguistic and ethnographical information about the peoples of Russia. Witsen made many contacts in Russia and when he left he continued to maintain an extensive correspondence with them. Later Witsen was to be burgomeester or mayor of Amsterdam. Over the next 28 years the scholar put together the material for his fundamental book *Northern and Eastern Tatary,* which was published three times in the Netherlands, in 1692, 1705 and 1785. With the aid of agents in Russia, Witsen purchased many valuable finds from ancient burials, his acquisitions determined not by material value but by scholarly significance. Hence he acquired not only gold and silver items, but also bronze and iron objects of a kind usually simply tossed aside by graverobbers. Nicolaas Witsen noted the contrast between the life of the local Siberian population, uneducated and severely impoverished, and the abundance of precious archaeological objects that demonstrated the high level of artistic culture in these lands in ancient times. In a letter of 18 September 1714 he wrote to Cuper, mayor of Deventer: 'Look at those civilised people who buried such rarities! ... The working of these gold objects is so fine and skilled that I doubt that they could have been made better in Europe.'[1] But his letters that year are also filled with concern at the ever-growing scale of the raids being made on ancient burials and at the rapacious trade in archaeological finds. A letter dated 1 June 1714 makes clear that gold objects despatched to Witsen from Tobolsk, including jewellery and other items, had not

1 CITED IN V. RADLOV, SIBIRSKIE DREVNOSTI [SIBERIAN ANTIQUITIES], VOL. I, ISSUE 3 (MAP NO. 15), ST PETERSBURG, 1894, PP. 131, 132.

arrived, having been sold on to someone else.[2] Witsen's correspondence helps determine the main period during which the scholar was assembling his collection of siberian archaeological items, encompassing the years from 1703 to 1716. But there is good reason to think that Witsen began his collection even earlier, back in the 17th century. Certainly his book includes an image of a silver cup that he was given by the boyar F. A. Golovin during a visit to Holland by a Russian embassy in 1697-98.[3] Golovin, once governor of Siberia, had in 1688 undertaken a journey around the province and to the east, travelling down the River Irtysh and reaching the point where it falls into the River Ob. At that point the river had worn away the bank to reveal an ancient burial, tossing a coffin, together with the skeleton it contained, into the waters. Found inside the destroyed burial were silver bracelets and the cup that thus came into Golovin's possession. Once in Witsen's collection, Golovin's cup was depicted in one of the tables – commissioned by Witsen and engraved by an early 18th-century draughtsman under his control – depicting the rarities he had assembled.[4] Between 1714 and 1717 Witsen received from Russia some 40 gold artistic items found in the barrows of Siberia, amongst them torques and belt buckles with zoomorphic images. The illustrated tables of items

published in the 1785 edition of Witsen's *Northern and Eastern Tatary* included jewellery that quite amazingly recalls items in Peter I's Siberian collection.

After Witsen's death in 1717 Peter I sought to acquire the collection from his widow, but without success: the objects were sold at auction in Amsterdam in 1728 and their further fate is unknown. Nonetheless, thanks to the publication of the illustrated tables, Witsen's collection retains its scholarly significance. Of particular interest are the very close analogies between some of his pieces and those in the Siberian Collection of Peter I. In the 19th century these led scholars to make a close study of Witsen's tables and items transferred to the Hermitage from the Kunstkammer to establish whether perhaps some of the same objects featured. Not a single instance where the pieces were identical was established. Rather it would seem that some of the items were pairs, such as placques from a belt buckle or temple pendants. A belt plaque with a wolf fighting a snake that appears in one of Witsen's tables was undoubtedly the pair to a plaque with a similar scene belonging to Peter I. They must have been discovered in a single barrow and split up in the early 18th century. We know when Witsen acquired his object from a description he provided in a letter to Cuper dated 18 September 1714[5], and we should

2 RADLOV OP. CIT., P. 130.

3 I. TOLSTOY, N. KONDAKOV, *RUSSKIE DREVNOSTI V PAMYATNIKAKH ISKUSSTVA. DREVNOSTI VREMYON PERESELENIYA NARODOV* [RUSSIAN ANTIQUITIES IN ARTISTIC MONUMENTS. ANTIQUITIES FROM THE TIME OF THE RESETTLEMENT OF PEOPLES], ISSUE 3, ST PETERSBURG, 1890, P. 34.

4 M.P. ZAVITUKHINA, 'N.-K. VITSEN I EGO SOBRANIE SIBIRSKIKH DREVNOSTEY' [N.-K. WITSEN AND HIS COLLECTION OF SIBERIAN ANTIQUITIES], *ARKHEOLOGICHESKIY SBORNIK GOSUDARSTVENNOGO ERMITAZHA* [ARCHAEOLOGICAL ANTHOLOGY OF THE STATE HERMITAGE MUSEUM], ISSUE 34, ST PETERSBURG, 1999, PP. 102-8.

5 RADLOV OP. CIT., P. 130.

6 I.I. GOLIKOV, *DEYANIYA PETRA VELIKOGO, MUDROGO PREOBRAZITELYA ROSSII, SOBRANNYE IZ DOSTOVERNYKH ISTOCHNIKOV I RASPOLOZHENNYE PO GODAM* [THE ACTS OF PETER THE GREAT, WISE TRANSFORMER OF RUSSIA, GATHERED FROM RELIABLE SOURCES AND ARRANGED BY DATE], PART 9, MOSCOW, 1789, P. 443.

probably assume that it was around the same time that its pair came into the hands of Peter (whose developed an interest in Siberian antiquities later than the Dutch scholar) or of some unknown individual who then sent it on to the sovereign. The Russian tsar was acquainted with Witsen, for whom he had a great respect, and by whom he was undoubtedly influenced.

MATVEY GAGARIN: GOVERNOR OF SIBERIA

Peter I's Siberian Collection encompasses a great variety of material. It includes objects from varied sources created over a vast period of time, between the 7th and 2nd centuries BC.

We should deal with one persistent theory, which states that the core of the collection was formed by a gift from one Demidov to Catherine I in 1715 on the occasion of the birth of the heir to the throne, Peter Petrovich. Indeed the whole collection has sometimes been called 'the Demidov collection'. There is, however, no documentary evidence that such a gift was ever made and the legend seems to have come from I.I. Golikov's multi-volume work on the life of Peter I, in which he stated 'During one of Demidov's visits to St Petersburg the monarch's son, the Tsarevich Peter Petrovich, was born. And when the nobles gave excellent gifts to congratulate the monarch, according to ancient custom, he, making use of the occasion, presented her Majesty with the rich gold Siberian objects from the barrows and one hundred thousand roubles, a magnificent sum by the standards of the time.'[6] Golikov does not give the initials of this 'Demidov' and some scholars have there-

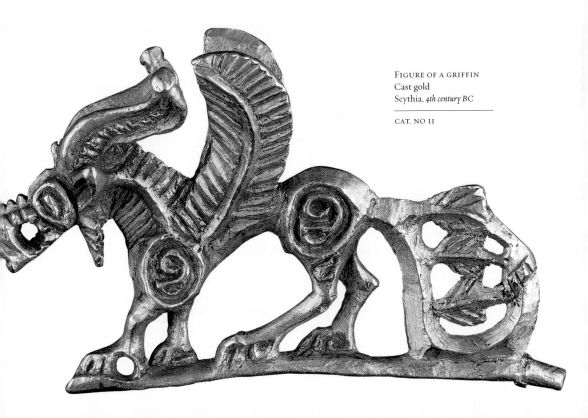

FIGURE OF A GRIFFIN
Cast gold
Scythia, *4th century BC*

CAT. NO II

fore identified him with Nikita Demidov (owner of vast lands and metallurgical factories in the Urals), while others have suggested it was Nikita's son Akinfy. From the context it seems likely that the author had Nikita in mind, but Golikov does not mention the quantity of items presented, nor does he describe them, and thus there can be no basis for any attempt to identify such objects.

In fact, the Siberian Collection was put together over a considerable period. Peter's main supplier of gold archaeological items from Siberian barrows was the governor of the province, Prince Matvey Petrovich Gagarin. Most of the objects were gathered in Tobolsk, capital of Siberia, in accordance with Peter's orders, and sent on to St Petersburg by the governor in several groups.

Gagarin was a wealthy grandee and a notable figure in Peter's close circle, a man whose services to Russia and to the sovereign are undisputed. Hence his appointement in 1711 to the important post of governor of Siberia, which he held until 1719. Hence too, his terrible punishment when he betrayed the monarch's trust. Such was Peter's ire that there could be no mercy. In July 1721 Gagarin was hung 'for misuse of power and consistently hiding accomplices'. One of the tasks entrusted to this de facto ruler of Siberia had been to gather information about all possible

sources of gold, but he was caught taking bribes and embezzling public funds. Investigation confirmed his guilt, revealing that he had used state funds to cover his own private expenses, taken bribes for revenues on the sale of wine and beer, extorted money from merchants travelling with goods in caravans from China to Moscow and, apparently feeling safe from all punishment, even stolen three diamond rings intended for Catherine I. The former Siberian governor was hung in front of the College of Justice in St Petersburg in the presence of the Tsar, high-ranking courtiers and his unhappy relatives. Kammer-Junker F.V. Bergholz described seeing the Prince's corpse hanging from another gallows, for as a warning to others the executed man's body was re-hung several days later and put on public display. In his diary Bergholz noted that 'to inspire even greater fear the body of this Prince Gagarin shall be hung for a third time on the other side of the river and will then be sent to Siberia, where it shall rot on the gallows.'[7] All of the executed man's property and that of his family was confiscated; even his widow's dowry and that of his daughter-in-law were taken for the treasury.

GAGARIN'S DESPATCHES

It is Gagarin's despatches that should be seen as the most certain and reliable con-

7 F.V. BERKHGOLTS, *DNEVNIK KAMER-YUNKERA* [DIARY OF A KAMMERJUNKER], PART I, MOSCOW, 1903, P. 72.

8 M.P. ZAVITUKHINA, 'SOBRANIE M.P. GAGARINA 1716 GODA V SIBIRSKOY KOLLEKTSII PETRA I' [THE COLLECTION OF M.P. GAGARIN IN PETER I'S SIBERIAN COLLECTION], *ARKHEOLOGICHESKIY SBORNIK GOSUDARSTVENNOGO ERMITAZHA* [ARCHAEOLOGICAL ANTHOLOGY OF THE STATE HERMITAGE MUSEUM], ISSUE 18, LENINGRAD, 1977, P. 41.

9 *IBID.*, P. 43.

10 M.P. ZAVITUKHINA, 'K VOPROSU O VREMENI I MESTE FORMIROVANIYA SIBIRSKOY KOLLEKTSII PETRA I' [ON THE TIME AND PLACE OF THE FORMATION OF PETER I'S SIBERIAN COLLECTION], *KULTURA I ISKUSSTVO PETROVSKOGO VREMENI. PUBLIKATSII I ISSLEDOVANIYA* [CULTURE AND ART OF THE PETRINE AGE. PUBLICATIONS AND RESEARCH], LENINGRAD, 1977, P. 66.

11 M.P. ZAVITUKHINA, 'THE COLLECTION OF M.P. GAGARIN...' *OP. CIT.*, P. 51.

12 M.P. ZAVITUKHINA, 'OB ODNOM ARKHIVNOM DOKUMENTE PO ISTORII SIBIRSKOY KOLLEKTSII PETRA I' [ON AN ARCHIVE DOCUMENT RELATING TO THE HISTORY OF PETER I'S SIBERIAN COLLECTION], *SOOBSHCHENIYA GOSUDARSTVENNOGO ERMITAZHA* [REPORTS OF THE STATE HERMITAGE MUSEUM], ISSUE 39, LENINGRAD, 1974, PP. 34-35.

tribution to Peter's Siberian Collection. Some of the items can be identified in inventories of finds Gagarin sent to St Petersburg. The very first despatch contained just ten items and according to archive reports, they were looked over by the Tsar and handed to P.I. Moshkov for safe-keeping. The next despatch was the largest of all to come from Gagarin, consisting of 122 items. Scholars have repeatedly noted that no more significant range of items came from Siberia either before or after this. Sent from Tobolsk on 12 December 1716, the items were delivered to St Petersburg in Peter's absence – he was abroad at the time – and they were thus received by Moshkov.

In his accompanying letter Gagarin wrote to the Tsar:

'Most gracious Sovereign,
Your Majesty ordered me to seek out old objects which are sought in the earth of ancient mounds. And on this subject Your Majesty I write this letter. And regarding their number, sovereign, and the nature of the objects and their weights, great sovereign, information is attached to this letter.
Most humble slave to Your Majesty Matvey Gagarin. From Tobolsk 1716 the 12th day of December.'[8]

Attached to this letter was an inventory with the weights of the objects, allowing us to identify them with those in the Hermitage today. Last in this inventory, which consisted of 'all fifty six items' (although there were 122 individual numbers), were 'small golden items twenty pieces sent to the great sovereign Tsarevich Peter Petrovich, which were found with the above-listed items'.[9] The 20 objects have not been uncovered amongst

the Hermitage collection today but it has been suggested that it is these pieces, addressed to the young heir to the throne, that laid the basis for the story – unsupported by documentary evidence, as we recall – of the 'Demidov gift'. Such suggestions lead us to further doubt that there was any gift at all from Demidov.[10]

We cannot, however, exclude the possibility that objects arrived before Gagarin started sending them, for there are objects in Peter's collection that form pairs to objects in Witsen's possession known to have been dug up no later than 1714, i.e. before the first despatch of goods by the governor of Siberia.

In a letter of 28 October 1717 Gagarin described his third despatch of Siberian finds (roughly 60 gold and two silver items).[11] It is interesting to compare this document with another, amongst the papers of the Tyumen Governorial Chancellory in the regional archive in Tobolsk,[12] which provides evidence of a search by Gagarin for specific gold and silver 'burial items' found and sold by 'Tatars'. This would seem to be in execution of a decree by which Peter banned the sale and purchase of archaeological finds by private individuals and ordered the obligatory acquisition (with financial recompense) of ancient worked precious metals by the state treasury. This letter sets out the weight of items found, 15 pounds, which accords with the weight of the items (including the silver) sent in Gagarin's third despatch that same month. Very possibly, the items described in both documents are the same.

Peter I understood the unique value of the Siberian finds and manifested great interest in them as historic monuments. For him, the brilliance of the gold as a measure of material wealth did not overshadow their

scholarly significance as works of art by ancient masters. Thus it was that the finds from Siberian tombs did not disappear in melting pots to be turned into gold coins but have survived as part of a unique collection. The collecting of antiquities in the petrine era played an educational role and was very much part of the trend for and contributed to the development of learning. For Peter the Great, Siberia's archaeological antiquities were of added interest in their potential contribution to his projected full history of Russia and the peoples who had inhabited its lands from ancient times. Like other 'worn or old objects, coins of all rulers and kings'[13], the archaeological finds of Siberia could 'adorn ancient history'. But the sovereign's sudden death was to put an end to such plans.

Even today we do not know exactly where the objects that make up the Siberian Collection were found or illegally excavated. We do know, however, the origins of other objects that provide close analogies: in Central Asia, Tuva, the Trans-Baikal region and the Khakassko-Minusinsk Basin. Yet the majority of those finds are unique, having turned up in ones and twos, while whole groups are concentrated in the Siberian Collection. We should probably therefore accept the theory, already common in the 18th century, that the robbing of ancient graves had been so widespread that as early as the 1730s and 1740s, in the words of F. Miller, head of a large academic expedition to Siberia in 1733-43, 'all the tombs in which there was once hope of finding any treasure had already been opened'.

13 *200-letie Kabineta ego imperatorskogo velichestva* [The 200th Anniversary of the Cabinet of His Imperial Majesty], St Petersburg, 1911, p. 167.

Anatoly Ivanov

On the Formation of the Hermitage's Collection of Medieval Art from Iran

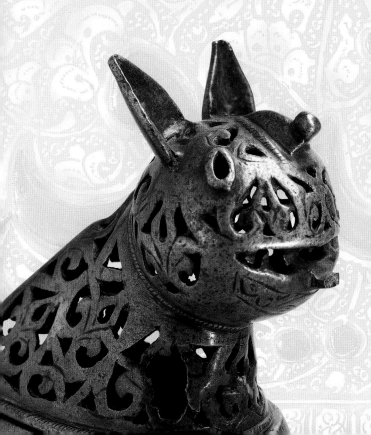

I It is the acquisition in 1764 of a collection of paintings put together by Johann Ernest Gotzkowski for the private imperial collection that is said to mark the foundation of the Hermitage Museum. A picture gallery of European paintings was to form the core of the palace collections. At this time there was no interest in collecting Iranian art, works created after the spread of Islam to the Iranian lands, in the Hermitage or in Russia, nor indeed anywhere in Europe.

The first examples of arts from Islamic lands to appear in the Hermitage were coins, although it is hard to say even today how many of those early coins were Iranian. They were kept in the Department of Numismatics, established in 1786 for the accumulation of coins and paper monies from all lands and ages. Even Catherine's celebrated collection of engraved gems – her driving passion – does not seem to have included any Iranian seals.

Even so, a small number of items were to be found in the Kunstkammer, the historic collection of curiosities set up by Peter the Great in St Petersburg. These were moved in the 19th century to the Arsenal at the imperial country palace at Tsarskoe Selo, from where they eventually came to the Hermitage.

During the first half of the 19th century considerable interest in the history of countries of the Near East emerged in Europe, but this interest was confined largely to the very earliest period, with almost no one looking more closely at art of the Islamic period.

Court art from the reign of Fath Ali Shah Qajar (1796-1834) appeared in St Petersburg during the first third of the 19th century, but these works did not enter the Hermitage, being hung in various country residences –

(previous page) CAT. NO 38
LAMP OR
INCENSE BURNER
Bronze (brass)
11th century

(right page) CAT. NO 39
EWER IN THE FORM
OF A COCKEREL
Bronze (brass)
11th century

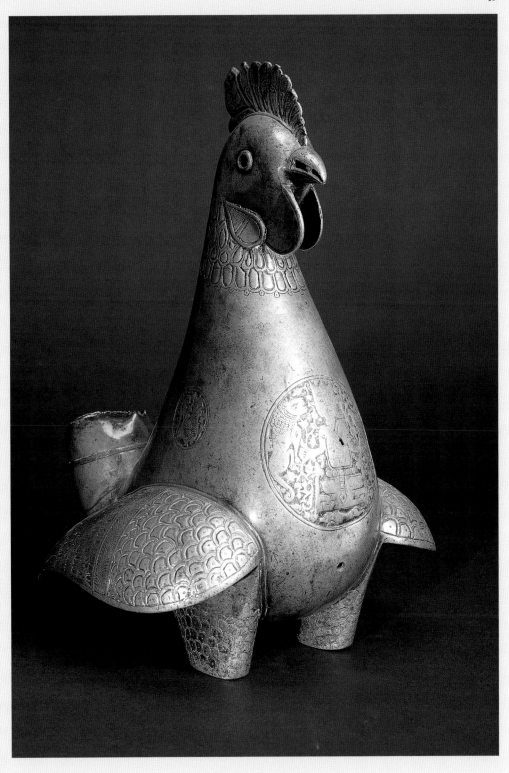

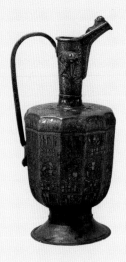
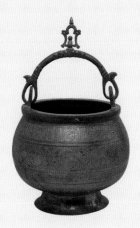
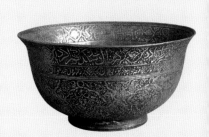

(from left to right)
CAT. NO 42 - EWER
Bronze (brass), silver
Second half 12th century

CAT. NO 43 - CAULDRON
Bronze (brass), copper
Second half 12th century

CAT. NO 147 - BOWL
Copper
811 AH / 1408-9

the paintings at Gatchina Palace, all kinds of jewellery at the Catherine Palace in Tsarskoe Selo. It was only a century later, in the 1930s, that they became part of the official Museum collection.

Very often we do not know how some of these objects came to be in the imperial country palaces. There were few diplomatic missions from Iran. Some items, such as weapons and banners, may have come to Russia as trophies of the Russo-Persian wars of the first third of the 19th century, but there is nothing to indicate the source of gold enamelled items and ceremonial weapons

adorned with precious stones that arrived during this same period.

In the 1830s Nicholas I started to assemble arms and armour at Tsarskoe Selo, in what was to become the Arsenal. This came to include Iranian sabres and daggers of the 16th to 19th centuries, including those moved from the Kunstkammer. In 1886 this collection too was transferred to the Hermitage, those items being divided between the Oriental Department and the permanent exhibition known as the Special (Oriental) Collection.

No large groups of Iranian objects arrived in the 19th century, although the collection of coins and (probably) seals continued to grow. Sadly, the documentation is not sufficiently precise for us establish the arrival date of many items.

Odd items were transferred to the museum by the Imperial Archaeological Commission, founded by Alexander II in 1859. Then in 1885 the Hermitage acquired the collection of Alexandre Basilewski in Paris. This included, amongst numerous

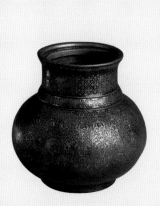
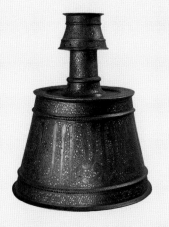
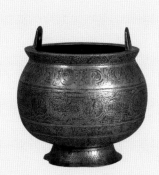

European and Byzantine pieces, a famous lustre-painted earthenware vase with a depiction of polo players made in the 13th century, probably in Kashan.

In 1915 acquisition began of frieze tiles from the mausoleum of Pir Hussein Ravanan in the northern part of Azerbaijan, made in 684 AH / 1285, probably in Kashan. They had been stolen in 1913 by inhabitants of the Daghestani village of Kubachi, who specialised in the antique trade. The last tiles from the frieze to enter the Hermitage were acquired in 1966, bringing the total to 24 (of 30 tiles overall).

THE ORIGINS OF THE HERMITAGE'S ORIENTAL DEPARTMENT:
LATE 19TH – EARLY 20TH CENTURY

Thus it was that by the time of the October Revolution of 1917, the Imperial Hermitage Museum, as it was until then, contained a number of Iranian objects of the Islamic period, but apart from those silver items included in Yakov Smirnov's atlas, *Oriental Silver,* published in 1909, they had been little studied.

(from left to right)
CAT. NO 148 - SMALL VASE
Bronze (brass), silver, *late 15th century*

CAT. NO 46 - CANDLESTAND
Bronze (brass), silver
Master Ruh ad-din Tahir, Muharram 725 AH / 18 December 1324 – 16 January 1325.

CAT. NO 41 - CAULDRON
Bronze (brass), copper
Second half 12th century

Radical changes were to take place in the study of Iranian art over the succeeding years. On 1st November 1920 the Sector of the Muslim East in the Medieval Age was established in the newly renamed State Hermitage Museum. This was to form the basis of today's Oriental Department. The following year its scope was increased and it became known as the Sector of the Caucasus, Iran and Central Asia. Its head was Iosif Orbeli, later Director of the Hermitage and Academician of the USSR Academy of Sciences. The task of the Sector, and later of the Department, was to determine the con-

Tiles from a frieze on
the Mausoleum of Pir Hussein
Faience, lustre and cobalt painting
684 AH / 1285-86

CAT. NOS 52-73

tribution made by peoples of the East to world art and culture.

Work commenced on assembling medieval monuments from oriental lands scattered around the Museum's different departments and special exhibitions were arranged. In 1922 there was an exhibition of Sasanian silver, in 1923 an exhibition of the Islamic tiles (both exhibitions had catalogues by Orbeli), and in 1925 a permanent display was at last established, *The Muslim East*.

During these first years, items flowed into the Hermitage from other museums in the city and from other establishments, as part of a general programme to expand and alter the function and structure of museums and in connection with the confiscation of private collections. One of the first such acquisitions was a body of Iranian ceramics that arrived in 1923 from the Society for the Encouragement of the Arts. During later years the new department gained a wealth of material: in 1925 gained the superb collection of Alexander Bobrinsky and that of Nikolay Veselovsky from the Russian (later State) Academy for the History of Material Culture, heir to the Imperial Archaeological Commission.

Count Bobrinsky was for many years head of the Imperial Archaeological Commission, himself leading excavations and putting together a notable collection. Some 200 hundred items from his collection were transferred to the Hermitage, among them a famous bronze bucket with silver and copper incrustation made in Herat in 559 AH / 1163.

Amongst the works of Iranian object from the collection of Professor Veselovsky, Arabic scholar and successful archaeologist, we should note the bronze ink-well from the second half of the 12th century incrusted

with silver and copper and a chrysolite seal bearing the name of Miran Shah, son of Tamerlane, and the date 802 AH / 1399-1400 (the earliest known Iranian seal bearing the precise date it was made).

Another major source of acquisitions was the State Museums Fund, to which most of the confiscated collections were transferred. We should also note that some Russian aristocratic collections, such as those of the Shuvalov, Sheremetev, Yusupov and Stroganov families, came to the Hermitage directly, although they included only a small number of Iranian items of the Islamic period.

MUSEUM OF THE BARON STIEGLITZ CENTRAL SCHOOL OF TECHNICAL DRAWING

The largest number of varied Iranian objects entered the Oriental Department from the Museum of the Former Baron Stieglitz Central School of Technical Drawing. Founded with money provided by the banker, Baron Alexander Stieglitz, the school had opened in 1881 with the established aim of educating specialists in all spheres of the applied arts. A museum forming part of the school almost immediately and its collections grew to such an extent that a separate building was later erected for it, opening on 30 April 1896. Works of art were acquired regularly for the museum, both in the Russian Empire and abroad. By the time the First World War broke out in 1914, the Stieglitz Museum contained some 21,000 objects, although it is unclear just how many of these were Iranian works.

From 1923 to 1927 the Stieglitz Museum was an official branch of the State Hermitage Museum. Transfer of object to the Hermi-

tage began in 1924-25, among them several thousand objects of Iranian origin, including the lustre tiles and fragments of tiles from the Mausoleum of Imam Yahya at Veramin, made in 660-61 AH / 1262-63 (more than a thousand inventory numbers). The Stieglitz Museum was also the source of the Oriental Department's oldest carpets, dating from the 16th and 17th centuries, as well as fragments of textiles from the same period, many examples of copper and bronze works from the 14th to 19th centuries and lacquer ware.

KUBACHI, DAGHESTAN, AND POST-WAR ACQUISITIONS

The village of Kubachi in Daghestan, was renowned for its involvement in the trade in antiquities. A large number of Iranian items was acquired by the Hermitage from two inhabitants of Kubachi, Said and Rasul Magomedov. The first purchases were made during the early years of the First World War but the acquisition of Iranian items there reached its height in the middle of the 1920s. The Magomedov brothers could well describe themselves as 'suppliers to the Oriental Department' for they sold the Hermitage some 2,000 items in the period before the Second World War, mainly Iranian ceramics of the 15th to 19th centuries and examples of Iranian textiles from the 16th to 19th centuries. Thanks to those purchases the Museum today has a world-famous collection of late Iranian ceramics, the only comparable collection being in the Victoria & Albert Museum in London.

A few other objects were also acquired by the Hermitage's own Purchasing Commission and thus the collection of Iranian works grew very quickly before the start of the

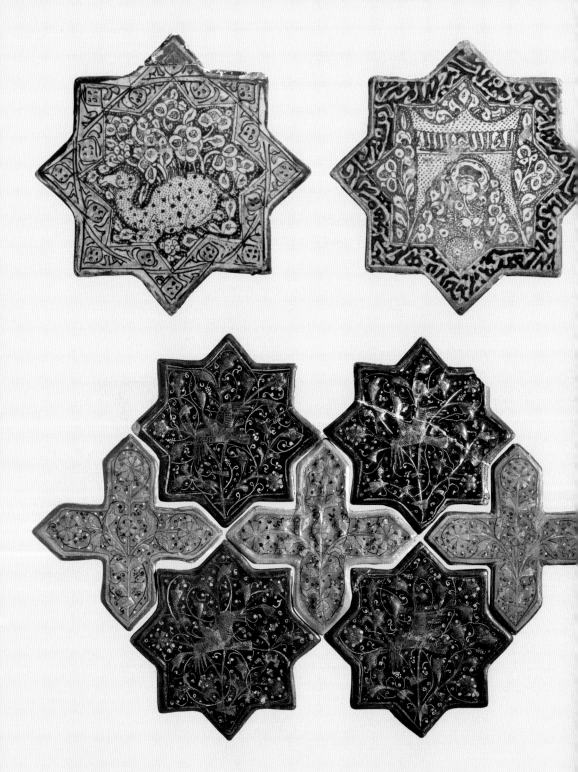

(above) CAT. NO 87
CUP
Faience, enamel
Mid-13th century

(below) CAT. NO 81
TABLE
Faience, lustre painting
Early 13th century

(left page)
CAT. NO 91
TILE DECORATED
WITH A CAMEL
Faience, lustre and
cobalt painting
Late 13th century

CAT. NO 92
TILE WITH
INSCRIPTION
Faience, lustre and
cobalt painting
Late 13th century

CAT. NOS 74-80
SEVEN TILES
Faience, gold
Late 13th–early 14th century

FRAGMENT OF
A PRAYER RUG
Cotton
Mid 14th century

CAT. NO 93

Second World War. There were, however, to be no large additions after the end of the war.

Most post-war acquisitions came via the Purchasing Commission and through transfers from other departments in the Hermitage and other museums in the city. Purchases continued to be made from the inhabitants of Kubachi, but on a more reduced scale. In 1973 an earthenware dish made in Mashhad in 878 AH / 1472-73 – an object of particular significance since we only rarely find late works indicating an origin in Mashhad – was purchased from Rasul Omarov of Kubachi.

In 1964 the bequest of Professor G. Lemmlein brought a collection of Islamic seals and amulets (176 items, of which 46 are indisputably Iranian seals of the 14th to 20th centuries, and many more are probably Iranian, such as the seals with inscriptions in Kufic script).

In 1980 the Department acquired 40 copper and bronze (brass) objects from the Leningrad collector S.N. Khanukaev, among them 24 Iranian works of the 11th to 19th centuries.

In 1985 purchase was made of a fragment of flat carpet in the *zílu* technique, dated to the middle of the 14th century, one of the earliest surviving examples of Iranian carpet weaving. Today the Hermitage has some 150 Iranian carpets but with the exception of two dozen pieces, mainly fragments, there are few early examples from the 16th and 17th centuries. Most of the Hermitage's Iranian carpets date from the 19th and early 20th centuries.

Today the Hermitage has some 7,000 Iranian works dating from the 10th to 20th centuries.

ADEL ADAMOVA

PERSIAN PAINTINGS
IN THE
HERMITAGE

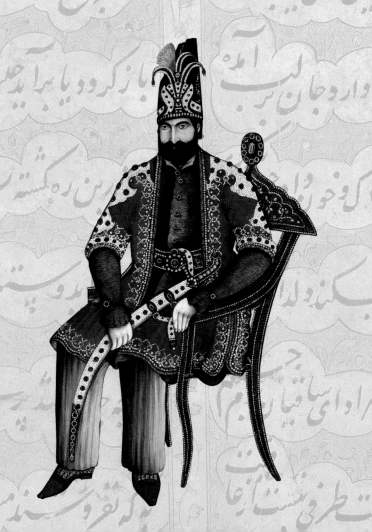

B By the 19th century the main oriental manuscript depositories in St Petersburg had been established: the Imperial Public Library (today the Russian National Library) and the Asiatic Museum (today the Institute of Oriental Studies). It was in these two places that handwritten books were concentrated. The oriental manuscripts that found their way to the Winter Palace as gifts to members of the imperial family (such as those presented by Prince Khusraw Mirza after the murder of Russian diplomat – and celebrated playwright – Alexander Griboedov in Teheran in 1829, or the collection of manuscripts presented by the Emir of Bukhara to Nicholas II in 1913, to mark the 300th anniversary of the house of Romanov on the Russian throne), were given to the Public Library. Today the small collection in the Hermitage consists of 31 Persian manuscripts, of which thirteen are illustrated, all of which arrived in the Museum (like the whole of the collection of Persian painting) after 1924. The most famous of all the Persian manuscripts in the Hermitage collection is the illustrated *Khamseh* of Nizami produced in 1431 (cat. nos 94-101), transferred from the Museum of the Former Baron Stieglitz Central School of Technical Drawing, while others were purchased from private individuals over the years.

If we look separately at Persian miniatures and drawings on separate sheets, i.e. those that do not form part of whole manuscripts, then there are 144 items the Hermitage, dating from between the 15th and early 20th centuries. This collection too was commenced in the mid-1920s, again with the transfer of objects from the Stieglitz Museum. These works, however, had started

(previous page) CAT. NO 182
PORTRAIT OF
MUHAMMAD SHAH
Gouache and gold
on paper
1840s

(right page) CAT. NO 102
FRAGMENTS OF TWO
QU'RAN MANUSCRIPTS,
ORNAMENTS ON FF. IV, 15V
Ink, gold, paper
Later card binding
Naskh script, 41ff
15th century

to arrive in Russia from Iran in the second half of the 18th century, their number increasing greatly during the first third of the 19th century as a result of Russia's military and political activities on the Persian border.

THE ART OF THE MINIATURE

Miniature painting is the most celebrated of all the different kinds of painting that developed in Iran during the medieval period, although its aesthetic value was truly recognised in Europe only at the start of the 20th century, prompted by exhibitions held in Munich in 1910 and in Paris in 1912, which presented Persian illustrated manuscripts and single-leaf miniatures from European collections. Europeans were amazed by the bright, sparkling colours, the fine drawing and perfection of detail, but most importantly they were presented with a visible manifestation of the unique world of the literary creations of Firdawsi, Nizami, Saadi, Hafiz, Jami and others whose works were by this time known in Europe. It was those texts that formed the basis for the majority of Persian miniatures. Europeans saw a totally new world, images based on centuries of traditions in the depiction of reality with their own understanding of beauty and harmony, their own rules, devices and forms for the

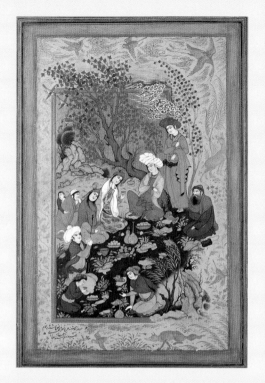 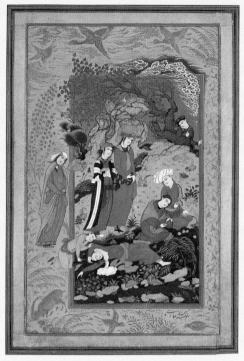

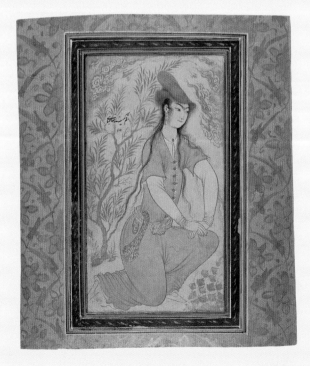

(above) CAT. NO 118
FEAST IN THE COUNTRY
(DOUBLE PAGE)
Gouache and gold on paper
Riza-i Abbasi, *1020 AH / 1612*

(below) CAT. NO 117
GIRL IN A FUR HAT
Ink, watercolour and gold
on paper
Riza-i Abbasi, *1011 AH / 1602-3*

(right page) CAT. NO 95 (94-101)
PAGE FROM THE *KHAMSEH* BY
NIZAMI: LAYLA IN THE PALM
GROVE (FF. 181R)
Gouache, ink and gold on paper.
Text copied by the calligrapher
Mahmud in Herat, for Sultan
Shahrukh, *completed 10 Rabi II 835 AH /
16 December 1431*
Nasta'liq script, 38 miniatures

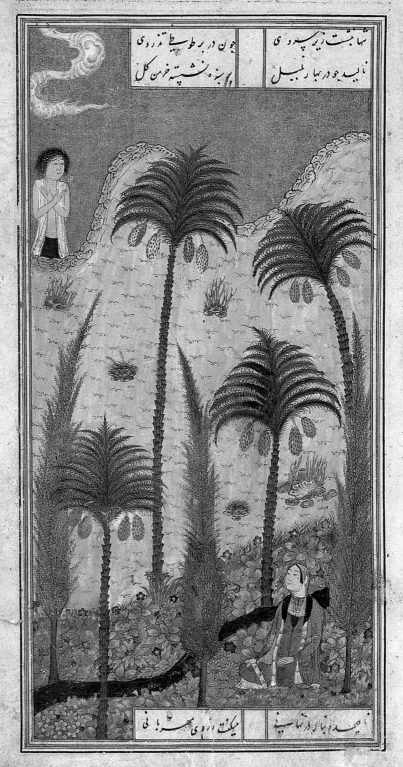

شها نشت زیر سپردی جون در بر طوسیا تنزدی
نالید چو در بهار نبل پای ننه نشسته خرمن گل

میلکت ازروی مهربانی زیسد ویای در تاسبینه

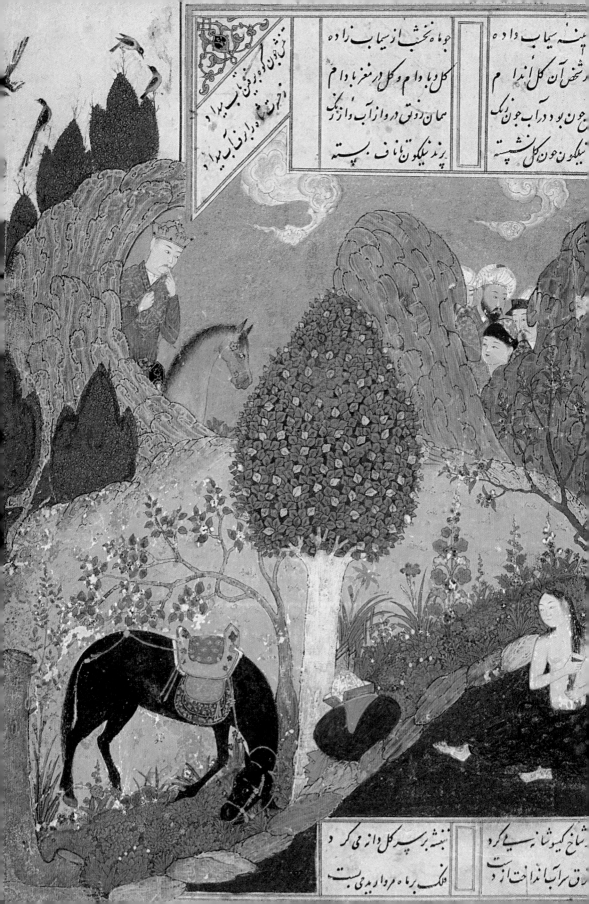

پیش سیماب داد ه

ز رخشن آن گل اندام

ج ح جن بو د درآب جون رنگ

نیلگون جون گل نشسته

جو ماه نخجب از سیماب زا د ه

گل وبا دام و گل در مغز با دام

سمان رنگی در رواز آب واز رنگ

پرند نیلگون تا ناف بسته

تا جون کاربری تا بیبها ؟

و خون رفت ه دارفتار بها ؟

embodiment of aesthetic conceptions. Persian miniatures were at last recognised as a brilliant and unique phenomenon in world art.

Right up to the middle of the 19th century painting was the main form of Persian fine art and it was in painting that we find the most perfect reflection of each age's artistic ideals. Different kinds of painting came to the fore in different eras, of course, to reflect current society's dominant mood, contemporary political and cultural aims and artistic concerns. As they replaced each other as the 'highest' form of art, the various kinds of painting expressed in turn the aesthetic norms of the age, with changing perceptions of what an artistic image should be and of the nature of painterly skill.

As far as we can judge from surviving archaeological materials and from written sources, wall painting existed in Iran from the earliest times right into the medieval period. Surviving fragments of monumental painting from the Seljuk era that directly preceded the Mongol invasion of Iran in the middle of the 13th century (the destructive Mongol conquest allowed only a few monuments to survive) reveal that it was wall painting which occupied the dominant place in fine art. It was thus wall painting that influenced the illumination of manuscripts and painting on ceramics, both in subject – with numerous scenes of royal hunts and

feasts, battles and episodes from epics and tales – and in stylistic features, notably in the free drawing, domination of line, use of local colour and of ornament in the background and so on. Under the Mongol rulers, from the late 13th to 15th centuries, the influence of Far Eastern – above all Chinese – art became stronger. Motifs such as the dragon, phoenix, lotus blossom and stylised clouds were borrowed from China. We gain judge the stylistic features of fine art of this period from contemporary ceramics (cat. nos 51-92), the painting on which is dominated by lively, sketchy drawing, symmetrical construction and the use of ornament to fill the ground.

15TH CENTURY TO MID-16TH CENTURY

Miniature painting flourished and indeed was dominant during the 15th and first half of the 16th centuries. Illustrated manuscrips and book illumination overall were already coming to occupy a leading position in Persian art at the end of the 14th century, by which time miniatures in books had totally overcome their dependence on monumental painting and the painterly approach with its stress on texture, tonal gradations and freedom of drawing had been replaced with the use of pure colours, fine elegant lines dividing even planes of colour covered with flat ornament. The whole appearance of manuscripts changed: now they were filled with all kinds of vignettes and insets, corner decorations and whole ornamental pages. The book became a unified, integral work in which text, ornament and figurative images were indivisibly linked.

The creation of manuscript books was the main art form at the court of Tamerlane's son

PAGE FROM THE *KHAMSEH* BY NIZAMI: KHUSROW SEES SHIRIN BATHING (FF. 6IR) Gouache, ink and gold on paper. Text copied by the calligrapher Mahmud in Herat, for Sultan Shahrukh, *completed 10 Rabi II 835 AH / 16 December 1431* Nasta'liq script, 38 miniatures

CAT. NO 94 (94-101)

and heir Shahrukh (1405-47) and indeed at the courts of all the Timurid princes. The *Khamseh* of Nizami, created for Shahrukh in 1431 in the town of Herat (cat. nos 94-101), is an outstanding masterpiece, achieving a striking unity of text, ornament and miniature illumination. Its arrangement of the text in three columns, one of them narrower than the others, with the text written along slanting lines, determined the deocrative system and in many cases influenced the composition of the miniatures themselves. All the pages in this relative small manuscript are decorated in some way, with corners and cartouches filled with ornament painted in gold and pure colours. Moreover the ornament is painted with such skill, it is so subordinate to the overall composition of each sheet, so rhythmically linked with the text, that literally every spread in the manuscript gives rise to breathless admiration. The ornamental composition on f. 143v (cat. no 101) is truly inspired.

Miniatures in this manuscript reflect all the key features of Persian miniature painting of the first half of the 15th century. Suffused with poeticism, they reflect the emotions and profundity of feeling found in the poetry of Nizami (1141-1203), one of the greatest lyrical poets in the Persian language. They capture the fairytale idealised world inhabited by the poem's heroes, an abstract world that stands apart from life on earth, a world in which all is harmony and beauty. Pure colours in magnificent combinations and lines that determine the rhythm of each image are the main artistic means used to convey the content and emotional resonance of each scene.

New stylistic features appeared in Persian miniature painting during the second half of the 15th century, apparently in connection

PAGE FROM THE *KHAMSEH* BY NIZAMI: BAHRAM GUR IN THE BLUE PALACE (FF. 293V-294R)
Gouache, ink and gold on paper.
Text copied by the calligrapher Mahmud in Herat, for Sultan Shahrukh,
completed 10 Rabi II 835 AH / 16 December 1431
Nasta'liq script, 38 miniatures

CAT. NO 98 (94-101)

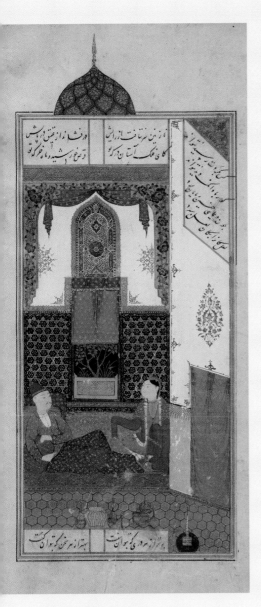

PAGE FROM THE *KHAMSEH* BY NIZAMI: BAHRAM
GUR IN THE RED PALACE (F. 288v)
Gouache, ink and gold on paper.
Text copied by the calligrapher Mahmud
in Herat, for Sultan Shahrukh,
completed 10 Rabi II 835 AH / 16 December 1431
Nasta'liq script, 38 miniatures

CAT. NO 97 (94-101)

with changes in literary priorities and in literary aesthetic ideals. Another of the older poets, Saadi (1200-92), became particularly popular, and the works of Jami (1414-92) and Nava'i (1441-1501), often remarkable for their greater realism, were often copied and illustrated. Jami said that he had no desire to write fairytales, seeing the beauty of art in its dependence on reality. New features to be found in miniatures of the Herat school, above all in the works of Behzad – described by his contemporaries as 'the wonder of the age' – were the more individual characterisation of heroes and the introduction of numerous realistic details and scenes with no relation to the text, scenes that seem to have been taken from everyday contemporary life. Elements of realistic depiction appear in illustrations to literary texts and the connection to the literary text itself becomes weaker.

SECOND HALF OF THE 16TH CENTURY

During the Safavid dynasty (1501-1736), towards the middle of the 16th century, overall alterations in aesthetic ideals and various social, political and artistic processes brought further change to the hierarchy of painting genres. Now miniatures and drawings on separate sheets were so important that it was they that determined Persia's artistic path, exerting a major influence on other painting genres.

Although illustrated manuscripts continued to be created in the later 16th, in even greater numbers than before, the status of the manuscript began to change: it began to lose its role as the leading art form, as the best expression of the ideas and outlook of the age. No longer was it to be seen as a pre-

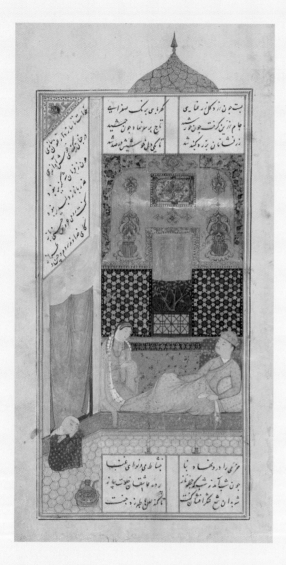

CAT. NO 96 (94-101)
Page from the *Khamseh* by Nizami:
Bahram Gur in the Yellow Palace,
F. 295R
Gouache, ink and gold on paper.
Text copied by the calligrapher
Mahmud in Herat, for Sultan Shahrukh,
completed 10 Rabi II 835 AH / 16 December 1431
Nasta'liq script, 38 miniatures

cious object created for those with refined, educated tastes, intended to glorify the owner and to be kept in a treasury. Manuscripts returned to their original function as books to be read and miniatures were once again directly dependent on and explanatory to the text (cat. nos 104-6).

Most common amongst miniatures on separate sheets were depictions of young men and women (cat. nos 117, 119), in which the artist was attracted by the charm of the youthful faces, the gracefulness of their silhouettes and elegance of their attire. In their idealisation, lack of desire to create images of concrete individuals and their great intimacy and sensuality, these images seem not to be simply embodiments of those literary heroes whose praises were sung by poets in lyrical love poetry, but bearers – like poetry – of a second meaning coloured by Sufic ideas and the desire to come closer to the divinity. Also extremely popular were images of Sufis and dervishes that often seem to have been drawn from nature, so naturalistic are they with their unshaven bearded faces and heavy overhanging brows.

Such subjects were to remain dominant for the next two and a half centuries, although the precise details of what constituted ideal appearance and the treatment of the images changed in accordance with alterations taking place in the court schools as successive capitals replaced each other, at Tabriz, Qazvin and Isfahan. Moreover, these changes were influenced at least in part by European art.

A new approach was required by the depiction of single figures on a larger scale than before. Face, figure and clothing were worked up in more detail, but the background was not, placing greater stress on the

Page from the *Khamseh* by Nizami: Page of Ornament (f. 143v)
Gouache, ink and gold on paper. Text copied by the calligrapher Mahmud in Herat, for Sultan Shahrukh, *completed 10 Rabi II 835 AH / 16 December 1431* Nasta'liq script, 38 miniatures

CAT. NO 101

EUROPEAN LANDSCAPE AFTER
ROELANDT SAVERY (1576-1639)
Gouache on paper
Ali-Quli ibn Muhammad,
1059 AH / 1649

CAT. NO 121

figure's silhouette. Greater dynamism was introduced, with the figures depicted in complex positions, preference being given to unstable poses and unexpected twists of the body. There were drawings using a lively calligraphic line that altered in thickness, thus giving the figure a tactile quality, a sense of movement, the impression of something just seen.

THE ISFAHAN SCHOOL: EAST-WEST EXCHANGE

These tendencies, behind which lay a desire for more vivid and expressive depic-

tions, were to be further developed in the Isfahan school. In the drawings of Riza-i Abbasi, one of the most famous artists of the late 16th and first third of the 17th century (cat. no 117), lines are not subordinate to the silhouette but seem rather to seize the figure from its surroundings. Without light and shade or modelling, using only lines and hatching, the artist captures the movements of the elegant female figure. Riza-i Abbasi (cat. nos 117-18) worked at the court of Shah Abbas I (1586-1629), first at the court in Qazvin, and then in Isfahan, which was declared capital in 1598.

The development of the Isfahan school of painting was more closely linked with European states than painting in previous centuries. Seeking European support in his battle with Turkey and to expand the markets for Persian silk and other goods, Abbas I

extended diplomatic and trading ties across the European states. Isfahan became a city open not only to ambassadors but to all kinds of Christian missionaries, merchants and artists. Under Abbas, European painting received what was tantamount to official recognition at the Persian court. Abbas even had several Dutch painters in his employ: one John the Dutchman, 'Lucas van Hasveld' and several others whose names are today unknown (W. Floor, 'Dutch Painters in Iran During the First Half of the 17th Century', *Persia,* vol. 8, 1979, pp.145-61). Two artists who worked for Abbas II, Angel and Locar, were also Dutch. At the start of the 18th century Isfahan was visited by the Dutch painter Cornelis de Bruyn, who painted a portrait of Sultan Hussein (1694-1722) and in 1711 published in Amsterdam a two-volume description of his second trip to Persia. Europeanising art, barely noticeable in the first half of the 17th century, became a separate tendency within the Isfahan school. Perspective and modelling in light and shade were to become standard elements in Persian art of the second half of the 17th century, undoubtedly borrowed from European art. There are even cases of Isfahan painters copying European paintings, mainly in the 1680s. The Hermitage's *European Landscape* (cat. no 121) of 1059 AH / 1649 is evidence that the practice existed even earlier.

In miniatures by Sheykh Abbasi, an artist of the second half of the 17th century (e.g. cat. no 124), and his followers, the figure is drawn with extremely precise lines, standing out against the pale blue sky and greenish distant hills. Once again drawing becomes lin-

ear, with a major role played by the paints and by tonal relationships. The stress on contour found in the works of all Europeanising artists is complemented by sharp contrasts of light and shade to model volume. Such stylistic features were characteristic also of portraits on canvas by anonymous Persian painters, probably working in the 1680s. These are the earliest examples of Persian painters turning to the European technique of oil painting (Eleanor G. Sims, 'Five Seventeenth-Century Persian Oil Paintings), *Persian and Mughal Art,* Colnaghi's, London 1976, pp. 223-48), a technique that was new to them at this time but which was to dominate in the 18th and 19th centuries.

In many of its purely external features – painting in oils, the nature of the portrait genre, perspectival construction, the use of light and shade etc – Persian painting of the 18th and 19th centuries came increasingly close to European painting. In order to correctly understand and assess paintings of this age, however, we must see them within the context of those same traditions that characterised Persian fine art in the medieval period. Right up to the middle of the 19th century, for instance, Persian painting continued to be an essentially court art, changes in which took place in accordance with the requirements, tastes and desires of the shah and his court.

During the second quarter of the 18th century Iran was involved in almost unending wars and internecine strife. The Afghan conquest of 1722, the invasion by the Turks, who in 1723-24 seized the north-western regions, and the despotic rule of Nadir Shah

1. W. FLOOR, 'DUTCH PAINTERS IN IRAN DURING THE FIRST HALF OF THE 17TH CENTURY, IN: PERSIA VOL. 8, 1979.

2. E.G. SIMS, 'FIVE SEVENTEENTH-CENTURY PERSIAN OIL PAINTINGS'. IN: PERSIAN AND MUGHAL ART, COLNAGHI'S, LONDON 1976.

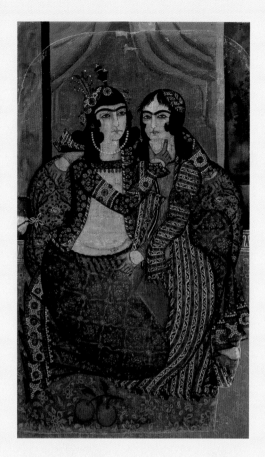

(above) CAT. NO 178
LOVERS
Oil on canvas
Early 19th century

(right page) CAT. NO 183
PORTRAIT OF NASIR AL-DIN SHAH
Gouache and gold on paper
Muhammad Isfahani, *1850s*

(1736-47) all wrought severe damage to Iran's artistic culture. Then in the middle and second half of the 18th century, during the reign of Karim Khan Zand (1752-79), many excellent works of art were created that clearly revealed a desire to revive the traditions of art as it flourished in Isfahan in the previous century. Now, however, these images of elegant melancholic youths and young women were painted in oils on canvas.

THE QAJAR STYLE

With the arrival of a new dynasty, the Qajars, at the end of the 18th century the style of Persian fine art underwent major changes once more. The style that is today known by the name of the ruling dynasty is purely a court style in spirit, somewhat eclectic in nature and strongly archaic. It took shape in Teheran at the court of Fath Ali Shah (1797-1834), influenced by numerous factors, above all the inordinate pretensions of both the Shah and his aristocrats to a 'renaissance' of the might and majesty of the Iranian state of the Achaemenid and Sasanian eras. Fath Ali Shah's rule was characterised by great outward brilliance, luxury and majesty at court, with attempts to revive some features of the court life and culture of ancient Iran. Fath Ali Shah called himself Shahinshah – King of Kings – in the manner of the Achaemenid and Sasanian rulers and he introduced convoluted rich ceremonial at court. He himself, and in his wake his courtiers, began to wear long ceremonial robes and to grow long beards. Reliefs were carved on rocks and cliffs, once again imitating the art of the Achaemenid and Sasanian ages, which glorified the rulers of ancient

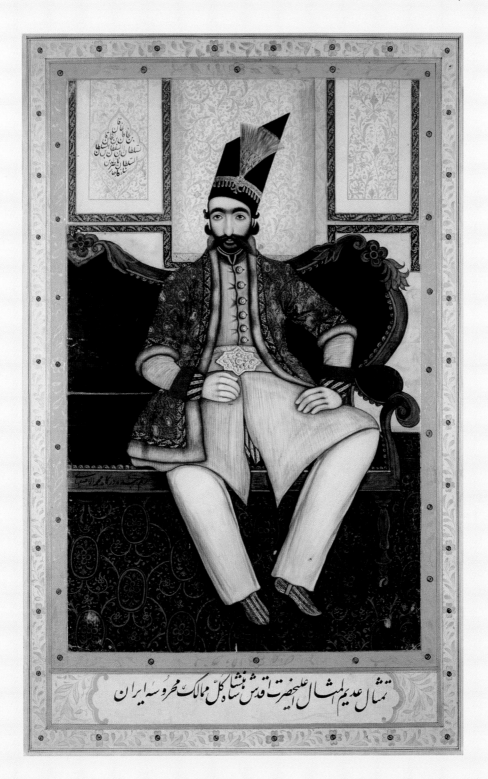

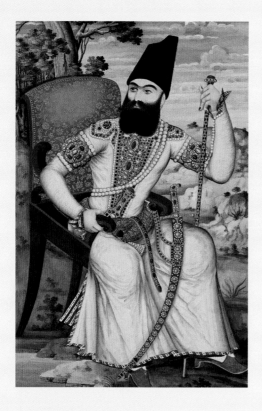

PORTRAIT OF ABBAS MIRZA
Gouache and gold on paper
± 1820

CAT. NO 179

Iran, only now they showed Fath Ali Shah enthroned or defeating some wild beast. Following the example of his predecessors, the Shah patronised literature and art and he himself wrote poetry under the pseudonym Hakan. A manuscript copy of his *Divan* (an anthology of lyrical poems) was amongst other gifts brought to Russia by the 16-year-old Prince Khusraw Mirza in 1829, during a mission to apologise for the murder of Alexander Griboedov and other Russian diplomats in Teheran (the presentation of gifts from Fath Ali Shah to Nicholas I in the throne room of the Winter Palace was one of the scenes depicted in Alexander Sokurov's prize-winning film *Russian Ark*).

The clash of consciously cultivated archaicising elements and the increasing influence of western painting led to an eclec-tic quality and inner contradiction within Qajar painting that for many years prevented its acceptance either by lovers of classical Persian painting or by those preferring the western schools. Today, however, the school is appreciated both for its undoubted historic value and for its unique artistic outlook, a reflection of the historical and aesthetic criteria of the age.

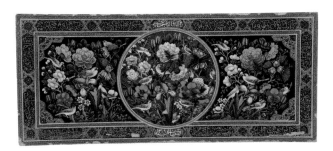

ADEL ADAMOVA

PERSIAN LACQUERWARE

The Hermitage has the largest collection of Persian lacquerware in Russia, some 295 items in all, of which 184 are playing cards. Most objects arrived in the 1920s from the Museum of the former Baron Stieglitz Central School of Technical Drawing, which had purchased them in 1886 from P. V. Charkovsky. Other items arrived, also in the 1920s, from the imperial country residences at Gatchina, Pushkin and Pavlovsk, transferred via the State Museums Fund. A group of lacquered objects from the 1870s to early 20th century, their decorative painting extremely fine and jewellery like, derives from the collection of the celebrated St Petersburg jeweller Fabergé.

Miniature painting on lacquered objects was one of the most widespread art forms in Iran for more than 300 years, from the 17th to 19th centuries. It is thought that it was taken up by Iranian masters in the 15th century, during the age of the Timurid dynasty, from China, where the art of lacquer was invented several centuries BC. In the late

(above, left) CAT. NO 187 - CASKET
Wood, lacquer painting
Abu-l Qasim al-Husseini al-Isfahani
1319 AH / 1901/2

(above, right) CAT. NO 127
QALAMDAN (PEN CASE)
Papier-mâché, lacquer painting
Zaman, *1120 AH / 1708*

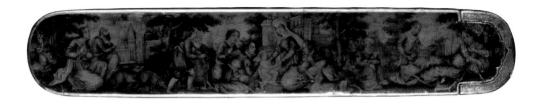

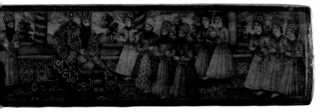

(above) CAT. NO 128
QALAMDAN (PEN CASE) DECORATED
WITH THE ADORATION OF THE MAGI
Papier-mâché, lacquer painting
Mid 18th century

(left) CAT. NO 184
CASKET DECORATED WITH A SCENE
AT THE COURT OF FATH ALI SHAH
Papier-mâché, lacquer painting
First third 19th century

17th and early 18th century lacquer painting even spread to Western Europe and Russia.

What precisely was borrowed from China would seem to have been mainly the basic idea of reinforcing the painting with a layer of transparent lacquer, since the lacquer itself (which in China is made from the sap of the lacquer tree that grows there), the paints and most particularly the appearance of the painting on Iranian works have nothing in common with Chinese lacquer.

Lacquer painting was initially used in Iran to decorate manuscript bindings but in the 17th century it came to be applied to all kinds of (mainly small) everyday objects, such as pen-cases (qalamdans), boxes and caskets and toilet mirrors. Over the course of the next two centuries lacquer was used to paint playing cards, weights, snuffboxes, small tables, decorative panels and many other varied objects.

Those forms changed little over the centuries, with the miniatures themselves being always dominant. One key feature in Persian lacquerware is its close links with large-scale painting, revealed in a commonality of style and subject and in the subordination to the same aesthetic canon. Only in the middle of the 19th century did lacquerware take on its own radically new features, mainly as a result of its increasing isolation from other forms of painting and the introduction of mass production in specialised workshops. These workshops were headed by painters whose individual style determined the nature of the objects they produced. The very high quality of the painting indicates that specialist miniature painters were employed.

Anatoly Ivanov

Metalwork

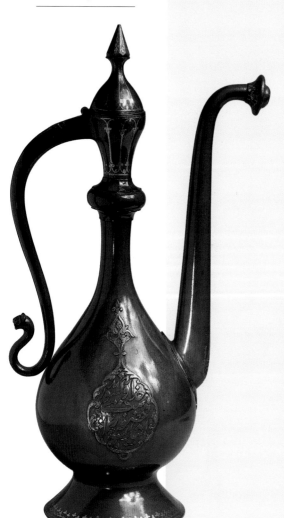

T

The Hermitage collection of Iranian objects in bronze (brass) and copper produced after the spread of Islam began to take shape only after the October Revolution of 1917. Its main sources were the collections of the the Museum of the Former Baron Stieglitz Central School of Technical Drawing and the Russian Academy for the History of Material Culture, which brought the collections of Alexander Bobrinsky and Nikolay Veselovsky. We know that Bobrinsky's collection included 162 items in bronze, or which 79 or even more, i.e. roughly half, were Iranian (although some objects have still not been precisely attributed), made between the 8th and 19th centuries. Veselovsky owned six pieces of Iranian metalwork dating from between the mid-14th century and mid-18th century, as well as a number of earlier items. Considerably more came from the Stieglitz Museum, including some 50 pieces that can be dated from the mid-12th to mid-18th centuries. A large number of bronze (brass) and copper items were acquired from private individuals, including the inhabitants of Kubachi in Daghestan.

Today the Museum has more than 650 pieces of Iranian metalwork, including fragments. These can be divided into four large chronological groups that differ from each other in form and style. Very few of the objects were created before the 12th century, perhaps two dozen at the most, most of which have been firmly identified only in recent years.

12TH – 13TH CENTURIES

Largest of all the groups – more than 200 objects in all – is that composed of works made in Khurasan in the 12th and early 13th

centuries. It includes many pieces decorated with silver and copper incrustation but there are also items with purely engraved ornament. Amongst the first are such world-famous items as the pen-case (*qalamdan*) of 542 AH / 1148 by Master Umar ibn al-Fadl ibn Yusuf al-Bayya (cat. no 40), a famous Herat cauldron of 559 AH / 1163 from the Bobrinsky collection made by two masters, Muhammad ibn al-Wahid and Masud ibn Ahmad, an aquamanile in the form of a Zebu made by Ali ibn Muhammad ibn Abu'l Qasim an-Naqqash in 603 AH / 1206 and bronze cauldrons where the makers' names bear the nisbas (adjectives) 'Marvazi' and 'Qazvini'.

13TH – EARLY 15TH CENTURIES

Composed of some 80 objects created not in Khurasan but in other parts of Iran. It is not possibly to be precise in establishing exactly where metal objects were produced during the second half of the 13th century, but we can state with certainty that new forms appeared at this time, along with techniques such as incrustation with gold that gradually replaced incrustation with copper (although objects continued to be incrusted with silver).

From the start of the 14th century metal objects were produced in Fars province, as we can tell both from the names of craftsmen whose names include the nisba 'Shirazi' and

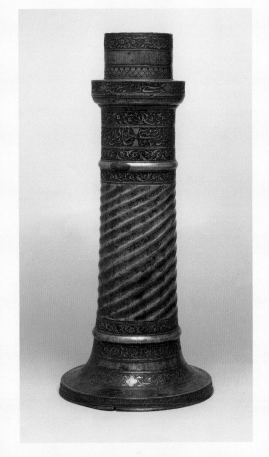

(above) CAT. NO 153
TORCH HOLDER
Bronze (brass)
Final quarter 16th century

(below) CAT. NO 196
QALAMDAN (PEN CASE)
Steel, gold
Early 20th century

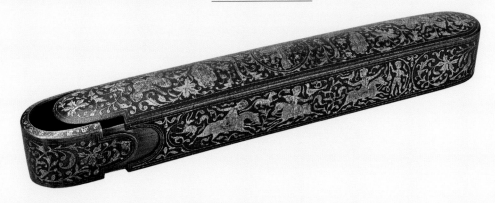

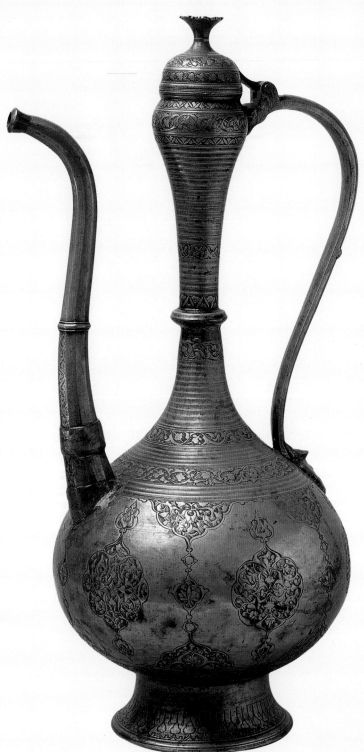

EWER
Bronze (brass)
Early 17th century

CAT. NO 154

from the existence of pieces made for the ruler Abu Ishak (the Hermitage collection includes a bronze bucket of 733 AH / 1332-33 made by Muhammad shah as-Shirazi, and a vessel made for Abu Ishaq). Incrustation would seem to disappear over the course of the 15th century, since very few such objects survive from this period.

MID-14TH – 18TH CENTURIES

The third group consists of 172 items, the earliest pieces dating from the middle of the 14th century, made at the same time as some items in the second group and closely linked with them in form, ornament and inscriptions, but wrought of copper and covered with tin plate. Moreover, the ground round the ornament and inscriptions is worked with a network that immediately sets these pieces apart from bronze (brass) items adorned with incrustation. Bronze (brass) items on which the ground is worked with a network do also appear and these sometimes have incrustation in gold and silver but far less than objects in the second group. From the middle of the 16th century the ground of objects in the third group came to be worked with hatching – the network disappearing entirely by the end of the century – and it is this that features on copper and bronze (brass) items over the course of the 17th century and first half of the 18th.

While objects in the first and second group mainly bore benevolent inscriptions in Arabic (with only extremely rare examples of Persian inscriptions), those in the third group bear inscriptions that bear witness to the victory of the Persian language. The decoration includes *ghazals* (a Persian verse form) by Hafiz, Saadi and Jami, with some *beyts* (lines) from *ghazals* by Amir Khusraw Dehlevi,

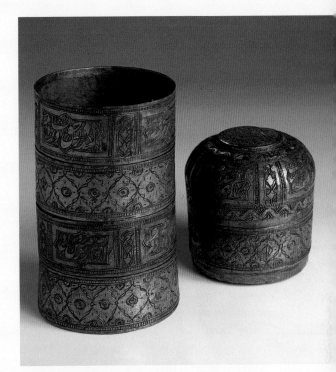

(above) CAT. NO 189
SPICE CADDY
Bronze (brass)
1261 AH / 1845

(below) CAT. NO 157
BOWL
Copper
1113 AH / 1701-2

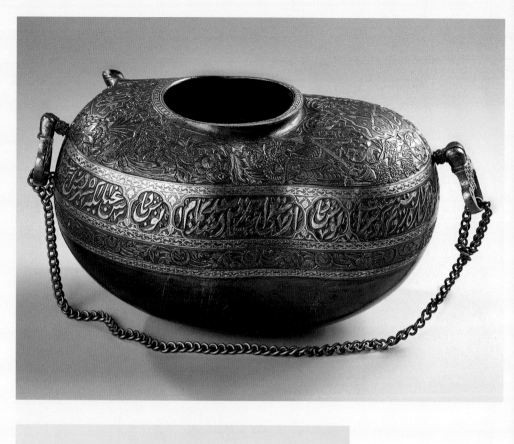

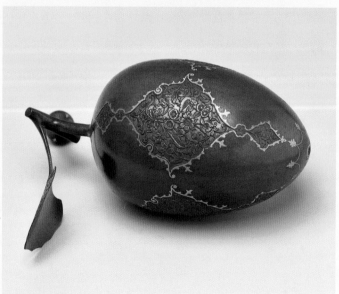

(left, above) CAT. NO 194
KASHKUL (DERVISH'S CUP
OR BEGGING BOWL)
STEEL, GOLD
Master Hadji Abbas (?),
late 19th – early 20th century
(false date 1207 AH = 1792-1793)

(left, below) CAT. NO 193
ALMOND FRUIT
Steel, gold
Master Hadji Abbas,
early 20th century

(right page) CAT. NO 158
DOOR PLAQUES
Steel
17th century

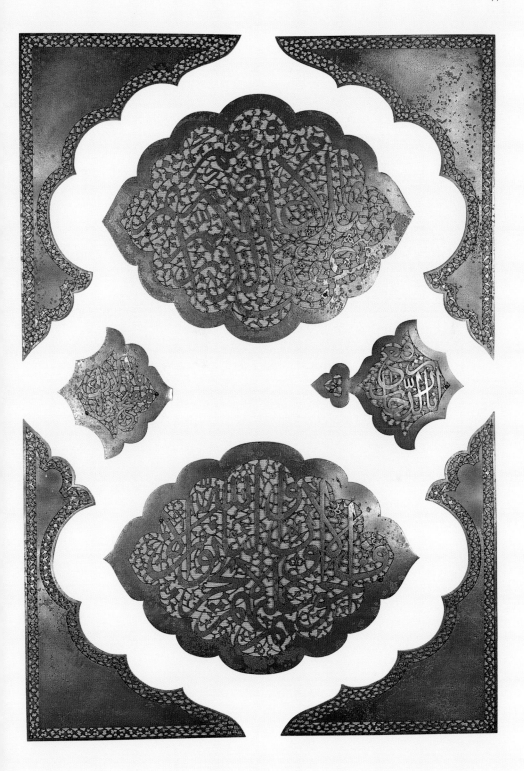

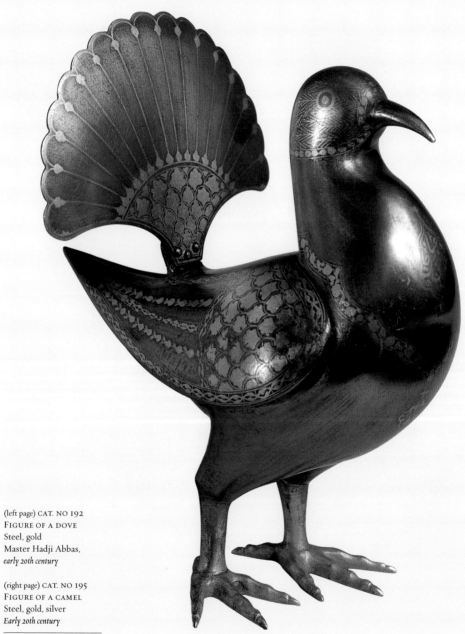

(left page) CAT. NO 192
FIGURE OF A DOVE
Steel, gold
Master Hadji Abbas,
early 20th century

(right page) CAT. NO 195
FIGURE OF A CAMEL
Steel, gold, silver
Early 20th century

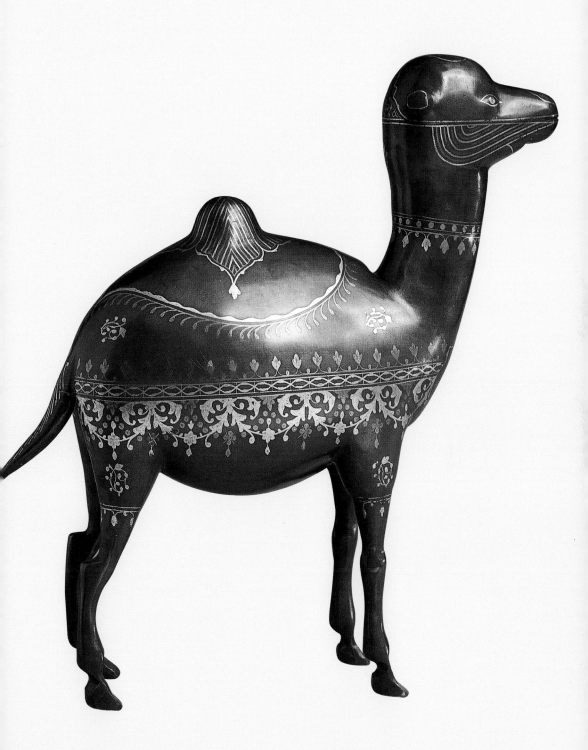

Kasim-i Anwar Tabrizi, Qatibi Turshizi, Hayreti Tuni and other less well-known poets (including Salihi Khurasani or Sharmi Qazvini). Amongst the objects in this group we have identified a number of small ewers with gold and silver incrustation made in the province of Khurasan during the second half of the 15th and first third of the 16th centuries. Unfortunately, it has not proved possible to identify other centres of production in this period.

18TH — 20TH CENTURIES

During the second half of the 18th century there was a sharp decline in the quality of copper and bronze (brass) objects. Compositions became weaker, whole surfaces came to be covered with pure ornament composed of very small elements, the range of inscriptions changed and the ground was pounced rather than hatched. The Hermitage has some 200 such objects, study of which is only in its early stages.

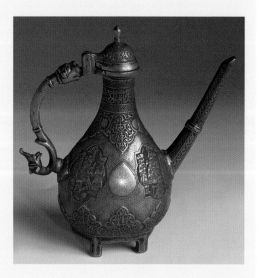

EWER
Brass, gold, silver
Late 19th century

CAT. NO 188

Adel Adamova

Ceramics,
glass and textile

O

(previous page)
CAT. NO 176
SCENT BOTTLE
Transparent blue glass
18th–19th century

(previous page and below)
CAT. NO 133
DEEP DISH ON A RING BASE
Faience, cobalt painting
Early 16th century

(right page)
CAT. NO 134
DISH ON A RING BASE
WITH SCULPTED RIM AND
DECORATION OF TWO FISH
Faience, cobalt painting
Early 16th century

One of the world's best collections of Persian medieval ceramics, consisting of some 3,000 items dating from the 12th to 19th centuries, is to be found today in the Hermitage.

Amongst the magnificent early ceramic pieces from the 12th to 14th centuries are dishes painted with cobalt and lustre and tiles that once adorned rich mausolea (cat. nos 51-92).

More than 700 items date from the 15th to first half of the 18th centuries, forming a body of items almost unmatched in its breadth and quality. We are particularly proud of pieces from the 15th and 16th centuries, unequalled anywhere in the world. These ceramics have come to be known as 'so-called Kubachi' works, since most of them come from Kubachi, a village high up in the mountains of Daghestan. In form and decoration, with cobalt painting beneath a transparent glaze (cat. nos 130-35), they clearly imitate early the 15th-century Chinese porcelain which was so much admired throughout the Middle East (part of an intense interest in Chinese art overall). The influence of Chinese porcelain is also notable in later 'Kubachi' ceramics from the late 16th and 17th centuries (cat. nos 136-38).

In the 17th and first third of the 18th century artistic ceramics was to be one of the most developed branches of Persian applied art, developing in close contact with other crafts and with Persian painting and involving an incredible variety of motifs, devices and means of decoration. The Hermitage has examples of nearly all types of earthenware produced in this period, most of them imitating Chinese Ming porcelain. From the start of the 17th century there was a growing passion in Europe for Chinese porcelain,

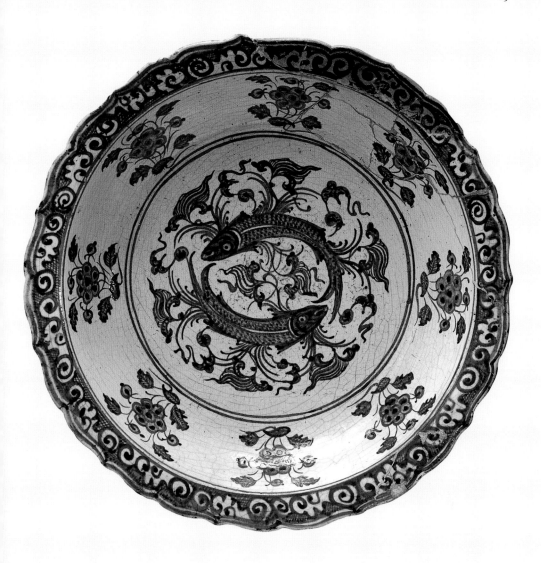

which was imported in large quantities by English and Dutch companies. In the middle of the 17th century, however, political and economic crisis in China and the fall of the Ming dynasty in 1644 led to the temporary cease of all trade with China and the Dutch started to order earthenware in Iran that was similar in appearance to Chinese porcelain. In Kerman, Mashhad and, possibly, other towns, earthenware crockery was produced that was not only extremely close to Chinese wares but that bore marks very similar to those on true Chinese obects (e.g. cat. no 139). Such wares were sold in Europe as Chinese. Meanwhile, cobalt ceramics created for the internal market were adorned with both purely Chinese and with mixed Iranian-Persian motifs (e.g. cat. nos 140, 144).

Other groups of works in the Hermitage's collection of Persian 17th- and 18th-century

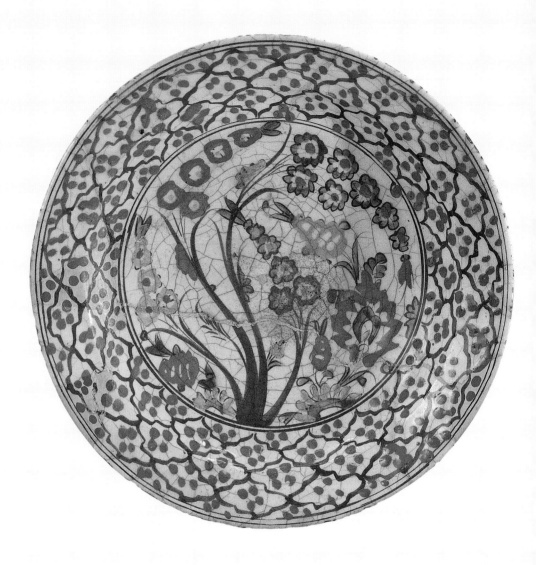

ceramics demonstrate the continuation and renaissance of Iran's own artistic traditions. There are earthenware pieces painted with miniatures that are clearly influenced by the Isfahan school, that influence being felt not only in the range of subjects and motifs but in the particularly 'painterly' manner in which the image is applied to the surface. Park landscapes inhabited by birds are painted in lustre over a white or blue ground (cat. nos 141,

142), while compositions by famous painters are imitated in relief and covered with a green glaze (e.g. cat. no 143).

GLASS OF THE 17TH TO 19TH CENTURIES

Despite its small size – just 90 items or so – the Hermitage's collection of Persian glass includes all the main types of wares.

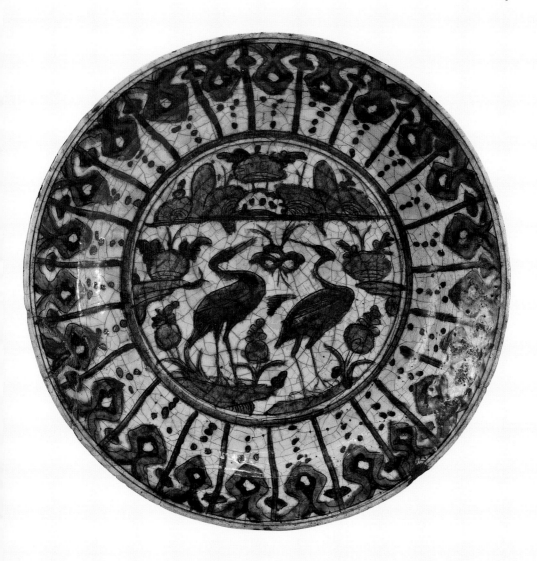

Under the Safavid dynasty the production of
artistic glassware, so highly developed in Iran
during the pre-Mongol era, became an impor-
tant (although not the most important)
branch of the applied arts. According to Euro-
peans, in the 17th and 18th centuries there
were workshops for the production of glass in
many towns across Iran, although all name
Shiraz as the main centre. It was there that
craftsmen produced bowls, ewers and bottles

(left page) CAT. NO 138
DISH WITH FLORAL DECORATION
ON A RING BASE
Faience, polychrome painting
17th century

(right page) CAT. NO 136
DISH WITH DECORATION OF
TWO HERONS ON A RING BASE
Faience, cobalt painting
17th century

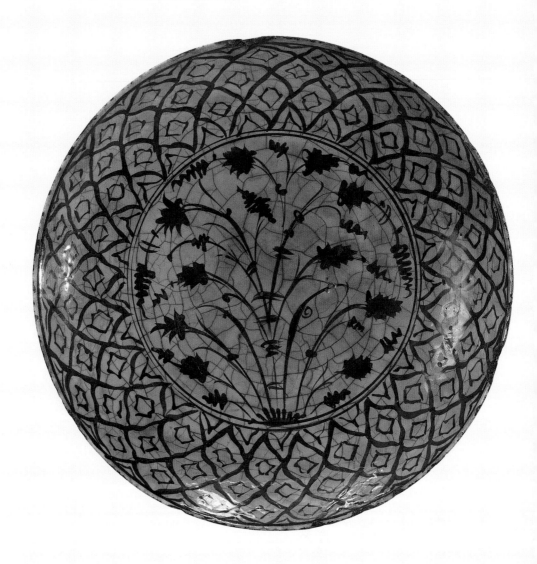

for the celebrated Shiraz wine, as well as perfume vessels for rose water and for perfumed oils made from the roses of Shiraz that are glorified in Persian poetry.

In making all these objects, great attention was paid to perfection of form, to harmony between all elements and to colour, for the glass was coloured by adding various metallic oxides.

Glass would seem to have been produced in large quantities and to have been both popular and accessible but the continued use of the same forms – bottles with a long high neck, small ewers with applied decoration – makes the dating of many objects a complex matter.

Persian perfume vessels, particularly those with long curving twisting necks recalling a swan (e.g. cat. no 176), were made in large quantities at the end of the 19th cen-

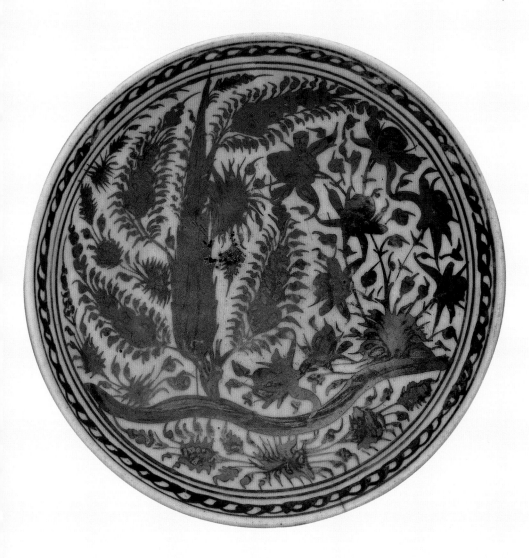

tury. They became fashionable in Europe and were much in demand. To judge by the vessels depicted in Qajar paintings, in Iran itself glass items of European and Russian make were popular.

Textiles

The greater part of the Hermitage's collection of Persian artistic textiles, some 700 pieces in all, is composed of fabrics from the

(left page) CAT. NO 137
DISH WITH FLORAL DECORATION
ON A RING BASE
Faience, black painting
under turquoise glaze
17th – first third 18th century

(right page) CAT. NO 142
PLATE DECORATED WITH
A LANDSCAPE SCENE
Faience, overglaze lustre painting
Late 17th–early 18th century

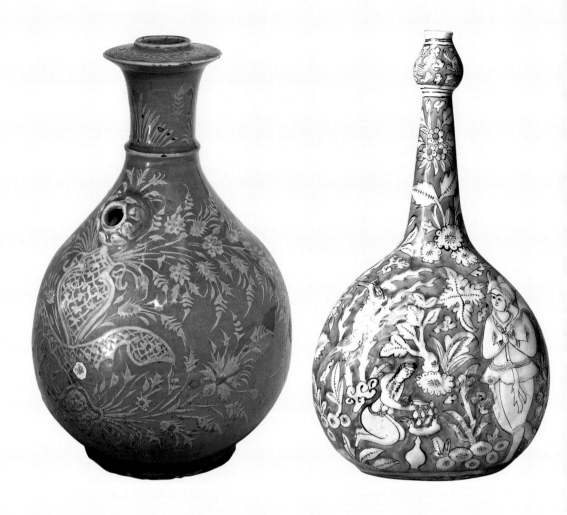

17th to 19th centuries. Only a few items can be firmly dated to an earlier period, among them fragments of silk velvet and brocade included in this exhibition, both with depictions of a prince feasting in a flowering garden (cat. nos 163, 164). Along with later Persian silk textiles adorned with figures of people, animals and birds, they represent the highest achievements in textile production of any age. Extremely complicated in terms of their technical execution, they were created in palace workshops to designs by court painters. Frequently they repeat subjects and compositions that appeared in Persian miniature paintings, closely following the style of contemporary miniaturists. The skill of the weavers in repeating even the finest details of the figures' clothes and weaponry continues to amaze us today. With their elegant and skilful patterns and their complex colour schemes, artistic textiles create a striking impression of the refined luxury of aristocratic court life under the Safavid dynasty (1501-1736). In Russia and Europe Persian textiles were highly prized and enjoyed great

demand, with silks and velvets often included amongst diplomatic gifts from Persian embassies. Silk was one of Persia's main export goods.

(from left to right)

CAT. NO 145
NARGHILE (HOOKAH)
Faience, polychrome painting
17th century

CAT. NO 140
HIGH–NECKED FLASK WITH
A HUNTING SCENE
Faience, cobalt painting
Late 16th-first half 17th century

CAT. NO 143
FLAT-SIDED FLASK
Faience
First half 17th century

CAT. NO 141
SELAFTAN (SPITTOON)
Faience, underglaze lustre painting
17th-early 18th century

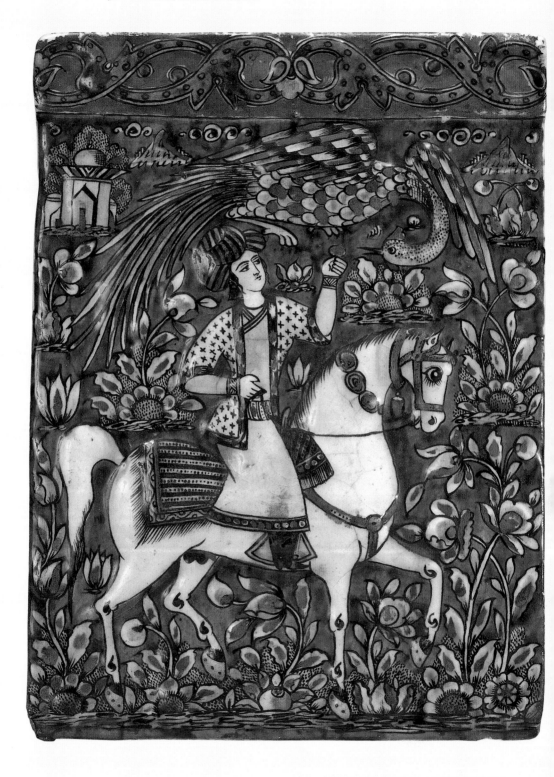

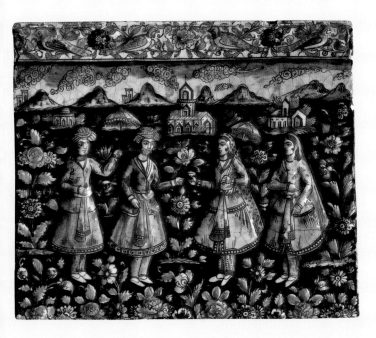

(left page) CAT. NO 197
TILE DECORATED WITH
A HORSEMAN
Faience, polychrome painting
19th century

(above) CAT. NO 198
TILE DECORATED WITH
AN ELEGANT GATHERING
Faience, polychrome painting
19th century

(below)
CAT. NOS 173, 174, 175
THREE EWERS
Transparent glass
18th-19th century

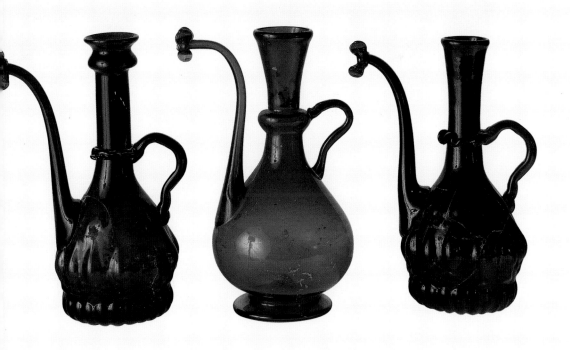

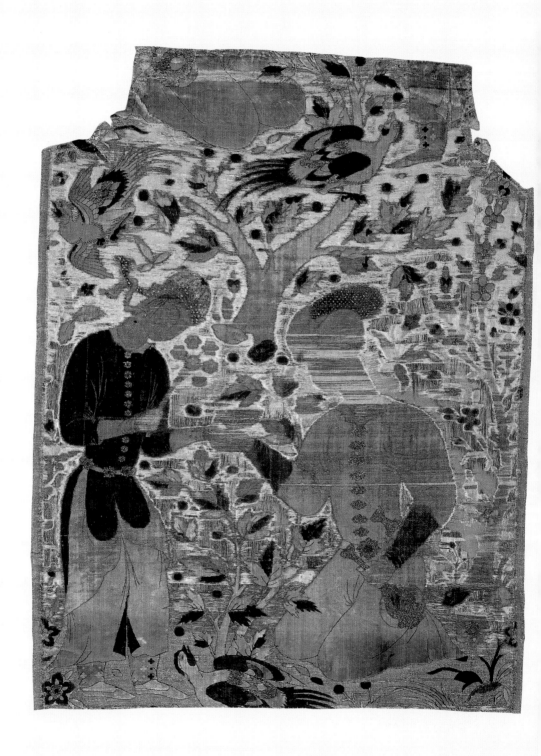

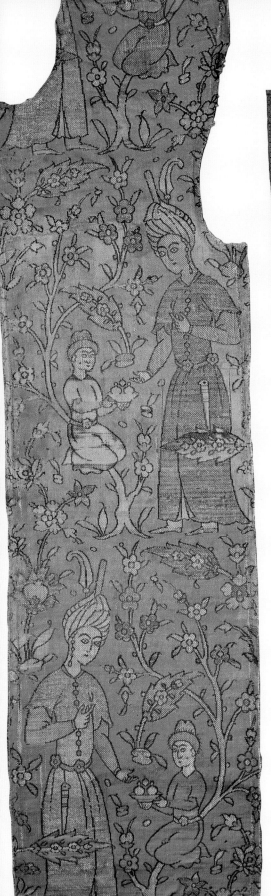

(left page) CAT. NO 164
TEXTILE FRAGMENT
WITH A GARDEN SCENE
Velvet
16th century

(above) CAT. NO 169
SASH
Silk, metal threads
18th century

(left) CAT. NO 163
CLOTHING FRAGMENT
Silk satin
First half 16th century

Catalogue

1-2
Elamite Vessels
4th – 3rd millennium BC
Pottery. *9 x 19.5; 23 x 16*
Inv. Nos. □ 6889, □ 6880
Provenance: 1912.
Literature: St Petersburg 2004, Nos. 1-2.

In 1912, D. D. Belyaev, the Russian Vice-Consul in Bushir, near the Persian Gulf, was able to provide assistance to members of a French learned expedition, headed by the archaeologist Jacques de Morgan, conducting excavations at Susa, capital of ancient Elam. Learning that Belyaev was a member of the St Petersburg Archaeological Institute the French suggested that they make a present to the Institute, in gratitude for assistance received, of some of the antiquities they had discovered. Addressed to 'M. le directeur du Musée Impérial de Saint-Pétersbourg', the gift of Elamite antiquities found its way not to the Institute but to the Hermitage Museum. It consisted of 10 fragments with cuneiform writing and 55 painted ceramic vessels dating from the 4th to 3rd millennia BC.
A.N.

3
Fragment of a Relief from Persepolis: Persian
warrior, one of the guards of Darius or Xerxes
5th century BC
Stone. *22.3 x 20.2*
Inv. No. □ 19105
Provenance: 1935.
Literature: St Petersburg 2004, No. 3.

Construction of Persepolis, new capital of the Achaemenid Empire, began under Darius I around 520 BC. The whole architectural ensemble, including the palace and temples, was intended to mark Novruz, the celebration of new year, most important of all Iranian religious festivals. The reliefs of Persepolis depicted delegations from the different peoples who made up the Empire bringing gifts to the King of Kings, and the royal guard of Medians, Elamites and Persians.
A.N.

4
Achaemenid Torque with a winged Lion
5th – 4th century BC
Gold, insets of turquoise and coloured smalt. *Diameter 16.5*
Inv. No. Z-568
Provenance: part of the Siberian collection of Peter I – it was acquired in Siberia by the governor, Prince Matvey Gagarin, in 1717, and sent to Peter I; until 1727 kept in Peter's Summer Palace in St Petersburg, then transferred to the Kunstkammer; 1859 transferred to the Hermitage along with other items from Peter's Siberian Collection.
Literature: St Petersburg 2004, No. 5.

Gold bands were worn around the neck as a sign of power worn by Persian grandees. A very similar pendant formed part of the Amu Darya Hoard found in 1877.
A.N.

5
Cylindrical Seal with a Persian King
and Vanquished Enemies
Late 5th – early 4th century BC
Sapphire. *2.8 x 1.2*
Inv. No. □ 19499
Provenance: 1880 from the collection of A. Zvenigorodsky, Kerch.
Literature: St Petersburg 2004, No. 6.
O.N.

6
Cone-Seal with a Triple Horse Protoma and a Disc
5th – 4th century BC
Agate, gold. *2.2*
Inv. No. GL 892
Provenance: 19th century.
Literature: St Petersburg 2004, No. 13.
O.N.

7
Scaraboid seal with a lionheaded mythical animal
Cornaline, gold, *L 2.4 cm*
Inv. GL 891
Provenance: 1893, from the collection of Dzh. Lemme, Odessa
Previously unpublished.
O.N.

8
Scaraboid Seal with a Persian Rider
Chasing Scythians
5th – 4th century BC
Chalcedony. *3.4 x 2.6*
Inv. No. □ 19496
Provenance: 1908 purchased from O. Nuri-Bey.
Literature: St Petersburg 2004, No. 20.
O.N.

9
Scaraboid Seal on a Movable Gold Hoop
with a Persian Rider Spearing a Hoplite
First half of the 4th century BC
Chalcedony, gold. *2.6 x 2.1*
Inv. No. GL 887
Provenance: 19th century.
Literature: St Petersburg 2004, No. 21.
O.N.

10
Scaraboid Seal with a Persian Archer
First half of the 4th century BC
Colourless stone. *2.6 x 1.8*

Inv. No. □ 19500
Provenance: 1900 from the collection of A.N. Novikov, Kerch.
Literature: St Petersburg 2004, No. 25.
O.N.

11
FIGURE OF A GRYPHON
4th century BC
Gold. *5.2 x 8.5*
Inv. No. Si 1727 1/143, PBz 315
Provenance: part of the Siberian collection of Peter I – excavated by thieves in the first quarter of the 18th c century (location unknown); possibly sent from Tobolsk to Peter I in St Petersburg by Prince Matvey Gagarin, governor of Siberia; until 1727 kept in Peter's Summer Palace in St Petersburg, then transferred to the Kunstkammer; 1859 transferred to the Hermitage along with other items from Peter's Siberian Collection.
Literature: St Petersburg 2004, No. 40.

The purpose of this cast figure is unknown. It may have formed the handle of a vessel although there are no signs of attachment on the figure itself. The fantastical winged beast has the head and paws of a beast of prey, a ram's horns and beard and a long tail with three leaf-shaped tips. Extremely stylised, the figure cannot be attributed with any precision but we can be sure that it relates to Achaemenid Iranian works.
E.K.

12
TORQUE WITH HEADS OF BEASTS OF PREY
4th – 2nd century BC
Gold, turquoise. *Diameter 19.3 cm*
Inv. No. Si 1727 1/61, PVz 102
Provenance: part of the Siberian collection of Peter I – excavated by thieves in the first quarter of the 18th century (location unknown); possibly sent from Tobolsk to Peter I in St Petersburg by Prince Matvey Gagarin, governor of Siberia; until 1727 kept in Peter's Summer Palace in St Petersburg, then transferred to the Kunstkammer; 1859 transferred to the Hermitage along with other items from Peter's Siberian Collection.
Literature: St Petersburg 2004, No. 42.

Spiral torques and necklets often had zoomorphic ends which served as protective talismans. Such bracelets and necklets were typical of nomadic Eurasian cultures during the 1st millennium BC and were undoubtedly apotropaic – intended to ward off evil. They would have been worn by higher ranks or members of the nomadic aristocracy.
The heads of feline beasts of prey have turquoise insets for the eyes, ears and mane. Inside, the hollow heads are filled with some tarry substance. The heads are very stylised and generalised and relief areas are emphasised by projections and diagonal incisions to mark the brows and contours of the cheeks. Fine details such as the lines marking fur on the face are engraved.

In modelling of the face and the nature of the stylisation, these images are clearly linked with Sakko-Sarmatian objects, finding direct parallels in Central Asia and Afghanistan, for instance Bactrian objects such as the scabbard from the Oxus Temple and zoomorphic images from the treasury of Tillya-tepe (1st century AD).
The torque cannot be identified amongst the inventories of objects despatched by Matvey Gagarin from Siberia but it certainly was transferred to the Kunstkammer from the Summer Palace in 1727 and must thus have entered Peter's Siberian Collection between 1717 and 1727.
E.K.

13
FRAGMENT OF A TORQUE WITH LION HEADS ON THE ENDS
4th – 3rd centuries BC
Gold. *Diameter 14.4*
Inv. No. Si 1727 1/237, PBz 345
Provenance: part of the Siberian collection of Peter I – excavated by thieves in the first quarter of the 18th century (location unknown); sent from Tobolsk to Peter I in St Petersburg by Prince Matvey Gagarin, governor of Siberia; until 1727 kept in Peter's Summer Palace in St Petersburg, then transferred to the Kunstkammer; 1859 transferred to the Hermitage along with other items from Peter's Siberian Collection.
Literature: S.I. Rudenko, 'Sibirskaya kollektsiya Petra I' [The Siberian Collection of Peter I], *Soobshcheniya Arkheologicheskogo Instituta* [Reports of the Archaeological Institute], issue D3-9, Moscow-Leningrad, 1962, pl. XVIII, 2.

Unusual stylisation and extreme generalisation of form were characteristic of the Scytho-Siberian animal style.
E.K.

14
SPIRAL BRACELET WITH NINE TWISTS AND ZOOMORPHIC TIPS (IN TWO PARTS)
4th – 3rd century BC
Gold. *Diameter 9*
Inv. No. Si 1727 1/52, PBz 190
Provenance: part of the Siberian collection of Peter I – excavated by thieves in the first quarter of the 18th century (location unknown); sent from Tobolsk to Peter I in St Petersburg by Prince Matvey Gagarin, governor of Siberia; until 1727 kept in Peter's Summer Palace in St Petersburg, then transferred to the Kunstkammer; 1859 transferred to the Hermitage along with other items from Peter's Siberian Collection.
Previously unpublished.

The figures at the ends are of feline beasts of prey, perhaps tigers, treated with characteristic stylisation and generalisation of form. In typical manner the overall composition is subordinated to the form of the object. The heads were cast separately and welded onto the ends of the wire.
E.K.

15-20

FRAGMENTS OF A RHYTON WITH AN IMAGE
OF AN ENTHRONED IRANIAN RULER (PARTHIAN KING)
WITH COURTIERS

2nd – 3rd centuries

Ivory. *12 x 12.7; 11.8 x 3.2; 10.3 x 3.1; 12.4 x 3.3; 10.4 x 3.1; 10.7 x 4*

Inv. Nos. S-316, S-318, S-320, S-321, S-324, S-325

Provenance: 1906 found during excavations in Olbia.

Literature: V.G. Lukonine, *Iskusstvo Drevnego Irana* [The Arts of Ancient Iran], Moscow, 1977, pp. 128-32; Loukonine, Ivanov 1996, No. 34; *Weihrauch und Seide. Alte Kulturen an der Seidenstrasse*, exh. cat., Kunsthistorisches Museum, Vienna, 1996, No. 73.

These ivory plaques were used to cover a rhyton or drinking vessel. They were found on the shores of the Black Sea during excavations of Olbia and the rhyton itself was probably not Iranian but of Graeco-Roman work. The figure of a Parthian king and the musicians and acrobats in the lower register are exotic scenes typical of the late Roman period.

A.N.

21

COSMETICS SPATULA WITH HANDLE
IN THE FORM OF A NAKED FIGURE

Parthia. *1st – 2nd centuries*

Ivory. *Preserved height (part of stick has been lost) 19.5; height of figure 10.4*

Inv. No. Kz 5740

Provenance: collected by Alexander Bobrinsky near Grozny; acquired in 1929.

Literature: R. Kinzhalov, 'Parfyanskaya tualetnaya lozhechka iz slonovoy kosti' [A Parthian Cosmetics Spatula Made of Ivory], *Soobshcheniya Gosudarstvennogo Ermitazha* [Reports of the State Hermitage Museum], 11, 1957, pp. 53-54; St Petersburg 2004, No. 62.

The stem of the ivory spatula is rounded and has a scoop (of which only a small part remains) at one end, with at the other a naked figure of a goddess standing on a hemispherical pedestal, wearing a tower crown and with a child on her breast. It is clear that the master made use of – but did not fully understand – and Antique prototype, reflected in the goddess' pose and in the inclusion of the traditional pillar by her left leg, with drapery tossed over it. Similar Parthian ivory statuettes are known from finds at Susa in Iran. The depiction of the child in the goddess' arms derives from ancient Oriental traditions, indicating the syncretic nature of the image.

A.Ie.

22

JEWELLERY WITH GRANULATION AND INCRUSTATION
Half of a two-part Buckle

Parthia. *Late 2nd – early 3rd centuries*

Gold, hessonite. *2.4 x 1.5*

Inv. No. Kz 7784

Provenance: chance find in a destroyed burial in the northern Caucasus; 2003 purchase.

Literature: St Petersburg 2004, p. 56, No. 63.

Such is the quality of this piece that it was clearly made by a skilled jeweller. The settings with hessonite were possibly attached later.

A.Ie.

23

EARLY SASANIAN SILVER DISH WITH
PARTHIAN INSCRIPTION

2nd century BC – 2nd century AD; later reworking 240s-260s AD

Silver, sheet gold, gilding. *Diameter 26.5; height 3.5 cm.*

Diameter of tray 9.5

Inv. No. Z-597

Provenance: 1995 purchase.

Literature: St Petersburg 2004, No. 53.

The inner space is filled with four concentric circles, with a relief figure of a silver gilded standing goat (height 4) iIside the central band (diameter 4.2)

The ring-shaped foot is adorned with large beading. On the outside, by the edge, is a punched inscription in late Parthian script that can be dated to the 2nd or 3rd centuries AD.

The object has a complex history, for the goat figure was probably attached at the time when the vessel underwent repair. The figure itself, however, is older than the dish, its closest analogies being an object found in a 1st-century AD burial at Tillya-tepe in Afghanistan. Scientific analysis in the Hermitage has revealed traces of restoration.

Without any reliable direct comparisons in oriental silverware either in Russia or abroad, dating of such an object is extremely difficult. Those features that relate to the Achaemenid period are clearly somewhat distorted and it is possible that the dish was made in the Parthian era (2nd century BC – 2nd century AD), but very little is known about Parthian silver. We can be more confident in dating the restoration and renewal of the dish, for an inscription was added on the outer edge when the goat figure was attached. Read by Alexander Nikitin, the inscription in late Parthian script is transliterated as '*M'NH ZNH LY nryshw bythšy BRY 'rthštr bythšy:*' or 'This is my vessel, Narse bidakhsh, son of Ardashir bidakhsh'. The identity of the owner, Ardashir bidakhsh, is known from other sources – he was Sasanian governor in the Caucasus during the 3rd century AD – but his son Narse bidakhsh was previously unknown. Thus the dish has particular interest as a historical source, adding to our knowledge of Sasanian rule in the Caucasus. The inscription and repair should be dated to no later than the 240s-260s. It is possible that the dish was given its final appearance somewhere in the lands governed by Narse bidakhsh, i.e. in the Caucasus.

A.N.

24

SASANIAN DISH WITH A KING ENTHRONED AND A
ROYAL RAM HUNT

6th century AD

Silver, gilding. *Diameter 26*

Inv. No. S-520

Provenance: 1908 found near the village of Strelka, Perm Region.

Literature: Trever, Lukonin 1987, p. 109; B. Marshak, in: *Weinrauch und Seide. Alte Kulturen an der Seidenstrasse,* exh. cat., Kunsthistorisches Museum, Vienna; Milan, 1996, p. 401.

Two independent scenes occupy the space on the dish, one above the other. In the central part is a king on a throne supported by two winged horses, with standing figures of courtiers or advisers to either side, their arms crossed over their chests. In the lower scene we see a royal hunt.

The form of the crown worn by the seated king matches that of a number of Sasanian rulers from Peroz I (459-84) to Khusraw II (591-628). We might identify the four figures beside him as the military commanders of the four regions into which Iran was divided under Khusraw I (531-79), of perhaps as the rulers (dynasties) subordinated to the king. The latter interpretation is founded on Plutarch's *Life of Lucullus* (chapter 21), in which he records that in the 1st century BC, in accordance with Persian practice, the king of Armenia treated conquered rulers in just this way:

'Many were the kings who were in attendance on him; but there were four who were always about him, like attendants or guards, and when he mounted his horse they ran by his side in jackets; and when he was seated and transacting business, they stood by with their hands clasped together, which was considered to be of all attitudes the most expressive of servitude, as if they had sold their freedom, and were presenting their bodies to their master in a posture indicating readiness to suffer rather than to act.'

Winged horses refer to the god Mithra, divine protector of the ruler, who was frequently depicted travelling in a chariot drawn by just such winged horses. A similar throne appears on a famous cup of gold, glass and mountain crystal in the Bibliothèque Nationale in Paris. In their attire and placing of their legs, the standing figures reveal similarities with paintings of the Hephtalite period (late 5th – first half of the 6th century) from Dilberjin in Afghanistan and with the figure of King Peroz I on another silver dish in the Hermitage. Such analogies allow us to relate this dish to the first half of the 6th century. Boris Marshak suggested a dating and interpretation of the seated figure as Kavadh I (488-97, 499-531) and in this case the figure hunting in the lower part may be seen as his heir, the future Khusraw I. The depiction of rams personifies royal success. The Bactrian inscription on the reverse contains the name and title of the vessel's owner.
G.S.

25
EWER WITH A *SENMURV*
6th – early 7th century
Silver. *Height 33; 31.5 without lid*
Inv. No. S-61
Provenance: 1823 found as part of a hoard near the village of Pavlovka, Starobelsky Administrative Region.
Literature: K.B. Trever, *Senmurv-paskudzh sobaka-ptitsa* [Senmurv-paskudzh Dog-Bird], Leningrad, 1937; Trever, Lukonin 1987, p. 113.

On the body are two oval medallions with an image of a senmurv, a fantastical beast with the head of a dog, half-palmettes on the neck and chest indicating feathers and a tail of stylised peacock feathers. The *senmurv,* or dog-bird, combines three states: dog, bird and something like a musk-rat, and is very closely tied to Zoroastrian cosmogony. It lives in the 'tree of all seeds', out of which grow all kinds of plants. When the senmurv flies from the tree the dried seeds fall into the water and return to land with the rain.

We should interpret the depiction of three pairs of stylised flowers inside the tendril twists between the medallions as representing the 'tree of all seeds'. At the back between the medallions are three pairs of long narrow leaves. The richly ornamented lid once had a loop that would have been attached to the bobble on the handle.
G.S.

26
SASANIAN DISH WITH A LIONESS IN FRONT OF A TREE
6th century
Silver, gilding. *Diameter 22.8*
Inv. No. S-41
Provenance: 1907 found near the village of Klimova, Solikamsk Administrative Region, Perm Province.
Literature: St Petersburg 2004, No. 54.

The border is filled with vegetable ornament and below are figures of a dog and two quails.
A.N.

27
SASANIAN 'CUP' (BEAKER WITH FOOT BROKEN OFF)
6th – 7th centuries
Silver, gilding. *Height without foot 8.3*
Inv. No. Kz-5322
Provenance: chance find in 1829 in the Ursdonsk Pass, Northern Ossetia; acquired in 1938.
Literature: Trever, Lukonin 1987, No. 38; St Petersburg 2004, No. 65.

The main images are engraved in low relief, occupying a central band of six medallions against a gilded ground (some of the details of the figures are also gilded). In the opinion of Camilla Trever and Vladimir Lukonin, the images present two very similar subjects divided into separate figures, each of them placed in a separate medallion, thus breaking down the unity of the original composition. The first scene is of two wild goats, one leaping, one with legs folded beneath the body, to either side of a tree; the second shows two quails, also by a tree. In the lower part of the vessel is a large gilded rosette. Along the upper, slightly flaring edge is a border of gilded sickle moons arranged vertically and placed alongside each other. The rim is also gilded inside. The original form of this vessel was close to that of the celebrated Sasanian gold cups from the Pereshchepina Hoard now in the Hermitage.
A.I.

28
Sasanian Dish with Hunting Scenes
and a Senmurv
Late 6th – 7th century
Silver, gilding. *Diameter 13.4*
Inv. No. S-57
Provenance: late 19th century chance find in Terskoy Region,
north-east Caucasus; 1909 purchased from M.I. Isakovich
(initials engraved below the edge), Grozny.
Literature: St Petersburg 2004, No. 66.

This small flattened hemispherical dish is smooth inside, the
outside totally covered with low-relief images with engrav-
ing. The compositional centre is a large medallion placed at
the bottom and framed with a relief border. Inside the medal-
lion is a figure of a fantastical beast known as a *senmurb*.
Abutting onto the medallion's border are four stylised trees
that rise up to the border running around the rim; these trees
separate two hunters with spears and the animals – a lion and
a bear – that they are chasing. There is gilding of the ground
on the outside of the cup and on some details in the figures
and the border with its ornamental design.
A.I.

29
Seal of the Marded (Treasurer) Anguist.
First half of the 3rd century
Amethyst. *2.7 x 1.9*
Inv. No. GL 978
Provenance: 1895 purchased in Yerevan, Armenia.
Literature: Borisov, Lukonin 1963, pp. 48, 74, No. 1.

Portrait of a bearded courtier in a high *kulakh* hat with a *tamga*
(a mark or seal) (to left on the seal itself, to right on the cast).
Parthian inscription with the name and title of the owner.
A.N.

30
Seal of Queen Denak
First half of the 3rd century
Amethyst. *2.3 x 2.1*
Inv. No. GL 979
Provenance: second half of the 19th century from the Stroganov
collection.
Literature: Borisov, Lukonin 1963, No. 2.

Queen Denak – consort of Sasanian King Ardasir I (226-40).
A.N.

31
Seal with a Cockerel and an Inscription
6th – 7th century
Chalcedony. *1.5 x 1.7*
Inv. No. GL 132
Provenance: unknown.
Literature: Borisov, Lukonin 1963, No. 496.

The inscription contains the name Gustasp Khormizd.
A.N.

32
Seal with a Camel and an Inscription
6th – 7th century
Yellowish-grey chalcedony. *2 x 1.9*
Inv. No. GL 407
Provenance: collection of Cherkasov, mid-19th century.
Literature: Borisov, Lukonin 1963, No. 753.

Middle Persian inscription around the edge with the title and
name of the owner.
A.N.

33
Seal with a Reclining Lion
6th – 7th century
Almandine. *1.1 x 1.3*
Inv. No. GL 630
Provenance: collection of Goldberg.
Literature: Borisov, Lukonin 1963, No. 334.
A.N.

34
Central Persian Clay Tablet from Merv,
Fragment of a Thick-walled Vessel
6th – 7th centuries
Pottery. *20 x 35.5*
Inv. No. Ä-1516
Provenance: 1904 found during excavations on Erk Kala, citadel
of Old Merv, by an American expedition led by Rafael Pampelli.
Literature: St Petersburg 2004, No. 55.
This is the draft of a letter of which we can make out only a
few faded lines in black ink, in Middle Persian cursive script.
A.N.

35
Tray
10th century
Bronze (brass). *Diameter 58*
Inv. No. IR-2322
Provenance: 1924 from the Museum of the Former Baron Stieg-
litz Central School of Technical Drawing.
Literature: St Petersburg 2004, No. 107.

One of the latest examples of early Iranian trays. The subjects
depicted upon it reveal its Iranian origin, but the absence of a
unifying concept behind the composition suggests that the
object was made during a later period, when the Sasanian tra-
ditions had largely been lost.
A.I.

36
EWER
8th – 9th century
Bronze (brass). *Height 40*
Inv. No. IR-2325
Provenance: collection of A.A. Bobrinsky; 1925 from the Russian Academy for the History of Material Culture.
Literature: St Petersburg 2004, No. 108.

The form of this ewer's body, its fluted sides and curving handle with gazelle heads refer to Sasanian traditions, which continued to make themselves felt in metalwork of the early Abbasid khalifate. A dating of the 8th to 9th century is suggested by the form of the spout and the ornament around it.
A.I.

37
EWER
8th – 9th century
Bronze (brass). *Height 34.5*
Inv. No. IR-2326
Provenance: unknown.
Literature: St Petersburg 2004, No. 109.

There are a number of unanswered questions surrounding the dating of this ewer. In form of its body and handle (compare cat. no 36) we can date it to the 8th and 9th century, but the engraved ornament is more characteristic of bronze works made in Khurasan in the 12th century. We might suggest that the ewer was given its decoration several centuries after it was made, although it is also possible that the object was made in the 12th century using earlier forms, and that both form and ornamentation were contemporary.
A.I.

38
LAMP
11th century
Bronze (brass). *Height 25*
Inv. No. IR-1566
Provenance: 1936 from the Museum in Ordzhonikidze (now Vladikavkaz).
Literature: St Petersburg 2004, No. 110.

In overall appearance the object is very like the incense-burners in the form of feline beasts that were widespread in Iran in the 11th century, but its construction reveals it to have been intended for use as a lamp. It is not clear, however, just how the oil was poured into the lamp, nor can we explain the openwork areas on the animal's head and back that were so necessary in an incense-burner but totally superfluous in a lamp.
A.I.

39
EWER IN THE FORM OF A COCKEREL
11th century
Bronze (brass). *Height 36*
Inv. No. IR-2323
Provenance: collection of A.A. Bobrinsky; 1925 from the Russian Academy for the History of Material Culture.
Literature: St Petersburg 2000, No. 241; Edinburgh 2006, No. 16.

Traditionally this vessel has been described as an incense-burner, although it lacks the necessary openwork lid or open parts that would let out the smoke. It seems more likely, therefore, that the vessel was in fact used to hold water. It once had long legs and supports beneath the wings to give it more stability. Water was probably poured into the opening in the tail.
A.I.

40
PEN-CASE (*QALAMDAN*)
Master Umar ibn al-Fadl ibn Yusuf al-Bayya
20 zi-l-qada 542 AH / 2 April 1148
Bronze (brass), silver, copper. *Length 18.8*
Inv. No. CA-12688
Provenance: 1925 from the Asiatic Museum of the USSR Academy of Sciences.
Literature: St Petersburg 2004, No. 111; Edinburgh 2006, No. 23.

The earliest precisely dated 12th-century bronze object made in Khurasan. In form, the pen-case relates to a relatively rare group of rectangular *qalamdans*. It is richly adorned with silver and copper, evidence that the incrustation of bronze items was already developed by the middle of the 12th century. The object has Arabic inscriptions and Persian poetry.
A.I.

41
BUCKET
Second half of the 12th century
Bronze (brass), copper. *Height 21*
Inv. No. IR-1489
Provenance: 1925 from the Museum of the Former Baron Stieglitz Central School of Technical Drawing.
Literature: Amsterdam 1999, No. 115; St Petersburg 2004, No. 112.

Buckets of this form are often found among 12th-century works from Khurasan (compare, for instance, the celebrated bucket made in Herat in 559 AH / 1163, Amsterdam 1999, cat. no 114). This example is richly adorned with copper incrustation and benevolent inscriptions in Arabic. It may have been produced in a workshop in Herat or perhaps in one of the other centres in Khurasan province.
A.I.

42
EWER
Second half of the 12th century
Bronze (brass), silver. *Height 39*
Inv. No. IR-1436
Provenance: collection of A.A. Bobrinsky; 1925 from the Russian
Academy for the History of Material Culture.
Literature: St Petersburg 2004, No. 113.

A masterpiece of metalwork from Khurasan, dating from the
second half of the 12th century. Its decoration is close to that
on a celebrated bucket in the Hermitage made in Herat in 559
AH / 1163, suggesting that the two objects were produced in a
single workshop.
A.I.

43
BUCKET
Second half of the 12th century
Bronze (brass), copper. *Height with handle 32.5; diameter 20*
Inv. No. CA-13694
Provenance: 1952 purchased.
Literature: St Petersburg 2004, No. 114.

This fully preserved cauldron was found near the town of
Merv in Turkmenia, the historic province of Khurasan. It is
adorned with benevolent inscriptions in Arabic and medal-
lions containing signs of the zodiac. The background to the
inscriptions and the ornament is pounced, a technique rarely
found on objects of this date.
A.I.

44
CANDLESTICK BASE
Late 12th – early 13th century
Bronze (brass), copper. *Height 20*
Inv. No. IR-1458
Provenance: collection of A.A. Bobrinsky; 1925 from the
Russian Academy for the History of Material Culture.
Literature: St Petersburg 2004, No. 115; Edinburgh 2006, No. 19.

Candlesticks are almost never to be found amongst the varied
bronze objects produced in Khurasan in the 12th century.
Thus this bronze base for a candlestick, adorned with relief
birds and lions, with medallions and benevolent inscriptions,
is something of a rarity. In decoration it relates to ewers pro-
duced in Herat during the second half of the 12th century.
The base found its way in later years to the village of Kubachi
in Daghestan, where it was remade for the storage of grains,
nuts etc.
A.I.

45
MORTAR
Late 11th – early 12th century
Bronze (brass), copper. *Height 10*
Inv. No. IR-1464

Provenance: collection of A.A. Bobrinsky; 1925 from the Russian
Academy for the History of Material Culture.
Literature: St Petersburg 2004, No. 117.

Bronze (brass) mortars of different forms, with relief or
engraved ornament, were very widespread right up to the 14th
century. The decoration seen on this example, in the form of
almond-shaped projections, is often found on bronze vessels
of the 10th and 11th centuries and can be linked with similar
decoration on Sasanian ewers. In this case, however, the mor-
tar is also adorned with copper incrustation and curving ten-
drils, elements that appeared on Khurasan metalwork only in
the second half of the 11th century, and it should thus be
placed at this later date.
A.I.

46
CANDLESTICK
Master Ruh ad-din Tahir
Muharram 725 AH / 18 December 1324 – 16 January 1325
Bronze (brass), silver. *Height 47.8*
Inv. No. IR-1980
Provenance: 1966 from Bakchisarai Historical and Archaeo-
logical Museum.
Literature: Amsterdam 1999, No. 7; St Petersburg 2004, No. 118.

The form of this candlestick is typical of 14th-century Iranian
works. On the holder for the candle itself is the master's sig-
nature and a text that probably comes from a *Hadith* (a saying
relating to the life and works of the Prophet Muhammad).
There is also an inscription with the name of the client or
owner, one Muhammad Falaki, about whom it has not proved
possible to find further information. An inscription on the
body contains a blessing for an unnamed sultan.
A.I.

47
TRAY
Late 13th century
Bronze (brass), silver. *Diameter 32*
Inv. No. VC-514
Provenance: 1933 from Leningrad Historical and Linguistic
Institute.
Literature: St Petersburg 2004, No. 119.

Richly adorned with silver incrustation, this tray was created at
time when this technique was reaching its greatest heights. The
benevolent inscription in Arabic is written in rhyming prose.
The tray probably had a pedestal on which it stood, since the
bottom of the tray itself is rounded and thus unstable.
A.I.

48
CUP ON A FOOT
Second half of the 13th century
Bronze (brass), silver. *Diameter 17; height 9.8*
Inv. No. IR-2284

Provenance: 1989 purchase.
Literature: St Petersburg 2004, No. 120.

Such cups were common in Iran in the middle and second half of the 13th century. They were usually adorned – like this example – with benevolent inscriptions in Arabic and with ornament. Here the medallions contain images of musicians. Such a cup may have been used during feasts. Curiously, there is a 17th-century Russian inscription on the foot.
A.I.

49
BASIN
Late 14th century
Bronze (brass), silver. *Diameter 41*
Inv. No. IR-1450
Provenance: collection of A.A. Bobrinsky; 1925 from the Russian Academy for the History of Material Culture.
Literature: St Petersburg 2004, No. 121.

Such vessels, often with rich incrusted decoration, appeared in Iranian metalwork in the 14th century. The scene of a monarch enthroned on this example gives rise to associations with bronze items made in Mosul during the first half of the 13th century, but the headwear, the content of the Arabic inscriptions and the vegetable ornament are characteristic of 14th-century Iranian work, indicating an Iranian origin. A certain coarseness in the execution suggests that the object was made in the late 14th century, when incrustation was falling into decline.
A.I.

50
VESSEL
Late 14th century
Bronze (brass), silver. *Diameter 23.5; height 11.5*
Inv. No. IR-1557
Provenance: 1935 purchase.
Literature: St Petersburg 2004, No. 122.

It is not clear what this vessel was used for, although the fish and crabs depicted on the bottom suggest that it might have been used to hold water. The depiction of the throne scene, benevolent Arabic inscriptions and ornament link the object closely with the bowl above (cat. no 49).
A.I.

CERAMICS

51
BOWL
12th century
Clay, white engobe. *Diameter 18; height 6.6*
Inv. No. IR-1721
Provenance: 1940s gift of Princess Ashraf Pahlevi.
Literature: Edinburgh 2006, No. 21.

One of a group of ceramic works in the style long known as Gabri and later as Garrus, after the place in southern Afghanistan where they were produced in the 11th and 12th centuries.
A.I.

52-73
TILES FROM THE FRIEZE OF THE MAUSOLEUM OF PIR HUSSEIN
684 AH / 1285-86
Earthenware, lustre, cobalt. *35 x 35 each*
Inv. Nos. Az-1–7, Az-9–12, Az-15–22, Az-437–439
Provenance: between 1915 and 1966 purchased from inhabitants of the village of Kubachi, Daghestan.
Literature: V.A. Krachkovskaya, *Izraztsy mavzoleya Pir-Khuseyna* [Tiles from the Mausoleum of Pir Hussein], Tbilisi, 1946; Turku 1995, No. 212.

Probably produced in Kashan, Iran, these tiles once adorned the tomb of the holy Pir Hussein Ravanan, in the north of what is today the Republic of Azerbaijan. Various structures grew up around the burial place in the 1240s but they would seem to have fallen into decline by the 1280s, when some kind of restoration (or 'renewal', as it says in the inscription) was undertaken. One Umar ibn Muhammad ash-Shirzadi al Qazvini was commissioned to produce this frieze and, possibly, some other smaller tiles. The frieze consisted of 30 tiles in all. They demonstrate the very high level of ceramics production in Iran during the second half of the 13th century.
In 1913 all 30 tiles were stolen from the mausoleum by inhabitants of the village of Kubachi and taken to Daghestan. Over the course of some 50 years they were purchased by different museums in the USSR but the first four were acquired in 1915 by the Imperial Hermitage. Today all but six tiles are in the Hermitage: five are in the Museum of the History of Azerbaijan in Baku and one is in the Museum of the History of Georgia in Tbilisi.
A.I.

74-80
SEVEN TILES
Late 13th – early 14th century
Earthenware, gold. *15 x 15 each*
Inv. Nos. IR-1291-1297
Provenance: 1923 from the State Museum Fund.
Literature: Amsterdam 1999, No. 158; Edinburgh 2006, No. 69.

Possibly part of a large panel, these tiles were made in a single workshop in the late 13th or early 14th century, the period when just such gilded leaves were a widespread decorative element.
A.I.

81
TABLE
Early 13th century
Earthenware, lustre. *Height 24*

Inv. No. IR-1425
Provenance: 1947 purchase.
Literature: St Petersburg 2004, No. 159.

The low hexagonal table served as a stand for a tray. Its form clearly echoes an architectural structure such as a pavilion, although the earliest surviving examples of such buildings date from the early 16th century. There are, however, several earthenware tables of this faceted form dating from the first half of the 13th century and a single bronze (brass) table of similar form from the 13th or 14th century.
A.I.

82
PANEL OF TILES
660-661 AH / 1262-63
Earthenware, lustre. *Height 240; width 78*
Inv. No. IR-1026–1062
Provenance: 1925 from the Museum of the Former Baron Stieglitz Central School of Technical Drawing.
Literature: Amsterdam 1999, No. 186; St Petersburg 2000, No. 213.

Once part of the wall decoration of the mausoleum of Imamzadeh Yahia in Veramin, not far from Teheran, these tiles were made in the 1260s, when the art of lustre painting on earthenware was at its height. Inscriptions running round the edge of each frieze contain quotations from the Qu'ran, parts of individual *surs* or whole brief *surs*, although there are a few examples of Persian poetry.
A.I.

83
PLATE
676 AH / 1277-78
Earthenware, lustre, cobalt. *Diameter 22.5; height 5*
Inv. No. IR-1305
Provenance: 1925 from the Museum of the Former Baron Stieglitz Central School of Technical Drawing.
Literature: Edinburgh 2006, No. 62.

Richly adorned with lustre and cobalt painting on both sides, this dish has a benevolent inscription in Arabic ending with the date 676 AH / 1277-78. Partially preserved on the outside is a Persian inscription.
A.I.

84
BOWL
14th century
Earthenware, lustre, cobalt. *Diameter 13.2; height 6.3*
Inv. No. VG-29
Provenance: 1925 from the Museum of the Former Baron Stieglitz Central School of Technical Drawing.
Literature: Edinburgh 2006, No. 63.

One of a group of lustre-painted ceramics produced in Iran around the middle of the 14th century. After that period the production of such items ceased for many years, although the reason is not known.
A.I.

85
BOWL
14th century
Earthenware, lustre, cobalt. *Diameter 13.8; height 6*
Inv. No. VG-27
Provenance: 1925 from the Museum of the Former Baron Stieglitz Central School of Technical Drawing.
Literature: Edinburgh 2006, No. 64.

Perhaps one of the last lustre-painted works to be produced in Iran around the mid-14th century, after which production – for some unknown reason – ceased for many years.
A.I.

86
BOWL
First half of the 14th century
Earthenware, lustre. *Diameter 9; height 5.3*
Inv. No. VG-61
Provenance: 1925 from the Museum of the Former Baron Stieglitz Central School of Technical Drawing.
Literature: Edinburgh 2006, No. 65.

The decoration of this bowl is somewhat unusual, with a broad pointed leaf in the centre and two leaves to each side, combined with broad bands of ornament over the outer surface imitating inscriptions. It was possibly produced during the first half of the 14th century, when a decline began in the production of lustre-painted ceramics.
A.I.

87
CUP
Mid-13th century
Earthenware, enamel. *Height 11.5*
Inv. No. IR-1311
Provenance: 1925 from the Museum of the Former Baron Stieglitz Central School of Technical Drawing.
Literature: Loukonine, Ivanov 1996, No. 135.

Painted with polychrome enamels, the cup has a central scene of some kind of celebration. Around the edges are benevolent inscriptions in Arabic written in Kufic script.
A.I.

88
TILE
Late 13th century
Earthenware, lustre, cobalt. *20.8 x 20.8*
Inv. No. VG-73
Provenance: unknown.
Literature: Edinburgh 2006, No. 66.

The flowers with six petals depicted on the tile were considered in the Near East to be lotus blossoms, but the motif was borrowed from the Chinese repertoire, where they were intended as chrysanthemums. Such motifs started to appear on applied art objects in the Near East from the end of the 13th century, a period when China exerted a strong influence on Iranian art as a result of close contacts between the regions during the Mongol dominance of Iran.
A.I.

89
TILE
Late 13th century
Earthenware, lustre, cobalt. *20.8 x 20.8*
Inv. No. VG-72
Provenance: 1923 from the State Museums Fund.
Literature: Edinburgh 2006, No. 67.

The dragon on this tile is depicted in typical Chinese form. Such motifs started to appear in Iranian art only from the late 13th century, a period marked by the considerable influence of Chinese art.
A.I.

90
TILE
Late 13th – early 14th century
Earthenware, cobalt, lustre. *20 x 20*
Inv. No. IR-1195
Provenance: 1925 from the Museum of the Former Baron Stieglitz Central School of Technical Drawing.
Literature: Edinburgh 2006, No. 70.

This eight-pointed tile with its two gazelles and vegetable ornament in the central field has Persian poetry running around the edge. Only the first of the two lines are legible however: 'May the creator of the world be protector of the owner of this [object], wherever he may be.'
A.I.

91
TILE WITH INSCRIPTION
Late 13th century
Earthenware, lustre, cobalt. *21 x 21*
Inv. No. IR-1275
Provenance: 1936 purchase.
Literature: Amsterdam 1999, No. 155; Edinburgh 2006, No. 71.

With its depiction of a camel and vegetable ornament in the central field, this tile is very close to the previous tile with gazelles (cat. no 90), evidence that they were produced at the same period. This piece, however, has no text inscribed around the edge.
A.I.

92
TILE
Late 13th century
Earthenware, lustre, cobalt. *20.5 x 20.5*
Inv. No. IR-1179
Provenance: 1925 from the Museum of the Former Baron Stieglitz Central School of Technical Drawing.
Literature: Amsterdam 1999, No. 156; Edinburgh 2006, No. 72.

In 13th-century Iran large surfaces were frequently covered with tiles, a combination of eight-pointed stars and four-pointed crosses. No fixed position within surface was intended for the tiles as each was conceived as an individual work of art. This tile, with its vegetable ornament, is closely linked with the two previous tiles (cat. nos 91-92), but it has not proved possible to read the inscription running around the edge.
A.I.

93
FRAGMENT OF A CARPET
Middle of the 14th century
Cotton. *104.5 x 46*
Inv. No. IR-2253
Provenance: 1985 purchase.
Literature: Amsterdam 1999, No. 1; St Petersburg 2000, No. 1.

Part of a large prayer carpet with a repeat composition known as 'saf'. Such carpets were two-sided and it is therefore difficult to decide which is the top or front. The writing of several letters in the inscription suggest that this carpet was made in the first half or middle of the 14th century, making it the oldest surviving example of Iranian carpet-making of the Islamic period.
A.I.

94-101
PAGES FROM A MANUSCRIPT OF NIZAMI'S *KHAMSEH*
Text copied by the calligrapher Mahmud in Herat, for Sultan Shahrukh, *completed 10 Rabi II 835 AH / 16 December 1431*
Gouache, ink, gold, paper. Unbound, 502 ff, 38 miniatures. *23.7 x 13.7*
Nasta'liq script in three columns; two main columns with 23 lines each, the third column narrower with 16 slanting lines; text field *17 x 8.7*
Provenance: 1924 from the Museum of the Former Baron Stieglitz Central School of Technical Drawing.
Inv. No. VP-1000
Literature: Adamova 1996, No. 1; Adamova 2001; St Petersburg 2004, No. 81.

The *Khamseh* of Nizami (1141-1203), one of the great monuments of world literature, consists of five poems, the philosophical and didactic *The Treasury of Mysteries,* the romantic poems *Khusraw and Shirin, Layla and Majnun* and *The Seven Beauties,* and the fantastical life of Alexander the Great (Alexander of Macedonia), known as the *Iskander-nama* or *Book of Alexander.*

94
KHUSRAW SEES SHIRIN BATHING, F. 61R

Khusraw and Shirin relates the love of a Sasanian prince, later Khusraw II Parvez, for the Armenian Princess Shirin. Their story was filled with dramatic events but one of the highpoints is when Khusraw meets Shirin. Miniatures depicting that scene were amongst those most frequently met in manuscripts of Nizami's poem.

Here the artist followed an already established scheme for depicting the subject but enriched it with details, creating a picture that is complex in both colour scheme and its capturing of the emotional tension. Shirin wears only a cloth wound around her waist as she sits in a stream brushing out her hair; nearby, tied to a tree, is a black horse champing at the grass. Shirin's clothes are folded beneath the tree. At the top of the image is Khusraw, half hidden behind a hill. The text on this page sings Shirin's praises, likening her beauty to the moon, to a rose, to an almond.

95
LAYLA IN THE PALM GROVE, F. 181R

Layla and Majnun relates the unhappy story of two star-crossed lovers and, unlike the other poems in the *Khamseh,* it is filled with lyricism, relating in great detail each emotion felt by the heroes. The action takes place in the deserts of Arabia, amidst the Bedouin tribes. The lines illustrated by this miniature describe a marvellous palm grove to which Layla came one spring day, walking apart from her friends. She sat down beneath a cypress tree, 'like a rose in a meadow', and she wept for her love like a nightingale in spring. Later, Layla heard Majnun's *ghazal* (a Persian verse form) and her voice came a halt. In earlier manuscripts of Nizami's poems known today this subject is not illustrated. In this miniature, therefore, the artist followed the text closely, conveying not only the events but even the mood it describes.

96
BAHRAM GUR IN THE YELLOW PALACE, F. 295R

The Seven Beauties (Haft laykar) relates the story of Bahram Gur who married the daughters of the rulers of seven lands. The architect Shideh built seven palaces for the princesses, the colour of each according with the colours of the seven planets. In the 1431 manuscript there are images of all seven palaces visited by Bahram Gur, which symbolise the seven stages passed by the soul on the mystic path to God.

This miniature opens the chapter in which Bahram Gur visits the Byzantine princess on Sunday (day of the Sun). Above the miniature are lines relating how Bahram Gur put on his golden robe and his golden crown and indeed we see him wearing a

crown upon his head, while in other scenes he wears simply a round hat. Below it says: 'When night fell...', words reflected by the sleeping serving maid and the burning candles.

97
BAHRAM GUR IN THE RED PALACE, F. 288V

On Tuesday (day of Mars), Bahram Gur visited the Slav Princess, dressing himself in red and setting off for the tower with its red dome. In the miniature he is wearing violet-coloured robes, but the small hat upon his head is red.

Just as Nizami each time found new words to describe repetitive actions (each morning Bahram Gur put on clothes that accorded with the colour of the dome on the palace to which he was heading, went to the palace, feasted all day with the princess, and when evening fell asked her to tell him a story), so the artist created compositions that are similar in type but varied in the details. The face of Bahram Gur has been repainted.

98
BAHRAM GUR IN THE BLUE PALACE, FF. 293V-294R

On Wednesday (day of Mercury) Bahram Gur set off to visit the princess of Maghrib, putting on turquoise robes. The patterns in the ceiling precisely repeat the insets on the neighbouring leaf and are executed in the same manner, allowing us to suggest that the miniatures and the decorative elements throughout the manuscript were all the work of a single artist.

99
BAHRAM GUR IN THE WHITE PALACE, F. 310V

On Friday (day of Venus) Bahram Gur set off to visit the Iranian princess. Once again the artist reveals incredible inventiveness in working up each interior based on variations of the set colour. The face of Bahram Gur has been repainted.

100
ISKANDER AND THE SIRENS, F. 484R

In the second part of the *Iskander-nama* we read of how Alexander visited different lands. During his stay in China he went to the sea shore, where he saw the sirens and listened to their singing. This miniature retains all the general compositional features and many details of early 15th-century miniature painting, such as the appearance of the sea-maidens with their long black hair, their modest skirts of leaves and their wings on their elbows. Nizami's text describes how their bodies shone like the sun and the moon. In the miniature here the brownish sandy shore and the red tree trunk seem to be illuminated by light radiating from the sirens' skin.

101
PAGE OF ORNAMENT, F. 143V

This ornamental composition is a true masterpiece, the work of an inspired and inventive artist. Stylised motifs are carefully arranged and organised and are combined naturally with large, brightly coloured flowers, painted in a free painterly manner with many tonal nuances.

A.A.

102

FRAGMENTS OF TWO QU'RAN MANUSCRIPTS
IN A SINGLE BINDING

15th century

Ink, gold, paper. Later card binding, 41 ff. *25.8 x 18.7*

Naskh script. Ornament on ff. 1v, 15v

Inv. No. VP-942

Provenance: 1939 purchase.

Literature: Adamova 1996, No. 1.

The pages are adorned with all kinds of decorative elements in colours and gold, picking out the different sections of the text.

A.A.

103

QU'RAN MANUSCRIPT (BEGINNING AND END LOST)

16th century

Ink, paper. 19th-century cardboard binding, 447ff. *14 x 9.5*

Small nask script. Ornament on ff. 216v-217r, with gold painting in the margins

Inv. No. VP-1004

Provenance: unknown.

Literature: Adamova 1996, No. 2.

A.A.

104

MANUSCRIPT OF NIZAMI'S *KHAMSEH*

Text copied by Hassan al-Husayni al-katib al Shirazi. According to the colophon at the end of each poem, it was copied over the course of six months, between Safar and Shaban 948 AH – May to December 1541

Ink, gouache, gold, paper. Manuscript in a 19th-century papier-mâché binding with lacquer painting illustrating the poems. 380 ff. *27.5 x 17*

Nasta'liq script in four columns with 19 lines each; text field *17.5 x 9.6*

Inv. No. VP-999

Provenance: 1945 purchased from V.R. Gardin.

Literature: Adamova 1996, No. 3; St Petersburg 2004, No. 82; Edinburgh 2006, No. 188.

The manuscript contains five poems: *The Treasury of Mysteries*, ff. 1v-32r; *Khusraw and Shirin*, ff. 32v-118r; *Layla and Majnun*, ff.118v-174a; *The Seven Beauties*, ff. 174v-242r; *Sharaf-nama*, ff. 242v-335r; *Iqbal-nama*, ff. 335v-380r.

 Unlike the *Khamseh* of 1431, which is in many ways a unique work, this manuscript – produced more than 100 years later – is one of a kind produced in large numbers. Its seventeen miniatures are executed in a style that is well known and has been closely studied and which is linked with Shiraz, a town with a reputation for the production in the 16th century of numerous manuscripts (mainly with texts from Persian poetry) intended for sale.

The illustration on f. 90r, *Khusraw Goes out Hunting and Heads for Shirin's Palace*, is one of a group of miniatures remarkable for their mainly pale colouring, built up of a rhythmic distribution of warm (yellow and orange) and cold (blue and green) tones.

Restoration – probably undertaken in the 19th century when the manuscript was given a new lacquered binding – has somewhat marred the beauty of these miniatures. Nearly all the faces have been 'corrected', the details of the robes reinforced with black ink.

A.A.

105

MANUSCRIPT OF JAMI'S *SILSILAT AL-ZAHAB*
(*THE GOLDEN CHAIN*)

Text copied Rajab al-murajab 995 AH / June 1587, according to the colophon to the first part on f. 145r

Ink, gouache, gold, paper. Manuscript in a stamped leather binding; 243 ff. *24.5 x 15*

Nasta'liq script in two columns of 14 lines each; text field *14 x 6.7*

Inv. No. VP- 992

Provenance: 1945.

Literature: Adamova 1996, No. 4; St Petersburg 2004, No. 83

The four miniatures in this manuscript are in a simplifed version of the court styles of Qazvin, capital of Iran during the second half of the 16th century, and Mashhad, then also a celebrated centre for the production of manuscripts. Possibly created in Mashhad, it is filled with indications that it was produced for a non-aristocratic circle of clients. Like other manuscripts of this type, it has none of the refined aristocratic elegance of works by court masters in Qazvin and Mashhad, aiming rather for expressiveness and being somewhat coarse in execution and content (two of the four miniatures in this manuscript are utterly frivolous).

Miniatures illustrating *The Golden Chain* were based on parables. In this case there is a pronounced genre feel to the scenes, which aim to represent everyday life. On f. 73r the miniature illustrates an episode from the first part of the poem which deals with a number of questions of Sufi philosophy and that provides a commentary on hadiths and the sayings of the sheykhs. The miniature *Catching a Crane* relates to the tale of a crane which sought to fly through the sky like an eagle and to catch other birds but which fell into the river and was caught by a youth washing clothes. In Persian miniatures there are always lots of details but here they are emphatically ordinary, creating a convincing picture of the surrounding world. Various items of clothing – wide trousers, shirt and sash – have been laid out on the grass to dry, introducing a humorous note to the scene.

A.A.

106

MANUSCRIPT OF JALAL-AD-DIN RUMI'S
MASNAVI-I MA'NAVI

Text copied by Mír Salikh ibn Mír Tahir ibn Mír Hussein al-Husayni, known as nabire-yi arbab, between 1002 AH / 1594 (f. 78) and 24 JumÇdÇ I 1004 AH / 26 January 1596 (f. 480r), for Judge Ikhtar ad-din Mahmud

Ink, gouache, gold, paper. Papier-mâché binding with lacquer painting, second half of the 18th century, 480 ff. *23 x 13.2*

Nasta'liq script, text in two columns of 17 lines each with slanting lines in the margin; text field (within border) *20.2 x 10*

Inv. No. VP-928

Provenance: 1914 Savostin collection; 1924 from the Museum of the Former Baron Stieglitz Central School of Technical Drawing.
Literature: Adamova 1996, No. 5.
Ten miniatures are arranged in pairs on full spreads at the end of each part of the poem. They are not contemporary to the copying of the text and were probably produced in the 18th century, when the manuscript was given a lacquered binding. Nor are they linked with the text and should be seen simply as adorning rather than illustrating the book.
A.A.

107
MANUSCRIPT OF FIRDAWSI'S EPIC POEM *THE SHAHNAMA*
Late 16th – early 17th century
Ink, gouache, gold, paper. Black leather binding with stamped yellow medallions, 737 ff. *33 x 21*
Nasta'liq script, text in four columns of 21 lines each; text field *21 x 11*
Inv. No. VP-929
Provenance: 1912 purchased by A.A. Romaskevich in Teheran; 1937 acquired from Romaskevich.
Literature: Adamova 1996, No. 6; St Petersburg 2004, No. 85

When the text was copied out empty places were left for 50 miniatures, of which 33 were never executed. Eleven miniatures in the manuscript, from the Mughal school of the late 16th and early 17th century, were cut out of a different manuscript and glued into the empty spaces, while a number of sheets have preliminary drawings directly on the paper, among them *The Fire Ordeal of Siyavush* on f. 135v. Unlike the other miniatures this work is by an artist of the Isfahan school of the early 17th century. The story of Siyavush, who was falsely accused by his step-mother Sudabe and had to undergo trial by fire, was one of the most popular subjects for illustration in Firdawsi's poem.
A.A.

108
MANUSCRIPT OF HATIFI'S *LAYLA AND MAJNUN*
Text copied by Mahmud Nishapuri, Herat, 969 AH / 1562
Ink, gouache, gold, paper. Black leather binding with gold stamping and appliqué, 91 ff. *21.6 x 13.8*
Text written on fine white paper stuck to sheets of thick paper of different colours, with gold in the margins. Ornament on f. 1v
Inv. No. VP-995
Provenance: on f. 91v an inscription by Prince Khusraw Mirza and the date 1246 / 1829, with a note in Russian that it was a gift to Prince Sergey Mikhaylovich Golitsyn from Khusraw Mirza on 2 November 1829; Golitsyn's ex libris on the inside of the cover; 1934 transferred from the Hermitage Library.
Literature: St Petersburg 2004, No. 86
A.A.

109
MANUSCRIPT OF THE *JAWAHIR AL-TAFSIR* (*PEARLS OF INTERPRETATION*), A COMMENTARY TO THE QU'RAN BY HUSEIN WA'IZ-I KASHIFI
Text copied by Abd al-Rahim, 986 AH / 1578-79
Ink, gouache, gold, paper. Black leather binding with a flap and gold stamping, 576 ff. *36.1 x 24.5*
Detailed frontispiece on ff. 1v-2r. Ornament on ff. 149v, 365v, 527v
Page edges painted with gold
Inv. No. VP-938
Provenance: Lobanov-Rostovsky collection – label with the name and a round mark with a monogram and crown on the cover; 1936 transferred from the Hermitage Library.
Literature: St Petersburg 2004, No. 87; Edinburgh 2006, No. 119.
A.A.

110
MANUSCRIPT OF HAFIZ'S *DIVAN*
17th century
Manuscript with gaps and no end
Ink, gouache, gold, paper. Leather binding with stamped medallions, 185 ff. *20.5 x 12.5*
Double-page frontispiece of two miniatures depicting a feast in a landscape (very poorly preserved) on ff. 2v-3r
Inv. No. VP-934
Provenance: possibly Basilewski collection – stamped oval seal with the name Basilewski in Arabic on ff. 1v and 4r; 1940 purchased from P.V. Likhachev.
Literature: St Petersburg 2004, No. 89.
A.A.

111
BINDING
Early 15th century
Leather, gold stamping. *26 x 16*
Inv. VP-84
Provenance: 1924 from the Museum of the Former Baron Stieglitz Central School of Technical Drawing.
Literature: Loukonine, Ivanov 1996, No. 15; St Petersburg 2004, No. 91; Edinburgh 2006, No. 77.

During the reign of the Timurids the art of the manuscript book became one of the most important of all art forms. All components, all elements in the making of the book, including the binding, were brought to the highest standard. This superb early 15th-century binding is made of brown leather, with gold ornament stamped on the cover and flap and the central medallion and corners made of cut leather against a blue ground. The central composition has a broad frame with geometrical ornament. This binding reflects the artistic norms and ideals dominating the art of the book in the Timurid era, incorporating patterns and motifs (particularly the lotus blossoms and leaves) often found in ornamental compositions on the pages of Timurid manuscripts and reflecting a general interest in the arts of China. On the spine

are two lines from Sa'di's poetry compendium, *Bustan:*
May the creator of the World be your guardian
May the world comply with your wishes and Heaven be your friend
A.A.

112
BINDING
16th century
Leather, gold stamping. *28.2 x 18*
Inv. No. VP-88
Provenance: 1924 from the Museum of the Former Baron
Stieglitz Central School of Technical Drawing.
Literature: St Petersburg 2004, No. 92.

In the 16th century the decoration of book bindings became
increasingly elegant, with craftsmen employing new devices,
new decorative and figurative motifs. This binding makes use
of the typical decorative scheme for leather bindings, but the
medallion, corners and broad frame are of cut leather, with
tiny vegetable ornament against a blue, green and orange
ground, the gilded field between them covered with two-lay-
ered stamped ornament, in which the lower layer of flower
pattern serves as the ground for typical 16th-century 'Chinese'
cloud-scrolls.
A.A.

113
BINDING
16th century
Leather, gold stamping. *31.4 x 19.8*
Inv. No. VP-89
Provenance: 1924 from the Museum of the Former Baron Stieg-
litz Central School of Technical Drawing.
Literature: St Petersburg 2004, No. 92.

Binding of red Morocco leather with gold stamped medal-
lions, corners and border, filled with tiny flower patterns.
A.A.

114
WARRIOR
First half of the 16th century; with later 16th-17th-century ornament
Gouache, paper. *Miniature 12.5 x 3.3; sheet 20.5 x 13.5*
Inv. No. VP-1149
Provenance: 1959 acquired from T.D. Gardina.
Literature: St Petersburg 2004, No. 95.

In composition this sheet, the miniature and example of cal-
ligraphy surrounded with ornamental frames, recalls sheets in
albums of the 16th and 17th centuries, but a close look reveals
it to be composed of fragments cut from worn manuscripts,
probably dating from the 16th century, and mounted no ear-
lier than the 19th century. The ornament in the border is also
made up fragments and the miniature with a standing warrior
placing 'the finger of surprise' to his mouth and a saddled
horse half hidden behind a hill clearly come from late 16th- or
early 17th-century book illustration.

The poetic text to left, written in slanting lines, recalls a *ghazal*
(a Persian verse form) and is perfectly relevant to the image:
it sings the praises of a beautiful girl, at the sight of whom the
author 'put the finger of surprise to his mouth'.
A.A.

115
PRISONER
16th century
Gouache, gold, paper. *Miniature 14.5 x 11; sheet 36.5 x 24.2*
Inv. No. VP740 / III
Provenance: unknown.
Literature: Adamova 1996, No. 9.

One of numerous versions of a subject extremely popular in
the 16th century. More than a dozen miniatures and drawings
have been published that depict a richly attired noble warrior
in full armour (usually with a bow attached to his belt, along
with a quiver, sword and mace, a dagger stuffed inside the belt
and a whip in his hand), one hand resting on his knee and the
other captured in wooden stocks at the back of the neck. By
the early 20th century the subject was being interpreted as a
portrait of Turkmen ruler Murad Ak-Koyunlu (1502-8). On
the frame beneath the figure the Hermitage miniature has the
words 'padishakh-i turkman' (Turkmen ruler) and in the
margin below a Russian inscription, 'Sovereign of the
Mungalshy' (Sovereign of the Monghols), dating from no
later than the 18th century. This provides evidence that the
interpretation of the subject existed as early as the 18th cen-
tury. Murad Ak-Koyunlu was put to rout in 1503 by Ismail I,
founder of the Safavid dynasty and the great importance
attached to the victory over the Safavids' main rival in an age
of power struggle was clearly the reason behind the subject's
popularity in Safavid painting.
A.A.

116
MAJNUN IN THE DESERT
Late 16th century
Ink, white gouache, watercolour, paper. *Miniature 11.7 x 6.7*
Inv. No. VP-704
Provenance: 1886 collection of P.V. Charkovsky; 1924 from
the Museum of the Former Baron Stieglitz Central School of
Technical Drawing.
Literature: Adamova 1996, No. 10; St Petersburg 2004, No. 96.

Depictions of Majnun in the desert were among the favourite
subjects of artists illustrating Nizami's poem *Layla and Majnun*.
In manuscripts, these images show many beasts in pairs,
emphasising Majnun's loneliness. Here, however, we see a sin-
gle gazelle approaching Majnun, a hare, a fox and a leopard
twisted in angry pose on the rocks above. Unusual for depic-
tions of this subject are the gnarled tree stumps putting forth
new shoots between which Majnun sits. Moreover, it is not
usual for such images to be drawn essentially in black and
white (the ink drawing has been only lightly tinted). There

are extremely few instances of traditional literary subjects being illustrated on separate sheets like this. M. Swietochowski and S. Babaie, who published two drawings on the same subject in the Metropolitan Museum, both – like the Hermitage drawing – dating from the late 16th century, made the interesting suggestion that drawings of Majnun in this period should not in fact be seen as illustrations to Nizami's poem. They recall the tales of Sufis who were able to communicate with wild beasts thanks to their purity of spirit. Majnun is thus not the hero of a poem here, but an allegory for the Sufic understanding of the pure soul (M.L. Swietochowski, S. Babaie, *Persian Drawings in the Metropolitan Museum of Art,* New York, 1989, Nos. 10, 11

A.A.

117
GIRL IN A FUR HAT
Riza-i Abbasi
1011 AH / 1602-3
Ink, watercolour, gold, paper. Miniature *14.8 x 8.4; sheet 19.3 x 16*
Inv. No. VP- 705
Provenance: collection of Alexander Polovtsov; 1924 from the Museum of the Former Baron Stieglitz Central School of Technical Drawing.
Literature: Adamova 1996, No. 14; Edinburgh 2006, No. 121.

Drawn in ink with light tinting, this is the earliest dated work by Riza-i Abbasi – it bears the inscription 'painted by the humble Riza-i Abbasi. 1011' – a celebrated artist of the Isfahan school. It is one of the best female images in his oeuvre and in Persian art overall. There is a whole series of works depicting a girl on one knee (sometimes the subject is described as a youth despite the long hair falling around the shoulders) which would seem to be the visual embodiment of some poetic image, since in poetry the subject of the author's praise is not always described in other than general terms.

A.A.

118
FEAST IN THE COUNTRY (DOUBLE PAGE)
Riza-i Abbasi
1020 AH / 1612
Gouache, gold, paper. *26 x 16.7 and 26.2 x 16.5*
Inv. Nos. VP-740/I, VP-740/XVIII
Provenance: unknown.
Literature: Adamova 1996, No. 15; Edinburgh 2006, No. 122.

Spread over two sheets, the image shows a royal youth and his suite feasting in the lap of nature. It is rightly considered to be one of Riza-i Abbasi's most magnificent works. The two miniatures possibly once formed the frontispiece to a now lost manuscript or album. Both halves of the diptych are signed at the bottom in the painted margin. At the very bottom of the right half on the card support is a Russian inscription providing a translation of the Persian signature; to judge by the handwriting it was added no later than the 18th cen-

tury. Yet on the back of both sheets is the stamp of a Persian seal with the date 1171 AH / 1757-58. The sheets would thus seem to have come to Russia in the second half of the 18th century.

This diptych differs from other works by Riza-i Abbasi in its unusually bright and varied range of colours, built up of combinations of yellowish-brown and bluish-violet tones. The resonance and variety of the colour combinations are the main means by which the artist creates a sense of festivity, while the precise rhythm of the areas of colour unites the figures and all elements in the composition.

A.A.

119
RECLINING YOUTH
First third of the 17th century
Gouache, gold, paper. *Miniature 9.8 x 18.8; sheet 20 x 30.8*
Inv. No. VP-706
Provenance: collection of Alexander Polovtsov; 1924 from the Museum of the Former Baron Stieglitz Central School of Technical Drawing.
Literature: Adamova 1996, No. 17.

Despite the utterly feminine appearance of the figure reclining on cushions in an extremely relaxed pose, the robe and the dagger stuck into the belt reveal it to be a youth. This unsigned miniature is built up of contrasts: the plasticity of the youth's figure contrasts with the flatness of the ground, and the colours would also seem, in theory, to be incompatible – the bright orange of his robe, the pale yellow sash with its gold ends, the narrow lilac scarf and darker purple trousers. A lack of modelling in light and shade of either figure or face allows us to date the miniature to the first third of the 17th century.

A.A.

120
DERVISH HOLDING A ROSARY
Muhammad Yusuf
Mid-17th century
Ink, watercolour, paper. *Miniature 13.3 x 7.8; sheet 36.5 x 25*
Inv. No. VP-740/XV
Provenance: unknown.
Literature: Adamova 1996, No. 22.

On the dervish's left knee is the note 'drawn by Muhammad Yusuf' (with a Russian translation nearby on the card support), suggesting that it was the work of a well-known 17th-century artist of that name, an attribution confirmed by the high horizon, the massy treatment of the pink and blue-tinted rocks, the tree with its thick gnarled trunk, the use of black and red ink and the nature of the lines.

Depictions of Sufis and dervishes were among the favourite subjects of the Isfahan school; they were produced by nearly all artists. Muhammad Yusuf's drawing is in keeping with the established traditions for such images.

A.A.

121

European Landscape

Ali-Quli ibn Muhammad

1059 AH / 1649

Gouache, paper. *Miniature 9 x 12*

Inv. No. VP-950

Provenance: unknown.

Literature: L.T. Gyuzalyan, *Vostochnaya miniatyura izobrazhayush-chaya zapadnyy peyzazh. Srednyaya Aziya i Iran* [Oriental Miniatures Showing European Landscapes. Central Asia and Iran], Leningrad, 1972, pp. 163-69; Edinburgh 2006, no. 123

Leon Gyuzalyan established that Ali-Quli's miniature (the artist's signature is on the rock in the foreground) was copied from a European print published by the Sadeler family (cat. no 122), taken from a painting by celebrated 17th-century Flemish landscape and animal painter Roelandt Savery. The provincial landscape with its little houses, mill and bridge over a river has many little figures not present in the original print: for instance, hurrying across the bridge is a villager with a sack over his back, with a donkey and two dogs. Of particular interest is the addition of a cross on the roof of a house to right and the boar in the lower right corner, apparently intended to make the landscape more 'European'.

A.A.

122

Bohemian Landscape

Engraving by Marc Sadeler (1614-after 1650) after the painting by Roelandt Savery (1576-1639). *15 x 21.5*

Published by Aegidius Sadeler

Inv. No. OG-144131

Provenance: before the 1820s.

Literature: Edinburgh 2006, No. 124.

A typical example of the kind of Mannerist landscape developed by the international group of artists working for Holy Roman Emperor Rudolf II at his court in Prague. Amongst those artists were members of the Sadeler family of painter and engravers, and one of the founders of modern European landscape painting, Roelandt Savery. Coming from the flat northern Netherlands, Savery (like many of his contemporaries) was much taken with painting mountainous landscapes, such as those he had seen and sketched during travels in the Tyrol and Bohemia.

R.G.

123

Monkey Riding a Bear

Muhammad Ali

Mid-17th century

Gouache, paper. *Miniature 16.5 x 8.9*

Inv. No. VP-948

Provenance: unknown.

Literature: St Petersburg 2004, No. 99; Edinburgh 2006, No. 125.

This drawing is unusual among 17th-century Persian works in its subject, technique and use of colour. The leaves of the trees and the grass growing on the bank of the stream in the foreground are painted in different shades of green, while fine gradations of brown are used for the monkey, bear, treetrunks, sky and river. In essence, this is a two-tone grisaille, a technique that would seem to have been borrowed from European works, like the manner of drawing using dots and short strokes.

Muhammad Ali, whose signature appears bottom left, was a well-known Isfahan painter of the middle of the 17th century. Although this and other similar subjects (a monkey riding a goat or a lion) were particularly popular in the 17th century, the true meaning of such images is not clear.

A.A.

124

Woman in Indian Dress

Sheykh Abbasi

1094 AH / 1682-83

Gouache, paper. *Miniature 14.9 x 8.2; sheet 37.5 x 25.2*

Inv. No. VP- 740 / XV

Provenance: unknown.

Literature: St Petersburg 2004, No. 100.

When they entered the Hermitage this miniature was thought to be of Indian origin, but the publication of works by Sheykh Abbasi, which usually bear a signature with the formula 'He achieved fame when he became Sheykh Abbasi' (it appears on the Hermitage miniature to left of the figure in the cartouche) led scholars to revise this view. Sheykh Abbasi was an artist working in Isfahan in the court workshop of Shah Abbas II (1642-66), the honorary title Abbasi indicating that his achievements had been recognised in the same way Riza-i Abbasi had been allowed to use the title when he served under Abbas I.

During the second half of the 17th century a new trend developed in the Isfahan school of painting, combining features of Persian, European and Indian (Mughal and Deccan schools) art. It makes its earliest appearance in miniatures by Sheykh Abbasi dated 1652 and later. The transition to the new style, with its official and formal depictions of the sitter, its precise line and strong modelling in light and shade, would seem to have prompted Persian painters to take up painting in oils, better suited to such effects.

This is one of the artist's last known works, evidence that he was still working in the early 1680s.

A.A.

125

Specimen of Calligraphy

Zein al-Abidin al-muzahhib al-Tabrizi

Mashhad, 1016 AH / 1607-08

Gouache, gold, paper. *Miniature 15.8 x 8; sheet 36.8 x 24.3*

Inv. No. VP-661

Provenance: collection of Alexander Polovtsov; 1924 from the

Museum of the Former Baron Stieglitz Central School of Technical Drawing.
Literature: St Petersburg 2004, No. 105.

Calligraphy was particularly highly prized in the Muslim East. Examples were collected together in special albums (*Muraqqa*), often mixed in with miniatures and drawings. Such albums formed what amounts to private picture galleries.

Four lines of Persian poetry are written diagonally across the page in a good example of the nasta'liq script, much beloved of calligraphers in the 15th and 16th centuries. The space between the lines is adorned with stylised leaves painted in gold. To either side of the poem and below is horizontal text in lilac ink with the date and place where the work was executed. The name of Zein al-Abidin al-muzahhib al-Tabrizi appears in the cartouche bottom left. The calligraphy is set in ornamental borders and attached to a sheet with broad margins filled with gold vegetable ornament against a yellow ground.
A.A.

126
SPECIMEN OF CALLIGRAPHY
1149 AH / 1736-37
Gouache, paper. *Miniature 15.5 x 7.5; sheet 36.8 x 24.3*
Inv. No. VP-662
Provenance: collection of Alexander Polovtsov; 1924 from the Museum of the Former Baron Stieglitz Central School of Technical Drawing.
Literature: St Petersburg 2004, No. 106.

The two-line poem is written in white on coloured paper covered with fine flower ornament. The margins of the album page are adorned with the same gold patterns against a yellow ground as cat. no. 125 suggesting that both sheets derive from the same album.
A.A.

127
PEN-CASE (*QALAMDAN*)
Zaman
1120 AH / 1708
Lacquer painting, papier-mâché. *24.5 x 4.3 x 3.5*
Inv. No. VP-6
Provenance: 1924 from the Museum of the Former Baron Stieglitz Central School of Technical Drawing.
Literature: Adamova 1996, No. 42; St Petersburg 2004, No. 219; Edinburgh 2006, No. 129.

A note above the woman's head by the edge reads 'Ya sahib az-zaman 1120' (Oh Ruler of the Times. 1120), an epithet of the 12th Shi'ite Imam Muhammad al-Mahdi, indicating that the qalamdan was painted by the artist Zaman in 1120 AH / 1708. Zaman was clearly of the Europeanising trend in Isfahan painting. The young woman with a gazelle by her feet – a motif particularly popular in Persian painting of the 17th

to 19th centuries – is set against a landscape painted in the European manner. Using devices common in European painting the artist conveys the texture of her dress, the sheen of her pearl necklace and the volume of both face and figure. In oval medallions on the sides are bust-length portraits of women in low-cut dresses and between them are landscape views with towers, cottages, bridges and little figures of riders, all clearly copied from European paintings.
A.A.

128
PEN-CASE (*QALAMDAN*)
Mid-18th century
Lacquer painting, papier-mâché. *23.7 x 4.3 x 3.4*
Inv. No. VP-124
Provenance: 1924 from the Museum of the Former Baron Stieglitz Central School of Technical Drawing.
Literature: Adamova 1996, No. 47; Edinburgh 2006, No. 130.

Scenes from the Gospels were extremely popular on Persian lacquerware of the 17th to 19th centuries: we frequently find images of the Virgin and Child, the Holy Family with saints and angels or the Adoration of the Magi.

It is an Adoration that appears on the lid of this qalamdan. At the centre are the Virgin and the Christ Child wearing haloes (a feature unusual on lacquerware). Mary, Christ, kneeling youth and the shepherd with a herd of pigs, the woman and the angel were all clearly copied from European works of art. The figures are set in the foreground against a European rocky landscape with buildings.
A.A.

129
CASKET
1190 AH / 1776-77
Lacquer painting, papier-mâché. *47.3 x 33 x 21*
Inv. No. VP-141
Provenance: 1927 from the State Museums Fund.
Literature: Adamova 1996, No. 49; St Petersburg 2004, No. 221; Edinburgh 2006, No. 132.

Two independent scenes appear on the lid of this casket, both scenes of teaching or preaching and probably intended to symbolise the co-existence of the Christian and Muslim worlds. To left a Christian priest stands before three kneeling figures, while to right there is an old man in a white turban with a youth in Indian attire. To emphasise the Christian nature of the scene to left the artist has included numerous details typical (at least in the minds of Muslims) of 'Christian' images: a herd of pigs, a candle, angels and European-style buildings. By contrast, to right we see a building with tall columns, a flock of sheep and very Oriental shepherd, intended to stress the Muslim nature of the scene.

Separating the two scenes is a river with a winding shore, the bridge across it recognisable as the Allahverdi Khan Bridge connecting Isfahan with New Julfa. From 1605 the suburb of

New Julfa was home to Christian Armenians resettled by Shah Abbas I and to nearly all the Christian missions that visited Iran from the start of the 17th century. The miniature would thus seem to show Isfahan and New Julfa, embodiments of the peaceful coexistence of the Muslim and Christian worlds.

This image captures the ideas and mood of the second half of the 18th century: after the taking and destruction of Isfahan by the Afghans in 1722, Catholic and other missions left Persia, and the privileges of Christian merchants and missionaries were only restored under Karim Khan Zand (1752-79), who sought to echo the policies of the Safavids.

The youth's Indian attire in the scene to right reflects a strong interest in Indian (Mughal) painting among Persian painters during this period.

A.A.

130
Dish with Curved Edge on a Broad Low Ring-shaped Stand
Second half of the 15th century
Earthenware, cobalt. *Diameter 44.4*
Inv. No. VG-2285
Provenance: 1938 purchased from Hadji Hussein, village of Kubachi.
Literature: St Petersburg 2004, No. 164; Edinburgh 2006, No. 81.

The decoration is divided into three parts, stressing the three elements of the dish's structure. Inside the bottom is a branch with two large birds facing each other. A pattern of alternating flowers and leaves runs around the walls, while a flowering leafy stem broken by scrolls trails around the rim. The whole scheme and the individual motifs are characteristic of works known as 'Kubachi', dating from the second half of the 15th and early 16th centuries. The subject is often found on works in this group and derives from early 15th-century Ming porcelain. All the images are painted in cobalt blue of several shades, in the somewhat careless manner, with rather fuzzy contours, typical of 'Kubachi' ware.

A.A.

131
Dish on a Tall Narrow Foot with Curved Edge
15th century
Earthenware, cobalt. *Diameter 34.4*
Inv. No. VG-743
Provenance: 1925 purchased from Rasul Magomedov, village of Kubachi.
Literature: St Petersburg 2004, No. 165.

As on cat. no 130, the central image – a cockerel amidst flowers – is presented as a framed picture in the bottom of the dish. The unbroken wavy stem with large flowers running around the wall and the spiral scrolls and leaves around the edge imitate the ornament seen on Chinese wares.

A.A.

132
Deep Dish on a Broad Low Stand
15th century
Earthenware, cobalt. *Diameter 47.2*
Inv. No. VG-2687
Provenance: purchased by R.S. Khanukaev in the village of Kubachi; 1982 purchased from Khanukaev.
Literature: St Petersburg 2004, No. 166.

The bottom of this large, heavy dish is occupied by a large flower (possibly a peony) surrounded by smaller flower motifs. On the wall is a band of large lotus blossoms and stems with small leaves. Running around the outside walls is a stem with multi-petalled flowers.

Close in style and its use of motifs to 15th-century Chinese porcelain, the dish is of extremely high quality. The cobalt painting over white engobe is covered with an extremely fine layer of transparent glaze, in the surface of which are numerous cracks.

A.A.

133
Deep Dish on a Ring-shaped Stand
Early 16th century
Earthenware, cobalt. *Diameter 31.5*
Inv. No. VG-749
Provenance: 1926 purchased from Said Magomedov, village of Kubachi.
Literature: St Petersburg 2004, No. 168.

This relatively small dish is adorned with several shades of cobalt freely applied, the contours marked in darker tones. All the ornament is subordinate to concentric compositional system with at the centre inside the bottom a geometrical multi-pointed star containing a flower, framed by trefoils. Running around the walls is a winding stem with flowers of the kind typical of this group of ceramics. On the outside walls is a band of highly curved leaves.

A.A.

134
Dish with Lacy Edge on a Ring-shaped Stand
Early 16th century
Earthenware, cobalt. *Diameter 37.1*
Inv. No. VG-730
Provenance: 1926 purchased from A. Aliev, village of Kubachi.
Literature: St Petersburg 2004, No. 169.

Several shades of cobalt blue are used in the painting, the images contoured with a darker tone. Inside the bottom are two fish, a motif found on a number of 16th-century objects. A dish in Berlin, dated 1563-64, features it inside one of twelve medallions with the signs of the zodiac (see A. Lane, *Later Islamic Pottery*, London, 1957, pl. 55A) and an astrological interpretation of the two fish would explain why they are set amidst 'Chinese' cloud-scrolls and not waves. Flowering

bushes like those on the walls and the hatched fields and scrolls that appear on the curving rim are to be found on other early 16th-century ceramics of this type. Also typical of works in this group is the garland of flowers on the outer walls.

A.A.

135
Dish with Fluted Walls on a Ring-shaped Stand
16th century
Earthenware, cobalt painting. *Diameter 35.5*
Inv. No. VG-2098
Provenance: 1933 transferred from the USSR foreign trade association Antikvariat.
Literature: St Petersburg 2004, No. 170.

Inside the bottom is a lotus blossom shown in profile with stems and leaves emerging from it. Unusually, the contours of the flower and the leaves are reserved against a painted cobalt ground. The rim is decorated with a garland of little four-petalled flowers. Running around the outside walls is a flowering stem typical of 'Kubachi' earthenware.

A.A.

136
Dish on a Ring-shaped Stand
17th century
Earthenware, cobalt. *Diameter 35*
Inv. No. VG-2213
Provenance: 1937 purchased from Rasul Magomedov, Kubachi.
Literature: St Petersburg 2004, No. 171.

The production of 'Kubachi' earthenware continued into the 17th and even the early 18th centuries. These objects were painted in one of three ways: with cobalt, in black beneath a turquoise glaze, and with polychrome painting. Cobalt-painted earthenware of this period has large, succulent patches of intense blue cobalt on some elements of the design, while the somewhat roughly executed images have dark contours created by engraving the lines and allowing the blue ink to pool inside the incision. On this dish the central image imitating Chinese wares (showing a rocky landscape and two birds) and the radial lobed ornament around the walls and rim are characteristic of 17th-century objects.

A.A.

137
Dish on a Ring-shaped Stand
17th – first third of the 18th century
Earthenware, black painting under a turquoise glaze.
Diameter 32
Inv. No. VG-329
Provenance: 1925 purchased from Said Magomedov, village of Kubachi.
Literature: St Petersburg 2004, No. 172.

This dish has the design drawn in black beneath a transparent turquoise glaze. It represents a continuation of a type that had existed in the 15th century, but the image is arranged over the surface in a manner characteristic of the 17th century, with a flowering bush at the centre and a single ornament running around the walls and rim consisting of a network of rhombuses containing smaller rhombuses. The whole of the outside is covered with a turquoise glaze.

A.A.

138
Dish on a Ring-shaped Stand
17th century
Earthenware, polychrome painting. *Diameter 33*
Inv. No. VG-548
Provenance: 1924 purchased from Said Magomedov, village of Kubachi.
Literature: St Petersburg 2004, No. 173.

One of a large group of 'Kubachi' earthenware items with polychrome painting beneath a transparent colourless glaze. The ornament and images were applied to the white engobe using broad relief strokes of cobalt, green and brown paint, red and yellow engobe, in a painterly manner specific to the group. In order to give the drawing greater precision (since the paints are metal oxides, they tend to blend somewhat with the glazes) the images are given a black contour to 'deaden' the edge. In their colour range the objects recall Turkish earthenware but the flower and landscape motifs adorning them, the depiction of people and animals and many ornamentatal motifs reflect the dominant artistic style in Iranian art of the late 16th and early 17th centuries. It is this which leads us to date this piece, like most such polychrome ceramics of such type, and attribute it to the capital, Isfahan.

The free painterly execution, with broad, somewhat careless strokes, the bright colour scheme, light confident contour and unusual depiction of landscapes with curving fantastically topped trees and large flowers, in which realistic features can only rarely be identified, give this group of Iranian polychrome ceramics their inimitable character.

A.A.

139
Dish on a Ring-shaped Stand
Late 16th century
Earthenware, cobalt. Diameter 40.5
Inv. No. VG-2093
Provenance: 1886 collection of P.V. Charkovsky; 1925 from the Museum of the Former Baron Stieglitz Central School of Technical Drawing.
Literature: St Petersburg 2004, No. 176.

The dish is totally covered with engraved scaly ornament, over which the image – two complicated cartouches filled with birds, running deer and Chinese 'cloud-scrolls' – is painted in bright blue cobalt. Cobalt covers the outside walls

and a mark composed of four symbols appears in two concentric circles on the bottom.

This clearly identifiable type of earthenware, the white crock painted in a pure blue cobalt imitating Chinese porcelain, is thought by specialists to have been produced in Kerman, a town named by many Europeans as one of the main 17th-century centers of production of Persian ceramics. The best works, in both a technical and artistic sense (among them this dish in the Hermitage), are usually dated to the 16th century.
A.A.

140
BOTTLE WITH FLATTENED BODY AND A HIGH NECK
Late 16th – first half of the 17th century
Earthenware, cobalt. Height 36.3
Inv. No. VG-290
Provenance: transferred from the Museums Fund, date unknown.
Literature: St Petersburg 2004, No. 179; Edinburgh 2006, No. 156.

Made of white earthenware, this bottle is decorated with relief images and painted with bright blue cobalt under a transparent colourless glaze. The cobalt serves as the ground for reserved images, a technique rarely found on blue and white ceramics. Some elements in relief are given a black contour for greater precision and certain details are also drawn in black.

Unlike the majority of cobalt objects, which mainly have Chinese motifs, here the subjects are purely Iranian. On one of the bottle's broad sides is a 'hunting' scene, a young hunter with a powder-horn and game-bag attached to his belt kneeling to shoot his rifle at a running beast, while a large bird, frightened by the shot, flies up to right. On the other side a young woman holding a cup kneels below a tree with birds seated on its branches, approached by a hunter carrying a dead gazelle over his shoulders, clasping its hooves over his chest with both hands. He has an animal's horns attached to his belt.

At least fifteen or so bottles showing the same scenes, with only minor differences, are known. They were produced in Mashhad, one of the largest Iranian centres for the production of cobalt ceramics in the 16th and 17th centuries.
A.A.

141
SELAFTAN (SPITTOON)
17th – early 18th century
Earthenware, overglaze lustre painting. *Height 13; diameter 6.8*
Inv. No. VG-62
Provenance: 1886 collection of P.V. Charkovsky; 1925 from the Museum of the Former Baron Stieglitz Central School of Technical Drawing.
Literature: St Petersburg 2004, No. 180.

During the Safavid era Iranian masters revived the art of lustre painting that had been so highly developed in Iran during the 12th and 13th centuries. This was the only kind of Safavid ceramics to remain untouched by Chinese influences, although lustre ware of this period (mainly relatively small dishes, vases and bottles with tall narrow necks) does not repeat traditional Iranian motifs. Rather it reflects the tastes of the Safavid age, relating in style and design to textiles and other Iranian artistic crafts. Usually the objects show vegetable motifs, sometimes animals and birds, painted – unlike the images on old lustre ware – not using the reserve technique but as silhouettes, in the manner more usual on Safavid cobalt ware. Safavid lustre wares are generally dated to the second half of the 17th or early 18th century, on the basis of the painting style and a surviving piece that bears the date 1084 AH / 1673-74.

The walls of this vessel have scattered stylised bunches of poppies, irises and other flowers, with a band of arabesque on the shoulders. Running around the widening neck is a band of vertical strokes. All the patterns are skilfully arranged on the different surfaces to emphasise the vessel's form.
A.A.

142
PLATE
Late 17th – early 18th century
Earthenware, overglaze lustre painting. *Diameter 20.5*
Inv. No. VG-53
Provenance: 1886 collection of P.V. Charkovsky; 1925 from the Museum of the Former Baron Stieglitz Central School of Technical Drawing.
Literature: St Petersburg 2004, No. 182.

Decorated with a stream, cypress tree and flowering bushes, with a chain pattern around the edge. On the outside walls is a band of interlinked ovals with flowers.
A.A.

143
FLASK WITH BROAD FLAT SIDES
First half of the 17th century
Earthenware. *Height 17.8*
Inv. No. VG-335
Provenance: 1886 collection of P.V. Charkovsky; 1925 from the Museum of the Former Baron Stieglitz Central School of Technical Drawing.
Literature: St Petersburg 2004, No. 183.

Relief images cover the flask, which has a green glaze. On one side is a landscape with a deer reclining beneath a tree, on the other a symmetrical arabesque pattern.

This flask is one of a small group of surviving Safavid earthenware items notable for their unusual technique (made using a mould and covered with deep relief), their colour and decoration. On their broad walls these flattened flasks, beakers and bottles bear all kinds of different images, combining Iranian, European and Chinese subjects, loosely linked with miniatures of the Isfahan school of painting. Most specialists consider that such earthenware was produced in Isfahan.
A.A.

144

FLASK WITH FLATTENED BODY

Late 17th century

Earthenware, cobalt. *Height 28*

Inv. No. VG-2614

Provenance: 1957 purchased from A.I. Shuster.

Literature: St Petersburg 2004, No. 184.

A wonderfully original and skilfully made object, with unusual decoration consisting not only of cobalt painting but also modelled and stamped ornament in the form of small rhomboid shapes. Reserved images on the two broader sides in different shades of cobalt show festooned circles with 1) two birds amidst clouds, 2) a dragon with a small goat.
It has not proved so far to identify the centre of production for objects of this kind, made from hard white earthenware of a kind that recalls porcelain, painted in different shades of cobalt from pale blue to almost black, and adorned with designs mainly derived from the Chinese repertoire.
The edge of the neck has been removed.
A.A.

145

NARGHILE (HOOKAH) WITH A PEAR-SHAPED BODY AND HIGH NECK

17th century

Earthenware, polychrome painting. *Height 27.2; diameter 3.6*

Inv. No. VG-291

Provenance: 1886 collection of P.V. Charkovsky; 1925 from the Museum of the Former Baron Stieglitz Central School of Technical Drawing.

Literature: St Petersburg 2004, No. 186.

By the rim is a horizontal broad curving lip to support a metal vessel holding tobacco while an opening in the side with a spout in the form of a flower was where the smoking pipe emerged. The vessel is painted with white and yellow engobe against a blue ground, using a symmetrical composition and ornament of the kind so beloved in Iranian ceramics. The motifs too are characteristically Iranian: festooned medallions filled with arabesques, bushes with long narrow leaves, flowers and pinks. It has been suggested that such earthenware items with polychrome painting against a white or coloured ground were produced in Kerman.
A.A.

146

TRAY

Late 14th century

Copper. *Diameter 70*

Inv. No. IR-2170

Provenance: collection of A.A. Bobrinsky; 1925 from the Russian Academy for the History of Material Culture.

Literature: Amsterdam 1999, No. 129; St Petersburg 2004, No. 123.

Copper came to be used to make household items in the Near East from the 14th century. This tray is a rare example of such an early piece. Many elements in its decoration have direct analogies in those found on bronze objects but the presence of living beings allows us to date it to the 14th century, since such subjects disappear from metalwork in the 15th century.
A.I.

147

BOWL

811 AH / 1408-9

Copper. *Diameter 23.9; height 12*

Inv. No. IR-2173

Provenance: 1890 from the Imperial Archaeological Commission.

Literature: Amsterdam 1999, No. 130; St Petersburg 2004, No. 124.

With its engraved ornament and inscriptions set against a ground worked with a broad network of lines, this bowl reflects a new tendency in the decoration of metalwork that appeared in Iranian art around the middle of the 14th century. This bowl is unusual in bearing the precise date of its making and excerpts from three *ghazals* (a Persian verse form) by Hafiz.
A.I.

148

SMALL EWER

Late 15th century

Bronze (brass), silver. *Height 12.1*

Inv. No. IR-2045

Provenance: 1925 from the Museum of the Former Baron Stieglitz Central School of Technical Drawing.

Literature: St Petersburg 2004, No. 125.

Small ewers of this form were very widespread in the 15th century. The form probably arrived in eastern Iran from Syria when Tamerlane resettled masters from Damascus in Central Asia.
One such ewer bears the titles and name of Hussein Bayqara, ruler of Khurasan in the late 15th and early 16th centuries, and it is thus thought that they were produced in that region.
A.I.

149

CANDLESTICK BASE

880 AH / 1475-76

Bronze (brass). *Height 10*

Inv. No. IR-2005

Provenance: 1896 from the Imperial Archaeological Commission.

Literature: St Petersburg 2004, No. 126.

The form of this candlestick was typical of such objects in the 15th and early 16th centuries. Around the middle part it bears engraved lines by the poet Salihi, who lived in Khurasan in the second half of the 15th century, and the date 880 AH / 1475-76, allowing us to suggest that it was made in Khurasan.
A.I.

150
CANDLESTICK BASE
Late 15th – early 16th century
Copper. *Height 11.5*
Inv. No. IR-2182
Provenance: collection of A.A. Bobrinsky; 1925 from the Russian Academy for the History of Material Culture.
Literature: St Petersburg 2004, No. 127; Edinburgh 2006, No. 79.

In form the object is typical of items made in the second half of the 15th century. The decoration and writing of the inscription allow us to attribute it to the workshop of Shir Ali ibn Muhammad Dimashqi, active in Khurasan during the late 15th and early 16th centuries.
In the middle of the body are benevolent Persian lines of poetry.
For some time the candlestick was in the village of Kubachi in Daghestan, where it was used to store dry goods.
A.I.

151
CAULDRON
Mid-16th century
Copper, tin. *Diameter 30; height 15.5*
Inv. No. IR-2146
Provenance: 1980 purchased from Semyon Khanukaev, St Petersburg.
Previously unpublished.

The rounded body of this tin-plated copper cauldron passes smoothly into the flat bottom. On its thickened rim is the incised name of the owner, one Ali attar. The cauldron probably once had a lid. Three bands of decoration run around the body, the first containing an Arabic inscription with blessings on Shi'ite imams, the other two with different elements of vegetable ornament. Around the name of the owner the ground is worked with a network of lines while that around the inscription and ornament has large hatching and it is this combination of differing methods of working up the ground that allows us to date the cauldron to the mid-16th century.
A.I.

152
MAGIC CUP
Mid-16th century
Bronze (brass). *Diameter 22.7; height 7.5*
Inv. No. IR-2193
Provenance: Provenance: 1933 from Leningrad Historical and Linguistic Institute.
Previously unpublished.

Set upon a low ring-shaped foot, the walls of the cup flare smoothly out towards the top; the rim is turned outwards and slightly thicker, while there is a round projection inside the floor of the cup. This is a form known from the middle of the 16th century for 'magic cups' used in folk healing.
Both the inner and outer surfaces are covered with Arabic inscriptions, individual surs from the Qu'ran or excerpts from surs considered to have magical significance. We should particularly note the Arabic poem in praise of Imam Ali incised in large script around the projection on the bottom, of a kind that appear on objects from the 1510s, and the inscription with blessings on Shi'ite imams in a large script near the edge of the outer surface. The latter inscription was very popular after the Safavid dynasty came to power in the early 16th century, when the Shi'ite denomination became the state religion in Iran.
A.I.

153
TORCH LAMP
Last quarter of the 16th century
Bronze (brass). *Diameter of base 19.5; height 43*
Inv. No. IR-2009
Provenance: 1925 from the Museum of the Former Baron Stieglitz Central School of Technical Drawing.
Literature: St Petersburg 2004, No. 130.

Lamps with a hollow base and removable 'torch' appeared around the middle of the 16th century. In this case the 'torch' bears lines of poetry from the *Bustan* of Sa'di, the upper part of the base bears lines by an anonymous poet, and the lower part has the words of Hayreti Tuni. The decoration and working of the ground allow us to date the lamp to the end of the 16th century.
A.I.

154
EWER
Early 17th century
Bronze (brass). *Height 49.3*
Inv. No. IR-2311
Provenance: 1925 from the Museum of the Former Baron Stieglitz Central School of Technical Drawing.
Literature: St Petersburg 2004, No. 131.

The form of this ewer is very characteristic of early 17th-century bottles (handle-less ewers) and it was probably originally made as a bottle, since the foot of the handle is attached over ornament and the spout was clearly added later. The ornament has analogies on objects made at the end of the 16th century but the working up of the ground is very different, with hatching instead of a fine network of lines of the kind found in the late 16th century. This allows us to date the ewer to the early 17th century.
A.I.

155
VESSEL
First half of the 17th century
Copper. *Height 11.5; diameter 22.1*
Inv. No. VC-434
Provenance: 1933 purchase.
Literature: St Petersburg 2004, No. 133.

Such metal vessels were very widespread in 17th-century Iran but their purpose remains unclear today. The working up of the ground, the script used in writing the text and the vegetable ornament allow us to date this example to the middle of the 17th century.

Around the neck are two engraved poetic texts, one benevolent and the other mentioning the ritual passing round the tomb of the Imam Riza in Mashhad. It is possible that the vessel was made in Mashhad.

A.I.

156
CUP FOR DECANTING
Mid-17th century
Copper. *Height 9*
Inv. No. IR-2302
Provenance: 1896 from the Imperial Archaeological Commission.
Literature: St Petersburg 2004, No. 134.

To judge by some Persian miniatures, vessels of this form were used to decant all kinds of liquids. The earliest surviving examples date from the end of the 15th century. This piece is adorned with benevolent Persian lines of poetry and images of animals. The curling stem in the ground allows us to date it to the middle of the 17th century.

A.I.

157
BOWL
1113 AH / 1701-2
Copper. *Height 15.5; diameter 31.5*
Inv. No. IR-2158
Provenance: 1980 purchased from Semyon Khanukaev, St Petersburg.
Literature: St Petersburg 2004, No. 135.

Both in form and decoration this cup is a typical example of 17th-century Iranian metalwork, although it was in fact made at the very start of the 18th century. The inscription with blessings on Shi'ite imams is one of two Arabic inscriptions frequently featured on Iranian objects during the rule of the Safavid dynasty (1502-1736).

A.I.

158
DOOR PLAQUES
17th century
Steel. *Maximum dimensions 35.3 x 24.5 and 34.5 x 26.8*
Inv. No. VC-1080
Provenance: 1925 from the Museum of the Former Baron Stieglitz Central School of Technical Drawing.
Literature: St Petersburg 2004, No. 136; Edinburgh 2006, No. 149.

Amongst the various steel items made in Iran during the 17th century we often find shaped placques used as door decorations. These festooned, openwork placques bear two *ayat*

(poems), the 23rd *ayah* from the 13th *sura* of the Qu'ran and the 63rd from the 10th sura. On the small plaques are sayings relating to Allah.

A.I.

159
TRAY
Second half of the 15th century
Copper. *Diameter 23.8; height 4*
Inv. No. IR-2006
Provenance: 1957 purchased from the heirs of S.M. Dudin.
Previously unpublished.

The tray's flat bottom stands on a low ring-shaped foot, the side walls widening towards the top. Only the inner surface of the tray is decorated, its ornament consisting of a large central rosette with large vegetable ornament surrounded by broad bands containing round medallions and four elongated cartouches with Persian inscriptions that cannot be fully deciphered.

A.I.

160
JEWELLERY BOX
1480s
Copper. *Height 4.5; diameter 8.5*
Inv. No. IR-2004
Provenance: 1931 from the State Academy for the History of Material Culture.
Literature: A. Ivanov, 'Tri predmeta so stikhami Dzhami' [Three Objects with Poems by Jami], *Epigrafika Vostoka* [Epigraphy of the East], Leningrad, 1971, pp. 97-103.

This box has an almost spherical body standing on a low ring-shaped foot. On the low vertical edge is a small lid. Engraved in the second broad band around the body are two lines from a *ghazal* (a Persian verse form) by the great Persian poet Jami (1414-92). They contain the word *huqqa*, a box for precious items, suggesting that vessels of this form (which continued in use until the start of the 18th century) were intended as such. It is worthy of note that the box was made during Jami's own lifetime.

A.I.

161
BOWL
1560s-1580s
Copper. *Diameter 21; height 13.5*
Inv. No. IR-2200
Provenance: 1925 from the Museum of the Former Baron Stieglitz Central School of Technical Drawing.
Previously unpublished.

With almost vertical walls and rim curving slightly outwards, this bowl stands on a low ring-shaped foot. Only the outside wall is decorated, divided into three bands: the first and third are filled with vegetable ornament while the second contains

seven cartouches containing the name of the owner, Hadji Suleiman ibn Hussein, and three lines from a celebrated *ghazal* (a Persian verse form) by the great Persian poet Hafiz (d. 1390). The background to the ornament and inscriptions is worked with a fine network of lines, allowing us to date the bowl to the 1560s-1580s. The lower part of the body and foot, where the ground is worked with vertical lines, were later additions to the object.
A.I.

162
EWER
First half of the 17th century
Bronze (brass). *Height 33.3*
Inv. No. IR-2312
Provenance: 1936 purchase.
Previously unpublished.

The rounded body stands on a high stem and passes smoothly into the upper part with a long slender neck and rounded projection in the middle. The rim curves outwards.
In form the object recalls bottles of the 16th and 17th centuries, which have no spout. The presence of a spout in this instance makes it clear that it was used as a ewer.
The body is adorned with three bands of vegetable ornament linked by different palmettes and medallions.
A.I.

163
FRAGMENT OF AN ITEM OF CLOTHING
First half of the 16th century
Silk. *83.5 x 22.5*
Inv. No. VT-1201
Provenance: 1925 from the Museum of the Former Baron Stieglitz Central School of Technical Drawing.
Literature: St Petersburg 2004, No. 203.

A repeat pattern of a prince being brought a pomegranate-shaped bowl by a servant is woven in the *sarji* technique, using coloured silks over yellow satin. The prince wears a turban with a tall body (*tadj-i haidari*), a form typical of the early Safavid period. Precious textiles such as this were probably worn only at court and not outside in more ordinary situations. They help create a picture of the refined luxury of the Safavid court.
A.A.

164
FRAGMENT OF VELVET
16th century
Velvet. *46 x 72*
Inv. No. VT-1911
Provenance: 1930, formerly in the Shchukin collection.
Literature: London 2004, No. 53.

The scene of a young prince and a girl talking and helping each other to wine, set in a flowering garden, frequently appears on single-sheet miniatures. Both the overall style of the image and the attire worn by the couple suggest a date at the end of the 16th century.
A.A.

165
FRAGMENT OF BROCADE
Early 17th century
Silk, gold thread. *99 x 24*
Inv. No. Ví-1203
Provenance: 1925 from the Museum of the Former Baron Stieglitz Central School of Technical Drawing.
Literature: St Petersburg 2004, No. 204.

Rich textiles of the Safavid era included brocades with designs in gold and silver threads. Whilst many textiles bore variations on vegetable ornament, there are also those with figurative scenes. Here the background is woven with golden thread and the image worked in coloured silks (linen weave) to show a flowering tree and a deer drinking from a stream rushing down from the rocks, with poppies growing on its banks.
A.A.

166
FRAGMENT OF BROCADE
17th century
Silk, gold thread. *47 x 19*
Inv. No. Ví-1008
Provenance: 1930.
Literature: St Petersburg 2004, No. 205.

Woven in coloured silks over the golden ground are parrots seated on branches of flowering trees. So large are the parrots that the deer and hares to either side seem disproportionally small. The butterfly fluttering above and the bird flying in the air are also overly large. Clearly the artist who created this design was interested above all in decorative effect.
A.A.

167
FRAGMENT OF BROCADE
17th century
Silk, silver thread. *16 x 15.4*
Inv. No. Ví-34
Provenance: unknown.
Literature: St Petersburg 2004, No. 206.

Reproduced on this fragment is the traditional Persian poetic image of 'the rose and the nightingale', frequently found in miniatures and on lacquerware. Using the *sarji* weave, coloured silks are used over a silver ground to depict a rose or dog-rose bush with flowers and buds, set on a hill, with two tulips. The bird seated on the tree puts its beak to one of the roses.
A.A.

168

FRAGMENT OF BROCADE

Mid-18th century

Silk, gold thread. *44.5 x 13.5*

Inv. No. Ví-1007

Provenance: 1925 from the Museum of the Former Baron Stieg-litz Central School of Technical Drawing.

Literature: St Petersburg 2004, No. 207.

Depicted on this fragment is a dramatic moment from a lion hunt: two lions are attacking a saddled horse whose rider has clambered to safety in a tree and seeks to let fly an arrow at the wild beasts. The image is worked in coloured silks over a ground woven with gold threads.

A.A.

169

SILK SASH

18th century

Silk, metal threads. *379 x 59.5*

Inv. No. Ví-1107

Provenance: 1925 from the Museum of the Former Baron Stieg-litz Central School of Technical Drawing.

Literature: St Petersburg 2004, No. 208; Edinburgh 2006, No. 184.

Fine silk covered with tiny woven geometrical vegetable ornament, the motifs repeated in horizontal rows and along the diagonal, seeming to melt into an unbroken rhythmic pattern. At each end of the sash are four repeats of the buta ornamental motif (the betel leaf), an almond-shaped element thickly filled with flower ornament, recalling veritable bouquets of flowers. The design is worked in a complex technique employing many coloured silks, the ground woven with metal threads.

Such sashes were used to tie robes in the 17th and 18th centuries. They came into fashion in Europe in the 17th century, particularly in Poland, where sashes were produced after Persian models in the town of Slutsk.

A.A.

170

SILK EMBROIDERY ON PAPER FABRIC

18th century

Silk, paper. *21.3 x 17*

Inv. No. Ví-111

Provenance: 1925 from the Museum of the Former Baron Stieg-litz Central School of Technical Drawing.

Literature: St Petersburg 2004, No. 209.

Stain-stitch embroidery in coloured silks over a dark blue fabric. Each of the festooned medallions embroidered in red contains a flowering tree with a bird seated in its branches and a rider in a yellow hat on a green horse.

A.A.

171

PERFUME VESSEL

18th – 19th century

Glass. *Height 26.5*

Inv. No. VG- 2621

Provenance: 1961 transferred from the Department of Russian Culture of the Hermitage Museum.

Literature: St Petersburg 2004, No. 197.

One of the most common late-medieval Persian glass forms, this vessel has a rounded body on a low ring-shaped foot and a straight, very high and narrow neck (such necks frequently thicken and flare towards the end). The elegant silhouette emphasises the lightness and fragility of the object. Applied goffered bands adorn the upper part of the vessel near the neck.

Glass vessels of this form, with applied coloured glass braids, have been found in the pre-Mongol capital of Iran. In the 17th and 18th centuries silver incense-burners of similar form were also produced.

A.A.

172

PERFUME VESSEL

18th – 19th century

Glass. *Height 28.7*

Inv. No. VG-2278

Provenance: 1886 collection of P.V. Charkovsky; 1925 from the Museum of the Former Baron Stieglitz Central School of Technical Drawing.

Literature: St Petersburg 2004, No. 198 (picture under No. 199).

Version of the form described under cat. no 171 with a more pear-shaped body, the high narrow neck thickening before it flares. The surface of the body is ribbed.

A.A.

173

SMALL EWER OF TRANSPARENT BLUE GLASS

18th – 19th century

Glass. *Height 19.2*

Inv. No. VG- 2255

Provenance: 1886 collection of P.V. Charkovsky; 1925 from the Museum of the Former Baron Stieglitz Central School of Technical Drawing.

Literature: St Petersburg 2004, No. 199 (picture under No. 202).

Such ewers, with a high neck flaring towards the top, a small curving handle and long curved spout decorated with characteristic flattened lobes, would seem to have been popular from as early as the 18th century. Just such a small ewer, probably of glass, appears in a miniature by Riza-i Abbasi (Sheila R. Canby, *The Rebellious Reformer: The Drawings and Paintings of Riza-yi Abbasi of Isfahan,* London, 1966, p. 157. Particular beauty derives from the colour, darker in some areas, which preserve traces of runs in the hot glass, pale and transparent against

the light, give the objects particular richness of hue. The Hermitage has several such glass vessels, differing in the details of their decoration, proportions and colour.

A.A.

174
SMALL EWER OF TRANSPARENT GREEN GLASS
18th – 19th century
Glass. *Height 18.3*
Inv. No. VG-2234
Provenance: 1937 from the State Museums Fund.
Literature: St Petersburg 2004, No. 200.

Similar in form to cat. 173, this ewer has a ribbed body and is adorned with an applied goffered band around the neck. The end of the spout is shaped like the prow of a boat.

A.A.

175
SMALL EWER OF TRANSPARENT RED GLASS
18th – 19th century
Glass. *Height 19.3*
Inv. No. VG- 2254
Provenance: 1937 from the State Museums Fund.
Literature: St Petersburg 2004, No. 201.

Another version of the type described under cat. no 173, this time of dark red glass.

A.A.

176
PERFUME VESSEL OF TRANSPARENT BLUE GLASS
18th – 19th century
Glass. *Height 37*
Inv. No. VG- 2265
Provenance: unknown.
Literature: St Petersburg 2004, No. 202 (picture under No. 198).

It is difficult to say when this vessel form developed, with its round body on a low round stem and a very long curving (frequently twisting) neck ending in a flaring end flattened at the sides and with a sharp projection on top. Certainly it was extremely popular in the 18th and 19th centuries, when it became increasingly complicated.

A.A.

177
PORTRAIT OF PRINCE ABBAS MIRZA ON
AN ALABASTER MIRROR FRAME
Carved by Muhammad al-Hasani al-Qazvini, calligrapher
Abul-Qasim Shirazi
1235 AH / 1819-20
Alabaster, sheet gold. *43.8 x 28.3*
Inv. No. VP-1057
Provenance: 1927.
Literature: St Petersburg 2004, No. 212.

On the back of the frame is a portrait of Abbas Mirza, Crown Prince of Iran, carved in alabaster. His identity is established by the inscription above his head. Son of Fath Ali Shah, Abbas Mirza was ruler of Azerbaijan, the richest and most important province of Iran, with its centre in Tabriz, and he led the Persian troops during two Russo-Persian wars in the first third of the 19th century. Abbas Mirza died in 1833, a year before his father.

The portrait is executed very much within the canons of the official Qajar portrait: Abbas Mirza stands in theatrical pose wearing ceremonial attire, his face turned in three-quarter view and absolutely without expression. Above his head is patterned drapery while the Lion and the Sun that form the arms of Iran are carved in the corners. Nonetheless, the half-length nature of the image is not characteristic of Qajar painting of the first quarter of the 19th century and indicates the sitter's desire to more closely imitate the norms of European portraiture.

On the front of the frame are Persian and Arabic inscriptions in gold blessing the Prophet Muhammad and his heirs (in the upper part), with the names of the craftsmen and the date (in the lower part).

A.A.

178
LOVERS
Early 19th century
Oil on canvas. *131.5 x 77*
Inv. No. VP-1156
Provenance: 1961 purchase from A.I. Shuster.
Literature: Adamova 1996, No. 63.

This painting can be dated to the start of the 19th century on the basis of the frozen poses, somewhat rigid figures, general flatness of the image and rather hard painting style, as well as the treatment of the faces (the form of the eyes and the manner in which they are depicted, the dark contour around the nose and lips, the band of white above the upper lip). The figure to right is the kind of effeminate youth frequently seen in Qajar painting while the figure to left, judging by the attire and headwear, is female.

Lovers provides us with some idea of early Qajar style in which, despite the borrowing of certain elements from western European art, the old tradition remains very strong. That traditional elements is felt here in the dominant role played by ornament. In depicting the attire the artist is clearly more concerned with the different patterns on the fabrics than, for instance, texture. The patterns are continuous, unbroken by folds or other surface texture, and they are painted absolutely frontally.

A.A.

179
PORTRAIT OF ABBAS MIRZA
c. 1820
Gouache, gold, paper. *Miniature 23.8 x 14.5; sheet 31 x 20.5*
Inv. No. VP-666

Provenance: 1886 collection of P.V. Charkovsky; 1924 from the Museum of the Former Baron Stieglitz Central School of Technical Drawing.
Literature: Adamova 1996, No. 78; London 2004, No. 98; Edinburgh 2006, No. 138.

Crown Prince Abbas Mirza has all the usual signs of a member of the ruling dynasty – the pearl sash, precious strap hanging from the waist, sabre and dagger – and he holds a sceptre in his hand. Moreover, he is seated in a European throne against a landscape background. His face is devoid of emotion, clearly in accord with perceptions of how important figures should appear. The combination of white robe adorned with precious stones and the deep red back of the chair, painted with vegetable ornament in gold, indicates the artist's developed sense of colour.
A.A.

180
PORTRAIT OF A MAN
(PROBABLY PRINCE MUHAMMAD MIRZA)
Sayyid Mirza
c. 1830
Gouache, paper. *Miniature 21.8 x 15.7; sheet 34.2 x 23*
Inv. No. VP- 691
Provenance: 1933 from Leningrad Historical and Linguistic Institute.
Literature: Adamova 1996, No. 80.

This miniature, by one of the most famous painters of the first half of the 19th century, very probably shows Muhammad Mirza, son of Abbas Mirza and thus grandson and heir of Fath Ali Shah. He replaced his grandfather after the latter's death in 1834, when he was 26 years old, ruling as Muhammad Shah. If this is indeed Muhammad Mirza then the portrait should be dated to before 1834, since he wears none of the regalia to be found in portraits of him as ruler, painted between 1839 and 1845. Such a dating would accord with the sitter's age. He wears a European shirt and jacket of European cut, but on his head is a Qajar lambskin hat of the kind worn in Iran until the middle of the 1830s.
A.A.

181
HALF-LENGTH PORTRAIT OF A MAN
WITH A BLACK BEARD (MUHAMMAD MIRZA)
1830s
Oil on canvas. *92 x 76*
Inv. No. VP-1099
Provenance: 1932 from Gatchina Palace Museum.
Literature: St Petersburg 2004, No. 214.

On the basis of similarities to known portraits of Muhammad Shah, grandson of Fath Ali Shah, we can be relatively certain that this work depicts the Qajar ruler who reigned 1834-48. He is depicted against drapery with repeated images of the Lion and Sun of Iran. Muhammad Shah wears a robe possibly

made of Chinese fabric, covered with a very unusual design in the form of trees with bushy branches (rather like feathers) and pagodas. On his head is a lambskin hat with a large adornment of precious stones but it lacks the crane feathers symbolising royal rank, suggesting that the portrait was produced not long before he came to the throne, i.e. about 1833-34, when he became heir to the throne and ruler of Tabriz in the wake of his father's death.

The artist had clearly studied European painting and was possibly one of the court painters working for Abbas Mirza. A new trend in art, strongly influenced by European academic painting, seems to have developed in Tabriz under the patronage of Abbas Mirza and it was to be taken up in painting in the Persian capital when Muhammad Shah came to power in 1834.
A.A.

182
PORTRAIT OF MUHAMMAD SHAH
1840s
Gouache, gold, paper. *27 x 19.3*
Inv. No. VP-664
Provenance: 1886 collection of P.V. Charkovsky; 1925 from the Museum of the Former Baron Stieglitz Central School of Technical Drawing.
Literature: St Petersburg 2004, No. 215.

Although the cartouche to right lacks an inscription there can be no doubt that the image shows Muhammad Shah. The portrait repeats the main features of a miniature portrait of Muhammad Shah in the British Museum by Muhammad Khasan Afshar dated 1263 AH / 1846-47. In the British Museum miniature, however, Muhammad Shah wears military costume, while the Hermitage image shows him in a mixture of European and Persian attire; the miniature in London has a carefully painted landscape, while that in the Hermitage has vague washes of colour, suggesting that the miniature was not finished.
A.A.

183
PORTRAIT OF NASIR AL-DIN SHAH
Muhammad Isfahani
1850s
Gouache, gold, paper. *Miniature 32.5 x 20.6; sheet 41.3 x 25*
Inv. No. VP-665
Provenance: 1886 collection of P.V. Charkovsky; 1925 from the Museum of the Former Baron Stieglitz Central School of Technical Drawing.
Literature: St Petersburg 2004, No. 216.

Inscriptions in the cartouches top left and below in the margin indicate that this is 'An image of His Incomparable Majesty Most Holy King of Kings of all the Protected States of Iran Sultan Nasir al-Din Shah'. To left of the figure on the divan is the artist's signature: 'Work of servant to the court Muhammad al-Isfahani'.

Nasir al-Din Shah came to the throne at the age of 17 and was to rule for nearly half a century (1848-96). Unlike other rulers, who never left Persia, in the 1870s and 1880s he made three trips to Europe and Russia. Each journey was followed by all kinds of innovation in Persia and painting did not remain unaffected by the changes. In the Hermitage portrait, as in most other portraits of Nasir al-Din Shah, he is shown not enthroned but on a European sofa. He wears a dark half-kaftan lined with fur, trousers of European cut and a lambskin hat tipped upwards and set higher on the head than was usual under Muhammad Shah, adorned with a precious aigrette.

There are several versions of this portrait, differing only in a few details and it seems likely that there was a large portrait in oils approved by the Shah himself and recommended for copying, the copies probably being presented as gifts.
A.A.

184
CASKET
First third of the 19th century
Papier-mâché, lacquer painting. *27 x 6.3 x 4.5*
Inv. No. VP-50
Provenance: 1886 collection of P.V. Charkovsky; 1925 from the Museum of the Former Baron Stieglitz Central School of Technical Drawing.
Literature: Adamova 1996, No. 69.

On the lid is a depiction of Fath Ali Shah enthroned, surrounded by his sons and courtiers, one of the most common subjects of paintings in oil. Indeed, this miniature version reflects all the typical features of monumental Qajar painting, with its frozen, somewhat abstracted figures and overall dominant sense of majesty.

Many examples of lacquerware from the first half of the 19th century repeat the subjects, images, compositions and painterly devices of court art. It is thus clear that they played the role played in Europe by prints, reproducing offical court works of art and proclaiming the ruler's majesty and power.
A.A.

185
CASKET
Second half of the 19th century
Wood, lacquer painting. *32 x 20.5 x 14.5*
Inv. No. VP-139
Provenance: Fabergé collection; 1925 from the Sector of Modern Applied Art.
Literature: Adamova 1996, No. 97; St Petersburg 2004, No. 224; Edinburgh 2006, No. 141.

On the lid and walls are circles and medallions with flowers, birds and butterflies against red, gold and green grounds. One wall is black with gold bands and three bushes painted in gold. This is one of a large group of lacquered works in the Hermitage collection adorned with similar ornamental compositions, flowers, birds and butterflies, dating mainly from the 1870s to the early 20th century. These decorative lac-

quered works, most of them small caskets and pen-cases, are unusually carefully executed, with extremely fine painting that recalls jewellery, which perhaps explains why they were once owned by St Petersburg's celebrated jeweller Fabergé.
A.A.

186
CASKET
Workshop of Mirza Muhammad-Taqi muzahhib
Teheran, 1299 AH / 1881-82
Wood, lacquer painting. *33.3 x 9.5 x 7*
Inv. No. VP-146
Provenance: Fabergé collection; 1925 from the Sector of Modern Applied Art.
Literature: Adamova 1996, No. 99; St Petersburg 2004, No. 226.

Festooned cartouches on the lid and walls are filled with very small flower and geometrical ornament against a gold, black and green ground. Amidst the gold on the lid is an inscription on a red ground: 'Sultan Nasir ad-din Shah Qajar, 1299' [1881-82]. In the frame around the edge are cartouches with text in gold on black indicating that the casket was made during the reign of Nasir al-din, 'in the capital of the khalifate Teheran'. Poetry on the walls praise the casket's beauty.
A.A.

187
CASKET
Abu-l Qasim al-Husseini al-Isfahani. *1319 AH / 1901-2*
Wood, lacquer painting. *35.5 x 15.3 x 11.5*
Inv. No. VP-145
Provenance: Fabergé collection; 1925 from the Sector of Modern Applied Art.
Literature: Adamomva 1996, No. 110; St Petersburg 2004, No. 229.

Medallions on the lid and walls are filled and surrounded with polychrome images of flowers and birds against a red and black ground. The artist's signature and the date are painted in white on the lid in two red cartouches above and below a round medallion. In the border around the edge of the lid and on the side facets is an inscription, a single poetic text the length of a tetrameter hazaj that sings the praises of spring, a beautiful garden, the scent of the flowers and a beautiful girl 'from whose locks of hair come the scent of Tatar musk'.

The Hermitage has other works by Abu-l Qasim (e.g. Adamova 1996, No. 109). His paintings are characterised by large flowers and leaves gathered in bouquets or picturesque groups, the larger flowers at the centre of the composition and smaller flowers arranged around the edge. They also employ emphatic effects of light and shade and bright colour combinations.
A.A.

188
Ewer
Late 19th century
Brass, gold, silver. *Height 19.5*
Inv. No. VC-796
Provenance: collection of N.I. Veselovsky; 1927 from the Russian Academy for the History of Material Culture.
Literature: St Petersburg 2004, No. 140.

The form of this small ewer has analogies in ewers made in India but the depiction of rulers and servants in medallions imitates the reliefs of Persepolis. Objects with 'Achaemenid subjects' came to be widely produced in Iran at the end of the 19th century and into the 20th.
The ewer is incrusted with gold and silver.
A.I.

189
Spice Caddy
1261 AH / 1845
Copper. *Height 21.3*
Inv. No. VC-331
Provenance: 1930 from the Asiatic Museum of the USSR Academy of Sciences.
Literature: St Petersburg 2004, No. 143.

In the 19th century caddies or holders for spices, usually cylinders that could be stacked one inside the other, became relatively widespread. Sometimes they had the name of the spices painted on them.
This vessel consists of five cups and lids adorned with benevolent inscriptions, poems in praise of the Imam Ali and an excerpt from Sa'di's *Gulistan*. The lid bears the date 1261 AH / 1845 while the mark on the bottom is probably that of the maker.
A.I.

190
Tray
Master Abd al-mutallib Isfahani
Late 19th century
Bronze (brass). *57.5 x 38.5*
Inv. No. IR-2165
Provenance: 1981 purchase.
Literature: Loukonine, Ivanov 1996, No. 282.

The rectangular tray is adorned with images of Shahs of the Sasanid dynasty in the central field and a depiction of Khalif Umar al-Khattab, who began the Arab conquest of Iran in the late 630s. The inspiration for creation of such a 'portrait gallery' was probably some European publication of Sasanian coins with images of Shahs and even of two female rulers, Purandokht and Azarmedukht. The name is inscribed beside each figure. By the edge in cartouches are excerpts from three *ghazals* (a Persian verse form) by Hafiz, although in such a context it would be more logical to expect poems from the *Shahnama*

or *Book of Kings*, describing the feats of the Sasanian rulers. One of the cartouches includes also the master's signature.
A.I.

191
Ewer
Master Hadji Abbas
Early 20th century
Steel, gold. *Height 39.2*
Inv. No. VC-853
Provenance: 1925 from the collection of I.P. Bachmanov, Leningrad.
Literature: St Petersburg 2004, No. 144.

The Hermitage has a large collection (87 items in all) of steel objects of varied form and purpose that derive mainly from the collection of I.P. Bachmanov (of whom, sadly, we know almost nothing). Among them are ten signed works by Hadji Abbas, whose career commenced in the late 19th century and who died in Isfahan in 1380 AH / 1960-61.
Elegant in form, this ewer recalls late Iranian glass vessels. It is adorned with Persian inscriptions and ornaments in gold inlay and it may have served purely decorative purposes since steel cannot be used to store water or wine.
A.I.

192
Figure of a Dove
Master Hadji Abbas
Early 20th century
Steel, gold. *Height 19.8*
Inv. No. VC-813
Provenance: 1925 from the collection of I.P. Bachmanov, Leningrad.
Literature: St Petersburg 2004, No. 145.

Works by Hadji Abbas in the Hermitage include little figures of birds and animals clearly intended for decorative purposes, of which this is an excellent example.
A.I.

193
Plum
Master Hadji Abbas
Early 20th century
Steel, gold. *Length 37.5*
Inv. No. VC-636
Provenance: 1925 from the collection of I.P. Bachmanov, Leningrad.
Literature: St Petersburg 2004, No. 146.

Bachmanov's collection included several pieces reproducing the fruits of various trees, notable among which is this large plum with a leaf and large cartouches containing vegetable ornament.
A.I.

194
DERVISH'S CUP OR BEGGING BOWL (KASHKUL)
Master Hadji Abbas (?)
Late 19th – early 20th century
Steel, gold. *Length 27*
Inv. No. VC-804
Provenance: 1925 from the collection of I.P. Bachmanov, Leningrad. Literature: Amsterdam 1999, No. 72; St Petersburg 2004, No. 147.

The kashkul bears a date, 1207 AH / 1792-93, which for many years led to confusion among specialists, particularly since a similar piece (formerly in the collection of Sadruddin Aga Khan in Geneva) bears the name of Hadji Abbas and the date 1015 AH / 1606-7. Both begging bowls are adorned with identical flower ornament without analogy in 17th- to late 18th-century Iranian works but with parallels on Iranian objects of the late 19th century. When it was at last established that Abbas worked in the late 19th century and first half of the 20th century it became clear that the dates on the begging bowls are false. The ornamentation allows us to date both begging bowls to the late 19th or early 20th century and they were probably the work of the same master, Hadji Abbas, although there is no absolute proof for such an attribution.
A.I.

195
FIGURE OF A CAMEL
Early 20th century
Steel, gold, silver. *Height 27*
Inv. No. VC-1000
Provenance: 1937 purchase.
Literature: St Petersburg 2004, No. 148.

These little steel figures served no utilitarian purpose but were used to decorate interiors. This particular figure probably did not come from the workshop of Hadji Abbas since it is adorned not only with gold but also with silver.
A.I.

196
PEN-CASE (QALAMDAN)
Early 20th century
Steel, gold. *Length 22*
Inv. No. VC-867
Provenance: 1925 Fabergé collection.
Literature: St Petersburg 2004, No. 150.

Steel pen-cases are extremely rare, although papier-mâché pen-cases of this form, with a sliding inner section, were well known in Iranian art from the end of the 17th century. This piece is adorned with gold inlaid hunting scenes and a medallion containing a seated figure.
A.I.

197
TILE
19th century
Earthenware, polychrome painting. *32.5 x 24.2*
Inv. No. VG-1638
Provenance: 1935 purchase.
Literature: St Petersburg 2004, No. 191.

The Hermitage has a good collection of 19th-century tiles with images in relief and underglaze polychrome painting. Their carefully executed drawing, bright colours and pure, brilliant glaze are evidence of the makers' skill. Tiles of such kind were used to decorate palace architecture.
This tile has a scene from some fairytale, a rider dressed in rich costume on a white horse with a large phoenix above.
A.A.

198
TILE
19th century
Earthenware, polychrome painting. *34.7 x 41.3*
Inv. No. VG-1649
Provenance: unknown.
Literature: St Petersburg 2004, No. 192; Edinburgh 2006, No. 164.

The depiction of elegant ladies and gentleman set against a landscape and architecture is in relief with polychrome underglaze painting. Running along the top is a frieze of bushes and birds.
A.A.

199
TILE
19th century
Earthenware, polychrome painting. *50 x 32.5*
Inv. No. VG-1650
Provenance: 1933 from the State Museums Fund.
Literature: Edinburgh 2006, No. 165.

An inscription top left names the old man shown seated on a hummock in the projecting central frame as Hushang, one of the ancient shahs of Iran. According to epic tradition, reflected in the *Shahnama*, Hushang's achievements included teaching people to mine metals, laying the basis for the working of iron, teaching people to plough and sow and to make clothing from the skins of wild animals (hence the robe and green cloak he wears seem to be made of fur). He also instituted the Zoroastrian Feast of Sada, celebrating the discovery of fire. Once upon a time he was walking along a mountain path when he came face to face with a huge beast; Hushang threw a stone at the beast but it hit a rock and gave forth sparks, and thus man learned how to make fire. This explains the mountain behind Hushang's back, the rock by his left hand and the yellow tongues of flame to either side.

The Hermitage has another tile from this series of ancient Shahs, on which the same frame runs around an image of the conqueror Iskander – Alexander the Great – dressed as a warrior in armour and helmet.
A.A.

200
CARPET
1311 AH / 1893
Wool. *125 x 198*
Inv. No. VT-1643
Provenance: 1970 purchase.
Literature: Loukonine, Ivanov 1996, No. 188.

The subject on this carpet is taken from the stone reliefs adorning the hundred column hall at Persepolis. An inscription in French in the lower part confirms that these are 'Personnages anciens à Persepolis', while the cartouche in the upper part bears the name of the client, Abd al-Hussein Mirza Fermanferma, and the date 1311 AH (1893-94). This carpet reveals the interest in ancient Iranian art and history that appeared in the late 19th century, possibly as a result of European influence.
A.I.

LOANS ALLARD PIERSON MUSEUM

201
BEAKED JUG
Amlash, *1350-1000 BC*
Black earthenware. *Height 27.5*
APM Inv. No. 9176
Literature: MVVAPM 24; Gifts to mark the re-opening 1976, Allard Pierson Museum, Amsterdam, 1976, p. 36; Western Asia 1988, p. 78, II; Gids 2002, p. 77, pict. 66

202
BULBOUS FLASK
Amlash, *1350-1000 BC*
Black earthenware. *Diam. 23*
APM Inv. No. 6857
Literature: Gifts to mark the re-opening 1976, Allard Pierson Museum, Amsterdam, 1976, pict. 15

203
RHYTON IN THE FORM OF A RAM
Amlash, *1350-1000 BC*
Red earthenware. *Length 25.5*
APM Inv. No. 11790
Literature: MVVAPM 47, p. 14, pict. 2; Gids 2002, p. 77, pict. 66

204
AXE
Luristan, *1350-1000 BC*
Bronze. *Length 19.5*
APM Inv. No. 9187
Literature: Western Asia 1988, p. 81, pict. 53; Gids 2002, p. 78, pict. 76

205
SMALL FIGURE OF A GOAT
Luristan, *early 1st Millennium BC*
Bronze. *Height 2.5*
APM Inv. No. 8435
Previously unpublished

206
FLASK
Iran, *1000-800 BC*
Grey earthenware. *Height 11.5*
APM Inv. No. 6852
Previously unpublished

207
BEER FLASK WITH BASKET-SHAPE DECORATION
Iran, *1000-800 BC*
Red earthenware. *Height 18.6*
APM Inv. No. 6830
Previously unpublished

208
PHIALE WITH CENTRAL FIGURE OF A GOAT
Iran, *750-550 BC*
Earthenware, red painting. *23.0*
APM Inv. No. 13320
Previously unpublished

209
SWORD OR DAGGER HILT,
DECORATED WITH A GOAT'S HEAD
Iran, *600-400 BC*
Ivory. *Diam 7.3, Height/depth 5.4*
APM Inv. No. 13372
Literature: MVVAPM 64, pict. 65

210
FLASK
Parthia, *200 BC-200 AD*
Red earthenware. *Height 23.6*
APM Inv. No. 9179
Previously unpublished

Bibliography

ADAMOVA 1996
A. T. Adamova, *Persidskaya zhivopis' i risunok XV – XIX vekov v sobranii Ermitazha* [Persian Paintings and Drawings of the 15th to 19th Centuries in the Hermitage Collection], exh. cat., Hermitage Museum, St Petersburg, 1996

ADAMOVA 2001
A. Adamova, 'The Hermitage Museum Manuscript of Nizami's Khamseh, Dated 835/1431', *Islamic Art* V, 2001

AMSTERDAM 1999
Earthly Beauty Heavenly Art. Art of Islam, exh. cat., De Nieuwe Kerk Amsterdam, 1999-2000

BORISOV, LUKONIN 1963
A.Ya. Borisov, V. G. Lukonin, *Sasanidskie gemmy* [Sassanian Gems], Leningrad, 1963

EDINBURGH 2006
Beyond the Palace Walls. Islamic Art from the State Hermitage Museum. Islamic Art in a World Context, ed. Mikhail B. Piotrovsky and Anton D. Pritula, National Museums of Scotland, Edinburgh, 2006

GIDS 2002
H. Brijder & G Jurriaans-Helle, *Gids voor de collecties van het Allard Pierson Museum* [Guide to the Collections of the Allard Pierson Museum], Amsterdam 2002

IVANOV, LUKONIN, SMESOVA 1984
A.A. Ivanov, V.G. Lukonin, L.S. Smesova, *Yuvelirnye izdeliya Vostoka. Drevniy, sredenvekovyy periody* [Oriental Jewellery. Ancient and Medieval Periods], Moscow, 1984

KUWAIT 1990
Masterpieces of Islamic Art in the Hermitage Museum, exh. cat., Dar al-Athar al-Islamiyyah, Kuwait, 1990

LONDON 2004
Heaven on Earth: Art from Islamic Lands, exh. cat., Hermitage Rooms, London, 2004

LOUKONINE, IVANOV 1996
V. Loukonine, A. Ivanov, *Persian Art,* St Petersburg – Bournemouth, 1996

MVVAPM
Mededelingenblad van de Vereniging van Vrienden van het Allard Pierson Museum (Bulletin of the Association of Friends of the Allard Pierson Museum)

ST PETERSBURG 2000
Zemnoe iskusstvo – nebesnaya krasota. Iskusstva islama [Earthly Art – Heavenly Beauty. The Art of Islam], exh. cat., ed. M.B. Piotrovsky, St Petersburg, 2000

ST PETERSBURG 2004
Iran v Ermitazhe. Formirovanie kollektsiy [Iran in the Hermitage. The Formation of the Collections], exh. cat., Hermitage Museum, St Petersburg, 2005

TREVER, LUKONIN 1987
K.V. Trever, V.G. Lukonin, *Sasanidskoe serebro. Sobranie Gosudartsvennogo Ermitazha* [Sassanian Silver. The Collection of the State Hermitage Museum], Moscow, 1987

TURKU 1995
Islamic Art from the Collections of the Hermitage, exh. cat., Wainö Aaltonen Museum of Art, Turku, 1995 (in three parallel languages)

WESTERN ASIA 1988
Gids voor de afdeling West-Azië (Guide to the West-Asian Department), Allard Pierson Museum, Amsterdam 1988

Colophon

Concept and Editing
Adèl Adamova
Anatoly Ivanov
Arnoud Bijl
Vincent Boele (final editing)

Coordination
Heleen van Ketwich Verschuur

Authors
Adèl Adamova
Vincent Boele
Anatoly Ivanov
Elena Korolkova
Oleg Neverov
Alexander Nikitin

Authors of the catalogue
Adèl Adamova (A.A.)
Roman Grigoriev (R.G.)
Anatoly Ivanov (A.I.)
Anna Ierusalimskaya (A.Ie.)
Elena Korolkova (E.K.)
Oleg Neverov (O.N.)
Alexander Nikitin (A.N.)
Grigory Semenov (G.S.)

Photography
D. Bobrova
Leonard Heifets
Terebenin
Yuri Molodkovets
Vladimir

Translations
Arnoud Bijl (ru-nl)
Catherine Phillips (ru-en)
Michele Hendricks (nl-en)

Graphic design
Artgrafica, Amsterdam

DTP
Zeeman & Beemster, Amsterdam

Print
Waanders Drukkers, Zwolle

Catalogue for the exhibition in the Hermitage Amsterdam,
Persia: Thirty Centuries of Art and Culture, 31 March till 16 September 2007, organized by the State Hermitage Museum in St Petersburg and the Hermitage Amsterdam.

isbn 978-0-85331-973-3

Published by
Lund Humphries
Gower House
Croft Road
Aldershot
Hampshire guii 3hr
United Kingdom

and

Lund Humphries
Suite 420
101 Cherry Street
Burlington
vt 05401-4405
USA

Lund Humphries is part of Ashgate Publishing

www.lundhumphries.com

British Library Cataloguing-in-Publication Data
A catalogue record for this book is available from the British Library

Library of Congress Control Number:
2007924521

COLOPHON *of the exhibition*
PERSIA, THIRTY CENTURIES OF ART & CULTURE

Exhibition Committee

STATE HERMITAGE MUSEUM, ST PETERSBURG

PROFESSOR DR MIKHAIL B. PIOTROVSKY
Director

PROFESSOR DR GEORGE VILINBAKHOV
Deputy director

DR VLADIMIR MATVEYEV
Deputy director

PROFESSOR DR GRIGORY SEMENOV
Head of the Oriental Department

HERMITAGE AMSTERDAM

ERNST W. VEEN
Director

CATHELIJNE BROERS
Deputy Director

FRANS VAN DER AVERT
Head of Communication, Education & Marketing

PIETER VAN EMPELEN
Project Director Hermitage Amsterdam Phase II

MARLIES KLEITERP
Head of Exhibitions

Concept of the Exhibition

ADÈL ADAMOVA
*Curator of the Oriental Department,
State Hermitage Museum*

ANATOLY IVANOV
*Curator of the Oriental Department,
State Hermitage Museum*

VINCENT BOELE
Curator of Hermitage Amsterdam

Restoration & Conservation

*Restoration of the exhibition items was prepared in
the Conservation Laboratories of the Department of the
Scientific Restoration of the State Hermitage Museum*

NATALYA BOLSHAKOVA　　ELENA STEPANOVA
EVGENIA CHEREPANOVA　　ARTEM STEPANOV
MARINA DENISOVA　　GALINA FEDOROVA
ANNA POZDNYAK　　VALENTINA KHOVANOVA

Exhibition design

GER FEIJEN, RHOON

Graphic design

ARTGRAFICA, AMSTERDAM

Packing and transport

KHEPRI LTD, ST PETERSBURG
JAN KORTMANN ART PACKERS & SHIPPERS,
AMSTERDAM

GREEK GOLD
ISBN 978-0-85331-924-5

NICHOLAS & ALEXANDRA
ISBN 978-0-85331-925-2

VENEZIA!
ISBN 978-0-85331-927-6

BYZANTIUM-JERUSALEM
ISBN 978-0-85331-939-9

SILVER
ISBN 978-0-85331-948-1

COLLECTORS
ISBN 978-0-85331-960-3

HERMITAGE AMSTERDAM
NIEUWE HERENGRACHT 14
AMSTERDAM

P.O. BOX 11675
1001 GR AMSTERDAM

TELEPHONE: 020 - 530 87 55
INFORMATIONNBR.: 020 - 530 87 51
FAX: 020 - 530 87 50
INFO@HERMITAGE.NL

Information about Lund Humphries
can be found at
WWW.LUNDHUMPHRIES.COM

Information about Hermitage Amsterdam
can be found at
WWW.HERMITAGE.NL